*The Magnificent Boat*

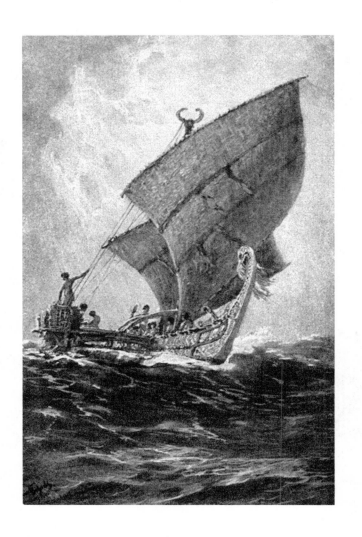

# The Magnificent Boat

The Colonial Theft of a
South Seas Cultural Treasure

## GÖTZ ALY

Translated by Jefferson Chase

*The Belknap Press of Harvard University Press*
Cambridge, Massachusetts ◆ London, England
2023

Originally published in German as *Das Prachtboot: Wie Deutsche die Kunstschätze der Südsee raubten,* Copyright © 2021 by S. Fischer Verlag GmbH, Frankfurt am Main

*Frontispiece:* Painting of the Luf Boat sailing the open seas by maritime artist Hans Bohrdt, from a 1916 postcard. The reverse side of the card reads: "The last boat from Agomes [Luf] Island in the South Seas, published by the Kolonialkriegerdank [Colonial Warriors Gratitude Association], a registered association supporting former colonial warriors of the army, navy, security, and police troops and those they left behind."

*Library of Congress Cataloging-in-Publication Data*

Names: Aly, Götz, 1947– author. | Chase, Jefferson S., translator.
Title: The magnificent boat : The colonial theft of a South Seas
    cultural treasure / Götz Aly ; translated by Jefferson Chase.
Other titles: Prachtboot. English
Description: Cambridge, Massachusetts : The Belknap Press of
    Harvard University Press, 2023. | Originally published in German
    as Das Prachtboot : wie Deutsche die Kunstschätze der Südsee
    raubten, Frankfurt am Main : S. Fischer Verlag, 2021. | Includes
    bibliographical references and index.
Identifiers: LCCN 2022031710 | ISBN 9780674276574 (cloth)
Subjects: LCSH: Luf-Boot (Boat) | Cultural property—Destruction
    and Pillage—Germany. | Cultural property—Destruction and
    pillage—Papua New Guinea. | Boats and boating—Papua New
    Guinea—History. | Papua New Guinea—Antiquities.
Classification: LCC DU740.3 A5913 2023 | DDC 995.3—dc23/
    eng/20220719

LC record available at https://lccn.loc.gov/2022031710

In general and without exaggerating, we can say the following about a great many colonies: A large percentage of the work of European officials, officers, merchants, and researchers is directed toward brawling, looting, vandalism, arson, and murder.

—SIEGFRIED LICHTENSTAEDTER, *Kultur und Humanität* (Culture and Humanity), 1897

# Contents

1 The Scene of the Crime:
German New Guinea     1

2 With Pastor Aly's Blessings     10

3 The Luf Boat as Museum Attraction     20

4 The 1882 Luf Massacre     25

5 "Bastian's Network" of Thieves     43

6 Deceit, Larceny, and Looting     53

7 Curators, Crusaders, and Cannons     63

8 Ethnology, Child of Colonialism     74

9 The Luf Boat Comes to Berlin     90

10 An Artifact of an Ancient Culture     101

11 Islands Stripped Bare     123

12 Where Does the Luf Boat Belong?     136

BRIEF BIOGRAPHIES     159

ABBREVIATIONS     167

VIII   CONTENTS

NOTES                                   169

BIBLIOGRAPHY                            183

SOURCES AND ACKNOWLEDGMENTS             195

ILLUSTRATION CREDITS                    199

INDEX                                   201

*The Magnificent Boat*

In late November 1884, the crews of the German navy corvette *Elisabeth* and the gunboat *Hyena* dropped anchor in Astrolabe Bay and raised the Imperial German flag over New Guinea. On board was the navy chaplain Gottlob Johannes Aly. A short time later, the German administration town of Friedrich-Wilhelmshafen (today's Madang) was founded.

# I

# The Scene of the Crime

## German New Guinea

For quite some time, the Bismarck Archipelago—a group of islands off the northeastern coast of New Guinea—has been on my radar screen as a historian. The reason is that my great-granduncle Gottlob Johannes Aly served in the Imperial German Navy as a chaplain and took part in the colonial subjugation of the archipelago in the 1880s. One of the islands was in fact named after him. I knew this even as a child. But like most of his countrymen, Pastor Aly didn't talk about conquering or subjugating; at most he might refer to occupying, but usually he spoke of civilizing, missionizing, and protecting.

The German "colonial possessions" near Australia included the northeastern quarter of the main island of New Guinea as well as the Bismarck Archipelago. The colony, which existed, at least de facto, from 1884 to 1914, was known as German New Guinea. Mount Wilhelm, the highest mountain (at around 4,500 meters), was named after Chancellor Otto von Bismarck's son and is still known by that name, and the Bismarck Sea has also kept its name internationally. Today, the former German colony, together with

what used to be the British southeastern part of the island, make up the nation of Papua New Guinea, which was founded in 1975.

During their thirty-year reign, the colonists of German New Guinea established plantations totaling around 35,000 hectares. Exports included phosphate, gold, caoutchouc (natural rubber), cocoa, pearls, mother-of-pearl, and trepang (dried sea cucumber, or bêche-de-mer), which is considered a delicacy. But the most important export product was copra (dried coconut), which was used to make margarine and soap.

Plantation owners and merchants wielded the sort of executive power normally reserved for governments. They officially enjoyed a "broad right to physically discipline" their workers, impose monetary fines upon them, and even "confine them to special spaces in chains or not."[1] In reality, they had far greater leeway. Colonists who stole from or killed "savages," raped women, or kidnapped young men for forced labor usually had no fear of being punished.

Such latitude was entirely in keeping with the German colonial endeavor Bismarck had laid out before the German parliament— the Reichstag—in the summer of 1884. Over and over, colonial policy prioritized mercantile initiatives and "permeation" of more and more territory and was backed by state and military support. The favored means of enforcing colonial interests were so-called punitive expeditions led by Imperial German gunboats. Bismarck spoke in convoluted but nonetheless unambiguous form of the merchants' "abiding sovereignty derived from the German Empire," which exclusively served the "free development" of German enterprises.[2]

German merchants, agriculturists, pioneers, and missionaries could thus call in the military whenever "natives" refused to obey or rebelled against their new masters. Both the rebellions and the interventions happened repeatedly. Because of the great distances

involved, colonial German "punishments"—in reality, acts of revenge—were often carried out months or even years later. Those who suffered were mostly the innocent victims of military actions that got out of hand and resulted in massacres. Nonetheless, such actions were regarded as necessary for making examples of rebels, preventing uprisings, and reinforcing German power and interests. German newspapers reported extensively on the massacres, which they portrayed as nothing at all out of the ordinary. The granting of state powers to profit-oriented entrepreneurs remained controversial, but that was the rule throughout German New Guinea—although it was obvious, given the gigantic distances and relative dearth of colonists, that selfishness, greed, violence, and capriciousness would inevitably flourish unchecked.

The colony was expanded through the addition of a number of far-flung Micronesian islands in 1899, after which voyages by sailing schooners across the territory of German New Guinea, 3,000 kilometers east to west, could take up to fifty days. In early 1914, for every 500,000 Indigenous people, there were 1,130 white people, including 247 women and 113 children. The statistics also listed "102 half-breeds." Most of the white people were German citizens. A third of this tiny ruling class were missionaries; the others were farmers, merchants, sailors, machinists, technicians, and officials.[3] Despite intense recruitment efforts, few settlers were lured to the mysterious world of the South Seas. Those who worked there had pledged loyalty to the German flag and lived in constant fear of being attacked. Countless stories were told and constantly embellished about murdered traders and slavering cannibals who roasted and devoured their fellow human beings. The fear of such horrors, combined with the colonists' own material interests, led to military aggression and everyday violence against Indigenous people, with their far greater numbers and vastly superior knowledge of the region.

## The Hermit Islands, Home of the Luf Boat

There has long been heated debate in Germany about unjustly acquired or stolen cultural artifacts in museums—with attention focused largely on items from Africa. Ethnological and anthropological treasures from the South Pacific have been largely ignored, including the object that is the focus of this book: the Luf Boat. This large outrigger was brought to Germany from the Hermit Islands, an atoll located on the western edge of the Bismarck Archipelago. Most of the atoll's constituent islands are small, uninhabited, and volcanic. The largest, measuring six square kilometers, is Luf (also Loof, Lub, or Louf).[4] From here originated the two-masted outrigger sailing vessel that is one of the most prized items in the collection of the Berlin Ethnological Museum, now located in the Humboldt Forum. The boat is fifteen meters long, was constructed without a single nail, and is decorated with marvelous carvings and paintings. It was built for the high seas and is capable of transporting fifty people.

In the summer of 2019, I chose this technical and artistic masterpiece as a jumping-off point for a study of looted art in the Humboldt Forum. Initially, my intention was to write a newspaper article or essay that would discuss my relative Pastor Aly. But the more I delved into the documents, the clearer it became that the Luf Boat is not just the highlight of Berlin's ethnological collection and a significant artifact of human culture, worthy of preservation. It is an extremely instructive representative example of the colonial violence done to Indigenous peoples in tens of thousands of other cases.

To start at the end of the story: the Luf Boat "made its way" to Berlin in February 1904, with the help of a Hamburg trading firm called Hernsheim & Co., which had been founded in the 1870s and was very active in the South Seas. An official report on the

Prussian royal art collections in 1904 noted among its acquisitions under the rubric "South Seas Purchases": "A large, fifteen-meter-long outrigger from the Agomes [Hermit Islands] with two masts and corresponding sails."[5] It was exhibited in the courtyard of the Royal Museum of Ethnology (Völkerkunde) before being moved, after the Second World War, to the renamed and relocated Ethnological Museum. Since 2021, it has been on display in the 500-square-meter main hall of the Humboldt Forum in the rebuilt Berlin Palace as part of an exhibit on "the global development of humanity."[6]

In 2018, the possessor of the boat under German law, the Prussian Cultural Heritage Foundation, staged a major media event in conjunction with the "spectacular" vessel being moved to its new location. In her ceremonial address, Monika Grütters, the German state minister for culture, proclaimed, "From now on, the Humboldt Forum will shine as a site in which the history of culture can be told."[7]

But what precisely is shining here? Whose histories are being told in the Humboldt Forum, and whose are not? German intruders committed countless violent crimes in Papua New Guinea, but hardly any place was so thoroughly ruined as the small island of Luf. There, Germans burned down all the huts, smashed all the canoes, murdered and raped, and allowed the Indigenous population to perish from starvation or disease so that the colonists could transform the Hermit Atoll, with the help of kidnapped slave laborers, into a profitable coconut plantation. Luf wasn't the only location where the conquerors looted cultural artifacts for their museums, treasures subsequently whitewashed for accession into institutions that touted having "rescued" and "preserved" them. The fact that these stolen items are still misused to symbolize cultures and humanity makes a mockery of actual history.

Around 1850, at least four hundred people lived on Luf. They were called either Hermits or Lufites, and they maintained economic relations, often friendly but occasionally hostile, with groups on other, sometimes faraway islands. Then, in December 1882, came the terrible punitive expedition and massacre carried out by the German warships *Carola* and *Hyena* (*Hyäne*), which I describe in Chapter 4.

Around twenty years after the massacre, the physician and ethnologist Georg Thilenius, who had conducted research on Luf in 1899, pondered the causes of the conspicuous cultural decline on the island. "Admittedly, here as well, punitive expeditions have had all too lasting an effect," he wrote. "Instead of the usual large traveling boats built back then, only one new one has been constructed." Thilenius stressed the hard work the Indigenous islanders had put into their subsistence economy: "Insofar as the land isn't cultivated, all the islands are covered with forests, which thanks to the care of Indigenous people aren't significantly less full of crop plants than on coral or volcanic islands." All of this would soon be destroyed by German merchants and plantation owners. Luf was the only island to retain its forest for any time. It was a de facto "reservation" for Indigenous people to go to die, while the bringers of "civilization" burned down forest on all neighboring islands to clear space for their coconut plantations.

Thilenius was impressed by the complex decorations of the boat when it was brought to Berlin five years after his visit, noting that they had been "made by carving" and that the designs' motifs were based on the "phallus figure." He was equally enthusiastic about the imagination of the Indigenous people of Luf, which allowed them to create "larger ornaments and forms."[8] In Chapter 10, by citing in detail Thilenius's description as well as other contemporaneous reports, drawings, and photographs of the vessel, I will attempt to recover the cultural value of the Luf Boat and

the sophistication of its construction and decoration, which have been obscured behind the history of destruction and looting.

Word about the beautiful boat on Luf electrified Felix von Luschan, the curator responsible for the South Seas section of the Berlin Ethnological Museum. In 1904, he succeeded in adding this, the final boat of its kind built after the 1882 massacre, to his collection. In Prussian Cultural Heritage Foundation records, it was given item number VI / 231116a and soberly described as "wooden, carved, painted red, white, and black, bound together with rattan and coconut fiber, plant caulking, bamboo, plant fibers, feathers, cloth, sails woven from strips of palm leaves; height × width × depth: 960 × 1520 × 650 cm (total dimensions); width (with outriggers, without counter bridge): 380 cm; height (front mast): 780 cm; height (highest sail, tip): 960 cm; weight: 1358 kilos."

## New Names and New Concepts

Today, museum curators tend to avoid terms like "ethnology," which have been tainted by their association with Eurocentric racism, and to use generalities like "legacies of human civilization." Often, if not always, this language serves to downplay the history of items acquired in dubious circumstances. The more or less explicit self-serving logic is that the cultural products of Europe's former colonies belong to humanity as a whole, no matter whether they're put on exhibit in Paris, Brussels, Amsterdam, Madrid, London, Vienna, or, as is the case here, Berlin.

To evade the unpleasant questions surrounding many collections, some ethnological museums have renamed themselves. The museum of ethnology in Berlin was transformed into the Humboldt Forum, the one in Munich into the Museum of Five Continents, in Vienna into the World Museum, in Frankfurt am Main into the Museum of World Cultures, in Basel into the Museum

of Cultures, and in Hamburg into the sprightly acronym MARKK, which stands for Museum am Rothenbaum—Kulturen und Künste der Welt (Museum on Rothenbaum Avenue, Cultures and Arts of the World). Paris boasts two ethnological museums. The older one is called the Musée de l'Homme, while the much younger one, founded during the presidency of Jacques Chirac, was simply named after its address, Musée du quai Branly. The ethnological museums in Cologne, Gothenburg, and Rotterdam have engaged in similar verbal gymnastics.

Instead of pondering, discussing, and debating colonialism in detail, such museums are awkwardly rebranding themselves as sites where "the cultures of the world" allegedly "convene in dialogue." But this strategy is little more than superficial, wishful thinking. Supported by high-minded concepts of equality and inclusivity, this extremely one-sided fictional conversation is, instead, a penitent form of indulgence—in the religious sense of buying one's way out of responsibility for one's sins. Sometimes the whole production is crowned by an anticolonial sculpture or installation by a more-or-less well-remunerated artist, optimally a person of color. At the same time, ethnological museums usually segregate their largely looted, "exotic" holdings from their collection of European artistic, artisanal, and everyday items. The implication, although hardly anyone dares say so out loud, is that the latter are of superior cultural value.

The curators in charge of ethnological collections today know that they owe them to deceit, the fencing of stolen items, looting, and murder. According to conservative estimates, more than 80 percent of the South Seas artifacts in Germany arrived during the colonial period.[9] In 2018, Stuttgart's Linden Museum determined that 95 percent of its South Seas collection could be traced back to the period of German colonial rule.[10] The holdings in Berlin have never been subjected to any similar examination.

This book describes the ruthlessness, ignorance, fear, and greed of the German colonists in the South Seas. I focus on the provenance of the one-of-a-kind Luf Boat, which, together with the histories of other items, shows how destructive the actions of most European soldiers, officers, officials, explorers, missionaries, researchers, plantation operators, hunters of rare birds, and merchants really were. These people saw themselves, of course, in a completely different light: as pioneers, messengers, and champions of civilization, culture, and humanity.[11]

## 2

# With Pastor Aly's Blessings

I have been familiar with the boat from the island of Luf for quite some time. In the 1970s, my family and I enjoyed visiting the South Seas section of the Ethnological Museum near our home in West Berlin. But it was (Gottlob) Johannes Aly, my ancestor, who first made me question how this splendid sea vessel got to the city and what became of the people who built it. In 2019, for another research project, I was thumbing through documents concerning Aly in our family archive, which is in my possession.[1] With recent discussions concerning colonialism in the back of my mind, I read through his account of his "longest and nicest" voyage as a navy chaplain. The voyage, from April 1884 to April 1886, took him to Africa and the South Seas.[2]

Pastor Aly was part of the 380-strong crew of the *Elisabeth*, a "fine-sailing" wooden corvette built in 1868 and equipped with nineteen guns and an auxiliary motor. As chaplain, he was also charged with spiritually supporting the crews of accompanying warships. According to imperial orders, these ships' mission was to "hoist the German flag at various points in Africa and the South Seas and place broad stretches of southwest Africa and the South Seas under German protection." Things went very much to plan, and my great-granduncle gave his Protestant blessings to all who participated.

Pastor Gottlob Johannes Aly, namesake of the
island of Aly (Siar) in the Bismarck Archipelago.

Pastor Aly administered last rites to sailors who drowned, and
whenever a comrade succumbed to a tropical fever, he gave "a
moving speech," asking the Lord for mercy. The bodies of the dead
were "slowly lowered into the sea to the strains of 'Jesus Christ, My
Sure Defense'" until "the waves came together silently above
them." As the *Elisabeth*'s physician, Dr. Harry Koenig, attested
in his subsequently published journal, Aly conducted morning
prayers on Mondays and Thursdays: "He had a splendid voice,

but he spoke plainly without unction or pathos. I have rarely seen as many listeners as our chaplain had—the troops and officers hung on his every word."[3] Every Sunday, the crews were called to services with "Eine feste Burg ist unser Gott" (A Mighty Fortress Is Our God). When the *Elisabeth* was in port, Aly would visit the Christian mission, where his brothers and sisters in faith from various countries, as he put it, "patiently tried to win over people of the most primitive sort for the Gospel."

## Trade, Flag Raising, and Violence

After several months of raising flags in German Southwest Africa, the *Elisabeth* reached the South Seas. The first thing Aly reported on, in a rather off-hand way, was a punitive expedition led by the gunboat *Hyena* and supported by the crew of his own ship. The attack targeted an island whose inhabitants had allegedly "swarmed a barque, stolen everything on board, and killed and eaten the crew." Because "the *Kanaker* had fled into the forest," the European intruders contented themselves with destroying their "belongings, huts, boats, and crops." That was all Aly wrote about this event. (The derogatory term *Kanaken*, or *Kanaker*, was typically applied to the native peoples of Germany's South Seas colonies. It came from Hawaiians, who called themselves *Kanaka maoli*. Neighboring peoples referred to them simply as *Kanaker*.)

The destructive raid Aly witnessed took place at the southern tip of the island of New Ireland in late October 1884, and it was intended, in the words of the *Elisabeth*'s captain, Rudolf Schering, to teach the people who lived there that "they would always be harshly punished whenever they ran amok." Following standard procedure, the raid began with a barrage upon the village in question, although the ship's revolver cannon jammed after the

fourteenth round. We don't have any more details about the expedition. As we now know, the specifics were expunged from the official file at an early date.[4]

An account by the commercial agent and ethnological researcher Otto Finsch sheds some light on the lead-up to this event. He wrote that the "German barque" to which Aly referred was the *Mirko,* and that it was used in the labor trade. In other words, the crew of the vessel was trying to capture islanders to sell to plantation owners. Tens of thousands of people in the South Seas were enslaved in this fashion, and most, as Finsch noted, "never saw their home islands again." The slave trade, Finsch added, had "the most pernicious sort of influence." It was often "the cause of those massacres that were attributed almost without exception to the bloodthirstiness and savagery of the natives" but that "commonly hurt innocent people on both sides."[5]

Hardly had the men of the *Hyena* exacted their revenge than the *Elisabeth* called at the large natural harbor on the island of Matupi, where the Hamburg trading company Hernsheim & Co. had been conducting its business for several years. (The firm's telegram address was MATUPICO.) The strategically located island was placed under German protection on November 3, 1884, at Hernsheim's behest. As was customary, the Imperial German flag was hoisted, followed by a twenty-one-gun salute from the *Elisabeth* and a "thunderous threefold celebration of the kaiser." To top it off, the conquerors sang rousing renditions of Prussian military songs accompanied by a brass band.[6]

Following standard protocol for territory placed under German protection, "sealed orders" from the kaiser, conveyed to Matupi in the safe aboard the *Elisabeth,* were opened and read out. After that, "the significance of this act" was explained to the native people in pidgin English: "Bye and bye you kill white man, man of war kill you."[7] Draconian punishments were by no means meted out only

in response to killings, however. On February 11, 1884, a few months before Matupi was placed under German protection, three homes there were burned down "to retaliate for a case of breaking and entering and theft seven months previously."[8] More than a year before, in late 1882 and early 1883, German naval forces had already carried out a deadly assault on Luf, as we will see in Chapter 4.

Such was the founding of the colony of German New Guinea, which only gradually took on clear administrative and legal form. The government's secret instructions to seize this land were issued in Berlin in August 1884 and read, "His Majesty the Kaiser himself has personally approved of the German flag being raised as soon as possible to preserve our interests in the western part of the South Seas, especially the islands of the New Britain Archipelago and the part of the northeast coast of New Guinea outside the legitimate sphere of interest of the Netherlands and England, wherever German settlements exist or are planned."[9]

New Ireland was renamed Neu-Mecklenburg, and New Britain became Neu-Pommern (New Pomerania). A few years later, German colonists established an administrative center across the street from Hernsheim's headquarters in Matupi. It was named Herbertshöhe after Herbert von Bismarck, the son of Otto von Bismarck and state secretary in the German Foreign Ministry. It is today's Kokopo. The city is located on St. George's Channel, one of the most important shipping lanes in the region, which is why the Hernsheim company, after a few false starts, set up its main offices there in 1879. By late 1884, the merchants from Hamburg, like their colleagues from Bremen in Southwest Africa before them, had accrued enough influence to convince the state to protect their interests.

This situation illustrates a truism in European colonial history: "The flag follows trade." The Hernsheim brothers and the

German Trade and Plantation Society, which was also active in the South Seas and with which they were connected, had previously made "numerous petitions" to the government. But it wasn't until the summer of 1884 that Franz Hernsheim could write with relief that Prince Bismarck was finally "inclined to secure German pioneer work in the South Seas through permanent seizure of possession."[10]

After a brief stay in Matupi, the conquerors aboard the *Elisabeth* hoisted the red, white, and black imperial war flag in the northeast of the island of New Guinea. The area was henceforth known as Kaiser-Wilhelmsland, and an outpost called Friedrich-Wilhelmshafen (today's Madang) was soon set up there. The surrounding twenty-one islands were mapped and renamed. With permission from the German Admiralty, they were given the names of the commanding officers and military clergy of comparable rank. My great-granduncle drily remarked, "That's how I got my Aly Island." (The native people called the island "Siar" and still do today.) In early December 1884, the *Elisabeth* sailed back to Matupi and headed off to Japan, raising the imperial flag together with the *Hyena* here and there along the way. Further stations on the voyage were Hong Kong, Singapore, and Dar es Salaam.

On December 23, 1884, the German Foreign Ministry ordered its diplomats all over the world to inform the respective powers-that-be that henceforth the parts of the South Seas known as Kaiser-Wilhelmsland and the Bismarck Archipelago stood "under German protection."[11]

## The Destruction of Canoes, Villages, and People

In his memoirs, Johannes Aly only touched upon the punitive expedition he had witnessed. To understand more about how such operations were carried out in almost all European colonies, it's

useful to look at the German commando raid against the inhabitants of the island of Ali on April 14, 1897. During the German colonial period, there were two islands with almost identical names: Aly and Ali. Although 300 kilometers apart, they were often mistaken for one another, even by Governor Albert Hahl—a confusion that continued in the secondary literature. Both islands had Christian missions: a Catholic Society of the Divine Word on Ali, and a Protestant Rhenish Mission on Aly (Siar). The typical colonialist action terrorizing islanders discussed here took place on Ali Island, near Aitape.

The day before that action, troops from the *Seagull* (*Möwe*)—an older gunship that was being used as a surveying vessel—had come under arrow fire from islanders. In the navy report, the incident arose "as a consequence of trees being cut down for the purpose of creating triangulation sight lines." The crew of the *Seagull*, according to the report, were only trying to precisely measure and map Ali.

But there are two other explanations for the attack by the islanders that plausibly cast it as an act of self-defense. An official account reads, "Among the South Seas *Kanaker*, certain trees and plants are considered holy and untouchable. They are, as the natives say, 'tabu.'" (This South Seas word was just beginning to be added to European languages.) Perhaps in order to stop the sacrilege of what they thought was arbitrary deforestation, the men of the island had sought to drive off the interlopers. A second, more likely explanation was put forward in an account by Pastor Franz Vormann, who had directed the Society of the Divine Word mission since 1896. He reported that members of the surveying team had not behaved "beyond reproach, particularly toward the women," and that the angry men had "launched a physical attack, as is customary among them."

What is certain is that none of the interlopers were harmed, aside from minor injuries. Nonetheless, Lieutenant Captain (later Admiral) Carl Schaumann, commander of the *Seagull*, ordered an armed commando unit and twelve hired hands to burn down the island's eight villages "with 120 to 150 huts," destroy the canoes, and cut down the coconut trees. Schaumann spoke of meting out an "emphatic punishment" for the attack, which had been carried out with "extraordinary gall and deceit," in order to "show these people that the warship is their master."

To this end, Schaumann tried to drive the inhabitants of the island, around eight hundred all told, into one "corner" of it so that he could bombard them with his ship's revolver cannon. His attempt failed because the islanders fled "with their women and children" to a neighboring island three nautical miles away, using bamboo, the remnants of their canoes, and similar material. "In the process, many are said to have drowned," read the official report. The unofficial count of the dead amounted to two hundred men, women, and children.[12]

It was standard procedure for the European aggressors to chop down coconut trees, burn huts, and destroy canoes during punitive expeditions. They knew only too well that boats were "the natives' greatest treasure" and absolutely essential to their survival.[13] These acts of destruction were clearly intended to leave the islanders helplessly exposed to the extremely wet weather. The loss of the coconut harvest and the implements needed to catch fish also undermined their ability to survive. The result was masses of people dying of fever and starvation. Without mentioning the large number of people who had drowned, Schaumann boasted of his "emphatic punishment": "Seven dead and injured and the loss of 96 canoes, as well as huts and coconut trees, will be a beneficial lesson and have positive

effects, particularly as the punishment followed hot on the heels of the deed, as it must."

No sooner had the attack been carried out than the interim regional commander, Curt von Hagen, declared Ali Island "ungoverned" and conferred ownership of it to the New Guinea Company, founded in 1882 in Berlin. (Hagen worked as a regional general director for the firm alongside his official state duties.) The new "owners" prevented survivors from returning to the island, and the missionaries expressed their gratitude. Pastor Vormann welcomed the prophylactic effect of this "exemplary punishment," which had instilled a "salutary fear in all *Kanaken* around here, so that these people . . . will take care not to do harm to any European or his kin."[14] On August 13, 1897, during a subsequent punitive expedition, Hagen was fatally wounded. His obituary in the *Kolonial-Blätter* newspaper bore the headline "Curt von Hagen: An East Prussian Cultural Pioneer in the South Seas."[15]

In 1896, in the publication *Katholische Familienblätter* (Catholic Family Pages), Vormann described how the islanders lived on Ali before the punitive raid. He characterized them as people "who stockpile food, who travel around over great distances in pursuit of trade," and who "sometimes overexuberantly" hold celebrations "at which there is much dancing, singing, eating, and rejoicing the whole night through." One year later, he credited these people, who had been so barbarously attacked, with "a love of peace." He wrote, "They don't enjoy embroiling themselves in conflicts. Their lives or property have to be threatened before they do. Thefts, slave raids, and kidnappings of women rarely happen here." The islanders never stole or swindled others in the fashion of the German colonists, who systematically threatened the way of life and belongings of the people of Ali and many others.[16]

In 1884 and 1885, Finsch described Aly (Siar) Island as a "thickly forested" island with an exceptionally well-fed and "numerous"

population. He admired the decentralized main village with its "large, well-built" houses, meeting hall, signal drum of "colossal proportions," carved and painted fish as "emblems of the fishing trade," fishing traps, nets and hooks, and canoes. Finsch related, respectfully, how the islanders had initially bristled when he curiously approached a holy site in order to document it. "But after they saw that I didn't take anything with me, as they may have feared," Finsch explained, "they allowed me to make my sketches in peace."[17]

# 3

# The Luf Boat as Museum Attraction

On May 28, 2018, when the 18-meter-long crate containing the Luf Boat arrived in the Humboldt Forum building, Hermann Parzinger, president of the Prussian Cultural Heritage Foundation, declared that the crown jewel of his exhibit, which had been built in 1890 on the South Seas island of Luf, had never been used "because, due to the decline in the island's population, the remaining men couldn't get it into the water." In 1902, Max Thiel, the director of the German trading company Hernsheim & Co., just happened to "see and acquire it," Parzinger added. Another source reports that Thiel "purchased" the boat. After a stop on the island of Matupi, the vessel was shipped to the Ethnological Museum in Berlin.[1]

Parzinger was not just president of the Humboldt Forum, but was also one of the three founding directors. The day after the boat's unveiling, the Berlin tabloid *B.Z.* printed an article with the headline "Everything's Afloat with the Boat!" that cavalierly declared, "Because the people of Luf, who died out in 1940, had too few men in 1890 to put the boat to sea, it was given to Berlin 100 years ago."[2] Dorothea Deterts, the curator who was responsible for the South Seas collection, had described the provenance of her "highlight" somewhat differently in 2015. She said that this "top attraction" had been "spotted on Luf in 1899 . . . in a boat-

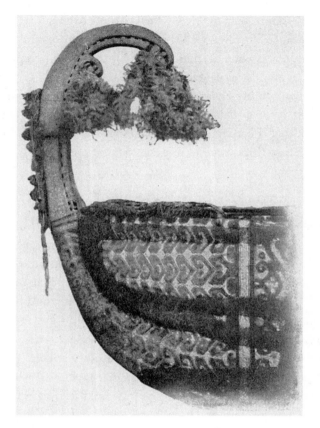

One of the two stems of the double-ended Luf Boat,
photographed in Matupi Harbor in 1902.

house, but because there were only a few men there, it could no
longer be moved, to say nothing of being sailed." Thereupon,
Hernsheim & Co. had "purchased" it and "offered it for resale" to
the Ethnological Museum.[3]

In 1949, Hans Nevermann, one of Deterts's predecessors, had
insistently characterized the Luf Boat, which had been on display

in the museum since 1904, as a "final witness to an aboriginal culture" because "the few survivors of what is today a completely extinct population had been unable to launch it to undertake expeditions of plunder to neighboring islands, as they had in the past."[4] Nevermann didn't say anything at the time about the boat being purchased. Nevertheless, five years later, he noted, rather less confidently, that the merchant Thiel had personally bought this cultural treasure from the Hermit Islanders.[5]

## Transported to Berlin and "Archived"

The cultural anthropologist Gerd Koch, curator of the South Seas exhibit that opened in the new wing of the Ethnological Museum in Berlin in 1970, euphemistically described the "accumulation of large collections" during the "general phase of European influence" as the "archiving" of major cultural artifacts. First and foremost among such artifacts was the large "boat from the island of Luf (Agomes)."[6] In the guide to the South Seas section, he blithely wrote of the "population of Luf, who have now died out" and who were "known above all for constructing large passenger boats capable of sailing the high seas." The final boat of that kind, Koch informed his readers, had been "transported to Berlin" in the early twentieth century.[7]

The ethnologist Augustin Krämer spent two weeks doing research on Luf in September 1906. At the request of his friend Felix von Luschan, he subjected thirteen native inhabitants to an anthropological examination.[8] He, too, briefly mentioned the story of a "large, majestic passenger boat" that the ethnologist Georg Thilenius had allegedly seen "lying about in the Luf boathouse." In 1903 and 1904, it had been "brought, thanks to the efforts of Mister Max Thiel in Matupi, to Berlin," where it had immediately become "one of the crown jewels of the Ethnological Museum."

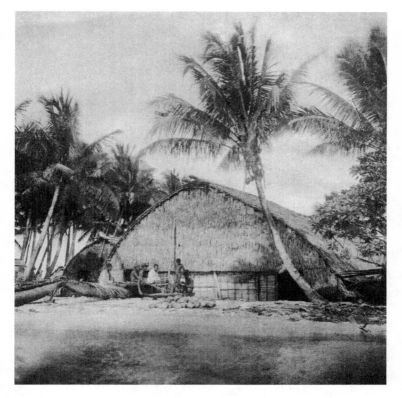

The Luf boathouse, which was also used as a communal men's house and a burial place, photographed by Otto Dempwolff in 1902.

The Danish German trader and colonist Richard Parkinson told a variation of this story in the section on the collector Thilenius from his 1907 memoir *Dreißig Jahre in der Südsee* (Thirty Years in the South Seas), which maintained that Thilenius had seen the "great passenger boat . . . on a beach on Luf," not in the boathouse.[9]

The stories surrounding the boat's origin raise numerous questions. Deterts and Parzinger asserted in 2019 that Thiel

"purchased" it, but is that in fact how he came by this unique artifact? The textual evidence from before 1954 makes no mention of the islanders receiving a fair price or commensurate services for it in 1902. Are the assertions of the legitimate acquisition, indeed the honest purchase, of the boat simply falsehoods? In the publicly available memoirs of Eduard Hernsheim, the man who— to put the matter gently—took possession of the boat, we find the following passage: "The lovely carved and decorated canoes are stitched together from planks that are cut with primitive tools from the wood of breadfruit trees. The last of these vessels that the dying tribe was able to produce later passed into my hands and now graces the Ethnological Museum in Berlin." The phrase "passed into my hands" (*ging in meine Hände über*) leaves no doubt that the boat was purloined—taken away from an island people who had been, as we will see, mercilessly slaughtered at the behest of none other than Hernsheim himself.

This happened at a time when Hernsheim had made great progress toward achieving his vision of a completely colonized, extremely profitable South Seas empire. Looking back on its early years, he wrote in 1910, "It took decades before my dream was realized, but it was realized. The coasts have been surveyed, outposts founded, the natives pacified, and comfortable connections via steamship established between the continents."[10] Suffused with a feeling of colonial omnipotence, Hernsheim and Thiel seized the Luf Boat and stuck it in a Berlin museum as a relic from an allegedly uncivilized epoch dominated by "savages without history."

# 4

# *The 1882 Luf Massacre*

On March 28, 2019, the entry about the Luf Boat in the German version of Wikipedia was expanded to include a long-standing, false historical legend: "The destruction of the fishing boats that were crucial to their survival and the loss of control of the main Ninigo island, 40 nautical miles away, left the inhabitants of Luf feeling hopeless. In 1889, three of their four boats capsized in a storm during an attempt to retake the island. Most of the men capable of fighting died in the incident. In its wake, the populace swore to have no more children and to die out."[1] It's worth asking who, shortly after the much-ballyhooed transport of the Luf Boat to its new home in the still unfinished Humboldt Forum, might have had an interest in disseminating such "alternative facts" on the internet.

As we have seen, Hermann Parzinger had already invoked, in his 2018 speech, the idea that this major museum holding had been brought to Berlin because it could no longer be used on Luf due to "a decline in the island's population." The idea that the native inhabitants of the island had died out, and even voluntarily decided no longer to reproduce, had been around for a long time. Elisabeth Krämer-Bannow, who had traveled to German New Guinea to make sketches, described the "decline in the populace" in her 1916 book *Among Art-Loving Cannibals:* "The most

significant cause must lie with the people themselves, who, sensing their acute demise, apparently have no great desire to reproduce. Many groups on the islands have died out because that's what the inhabitants wanted."

But Krämer-Bannow also mentioned as another factor the deterioration of the native inhabitants to the status of "pack animals" on the plantations and the pitiless eradication of their cherished customs and habits. "The powerful white people," she wrote, "refused these people the right to exist for their own sake."[2] The self-proclaimed bringers of civilization—in the words of the explorer and patron of the Berlin Ethnological Museum Arthur Baessler—did indeed consider that letting the islanders exist simply for their own sake was "the gravest ill." For Baessler, this justified the colonial practice of forcing people to work and bringing in conscripted laborers: because "the natives had no desire to work," the plantation operators had no option but to "introduce workers from other islands."[3]

The Hernsheims complained that the Hermit Islanders were unwilling to dive for sea cucumbers or extract copra from coconuts for them, even though there were "at least 3,000" coconut trees on the islands. In other words, the inhabitants were disrupting the colonial exploitation of the Hermit Islands by withholding their labor. The German masters tried everything to force these people to work, even if the result was their extermination.

This was the context from which arose the stories of the "voluntary extinction" of the people of Luf and elsewhere in the South Seas. Such stories remain in currency today, less as legends than as out-and-out lies: perfidious inventions of precisely those people who had caused the "decline in the population" and taken various sorts of loot back to Germany, and later wanted to assuage their own consciences and those of the German public.

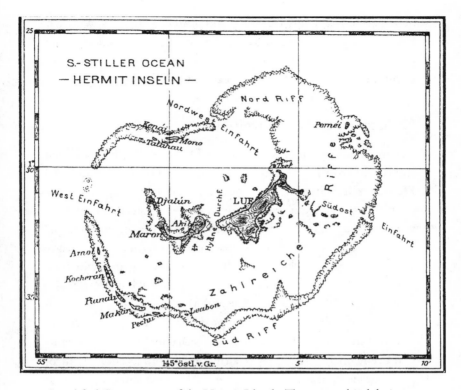

Simplified German map of the Hermit Islands. The geographical desig-
nations "Hyena Passage" ("*Hyäne DurchF.*") and "Carola Harbor" (not
shown on this map) are located between Great and Little Luf. In late
1882 and early 1883, the gunship *Hyena* and the corvette *Carola* destroyed
houses, boats, and other necessities for life on the island.

The entry on the island of Luf in the sixteen-volume 1902 ver-
sion of the Brockhaus encyclopedia underscores the importance
of such imaginatively spun tales to the colonial exploiters, looters,
and thieves. It reads, "Hermit or Agomes Islands or Luf Group:
A group of smaller islands in the western Bismarck Archipelago,

of which only the largest, Luf, is inhabited by natives, who are, however, in the process of dying out; coconut tree fronds (copra production); fishing for tortoise shells, mother-of-pearl and sea cucumber; trading station on a reef east of Luf."

## Civilization and Syphilization

According to the navy doctor Otto Dempwolff, who had been trained in tropical medicine, malaria had not yet reached the Hermit Islands in 1902, so it could not have been responsible for people there dying out, even though this pernicious disease, which was spread by colonists, had "advanced in a devastating triumphal march" to other South Seas islands.[4] Merchants, missionaries, and sailors also spread other, often deadly diseases against which islanders had no natural immunity.[5] In 1904, Richard Parkinson noted that on the islands of Aua and Wuvulu (Maty), the establishment of Hernsheim trading posts had "introduced diseases that had decimated the people there."[6] Originally the inhabitants had been considered a "very healthy breed." But as soon as Europeans arrived, "the widest range of sicknesses showed up," first and foremost malaria, "from which the islanders had previously been free."[7]

Even people at the time knew that to get an accurate picture of the reasons for the increased death rate on the Hermit Islands, various factors had to be considered: punitive expeditions, the deportation of people for forced labor, the plantation economy, and the introduction of previously unknown infectious diseases, particularly syphilis, gonorrhea, smallpox, leprosy, rubella, cholera, typhus, tuberculosis, influenza, and the common cold.[8] The extent to which such diseases were introduced and spread by representatives of "Western civilization" was confirmed by a short report concerning a trip to Luf by the English merchant David

Dean O'Keefe, who worked with Franz Hernsheim. On June 21, 1875, Hernsheim noted in his journal, "Three and a half months ago, O'Keefe set out from here with 170 natives to the Hermits & most of them . . . died on the trip back from influenza, a deadly infectious cough."[9]

Felix von Luschan spoke of the "threefold plague we have visited upon our darker brothers": alcoholism, venereal disease, and "the slave trade, which, although known in the South Seas as the 'labor trade,' is not a hair's breadth less brutal, base, and dastardly than in Africa." Luschan made his excoriations public in 1902 at the German Colonial Congress, but it was too late. "Let me remind you of the equation 'civilization = syphilization,' as shameful as it is terrible, which applies to all of Africa and Oceania."[10]

Such criticisms simply washed over German businessmen, who didn't comment on them. Instead, men like Franz Hernsheim spoke of a civilizing mission and formulated lofty goals, such as "teaching the natives . . . the cultivation of coconut trees and the value of productive labor."[11] Economically speaking, the existing cultures and ways of life in the region had to be destroyed because although the peoples of the South Seas built houses and boats, secured food and engaged in cultural rituals, they had little desire to slave away on coconut plantations for the benefit of an abstract global market. The people of Luf did what was necessary to maintain a subsistence economy. They had what they needed: bananas, taro, coconut and sago palm, breadfruit trees, and an abundance of fish.

This self-sufficiency, in the best sense of the word, began to come to an end when Eduard Hernsheim set up his first trading outpost on a tiny uninhabited bit of rock and sand in the Caroline Islands, ten years before Germany first officially usurped land in the region. From there, thanks to an Englishman named Tom Shaw, who lived on one of the Hermit Islands, Hernsheim became

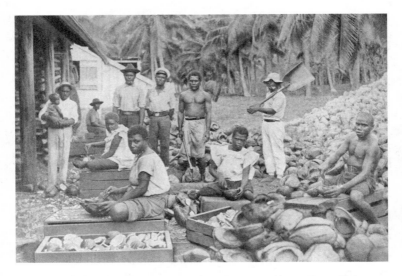

Coconut plantation in German New Guinea around 1900. Forced laborers, some brought in from the Solomon Islands, peel coconuts to extract copra under strict supervision. On the left is the building where the coconut meat was dried.

"Civilization = syphilization." German sailors from the cruiser *Buzzard* in Apai on the island of Samoa.

aware of Luf. On November 21, 1874, he accompanied a British punitive raid against the island's "numerous" inhabitants. Some time previously, two men from Luf had allegedly murdered the crew of an American schooner, which had anchored off the island to harvest sea cucumbers. There is no way of knowing how and why this situation turned violent. When the British warship appeared, the islanders fled into the bush, and the troops then set their homes on fire: "After the flames had been put to the first row of huts, they spread unbelievably fast to all the others." Along with forty huts, the attackers destroyed all the canoes they could find, "some wonderfully carved," as Hernsheim reported.

## Bismarck's Order to Destroy Luf

Although Hernsheim freely admitted that he didn't know what had caused the initial violence against the American ship, he still characterized "the Hermit Island natives" as "extremely dangerous killers," a "terrible gang," and "treacherous savages."[12] Five years later, in June 1879, he set up a small trading outpost in the Hermit Atoll on the island of Carcone, near Luf. It dealt—profitably—in coconuts, sea cucumbers, mussel shells containing mother-of-pearl, and sea snail shells. In January 1881, he moved the outpost to Luf.

In the summer of 1882, news reached Hernsheim, who was in Germany at the time, that Hermit islanders had allegedly attacked his ship *Freya* and killed the captain. In addition, two weeks previously, his ship *Pacific* had been attacked near Luf and his trading outpost set on fire. Hernsheim turned to the chancellor of the Wilhelmine Empire, Otto von Bismarck. By way of introducing his agenda, he praised the punitive British raid he had witnessed in 1874 as an effective "disciplinary measure" that had had the desired effect of keeping the peace for eight years. Unfortunately, that effect was now beginning to dissipate. Thus, Hernsheim urgently

requested that German warships pay "more frequent visits" to teach the Hermit islanders a lesson. Bismarck reacted immediately. On July 24, 1882, he dispatched a navy commando charged with meting out "quick and effective punishment" upon "the natives." The German navy fulfilled its mission thoroughly and cruelly several months later.

Another reason for the punitive expedition, in addition to the attacks on the two ships, was the alleged murder of Hernsheim's agent in the Hermit Islands, Charlie Southwell. The preponderance of the evidence suggests, however, that Southwell was not murdered, but rather died of natural causes. During the German raid, a letter was found that Southwell had left in his hut, addressed to Hernsheim. Southwell wrote that he had fallen seriously ill and requested that "should he not be found on a later visit, the blame should not be assigned to the people of the Solomon or Hermit Islands." (Southwell had had people from the distant Solomon Islands brought in as forced laborers.) That is the summary of the letter, at least, contained in the report to the head of the admiralty.[13]

On December 26, 1882, the gunboat *Hyena* and the corvette *Carola*, with around three hundred men on board under the command of Captain Guido Karcher, arrived at Luf. Among the men aboard was Hernsheim's captain F. Scherrl, by all accounts a nasty drunk, who served as a pilot, a guide to the area, and an envoy to report back to his employer, who had initiated this destructive mission.

Concerning the goals of the raid, Karcher later told the admiralty: "I intended right from the start to remove [the natives'] means of escape and put them in a state of fear and terror by destroying their canoes and homes." Another goal, which Karcher was unable to achieve, was "to make the chieftains surrender" and force them "to hand over and punish those primarily responsible,"

or "at least" to impose a punitive delivery of copra, with which "the Hernsheim company could have been compensated." The surviving islanders' view of this campaign of violence and murder was recorded in paintings that the merchant Franz Hellwig documented on the nearby island of Aua in 1900: "A man shoots from a boat at natives [in one painting], while the following picture depicts two natives carrying away a man who had been shot to death."[14]

In September 1906, the ethnologist Augustin Krämer described the destruction of the people of Luf and their culture in much the same terms as those used later by the historians Jakob Anderhandt and Alexander Krug. Krämer reported that the *Carola* and *Hyena* had bombarded the island with cannon fire, before attacking from the north and south and "joining hands" in the middle. All told, the ferocious attack on the 6.7-square-kilometer island lasted eleven terrible days, from December 26, 1882, to January 5, 1883. The invaders destroyed boats and homes, the largest island village, and five smaller ones, obliterating the means of existence of three to four hundred people. According to Krämer, a total five to six hundred people had lived there in 1880.[15]

## The German Navy Lands on Luf

On December 27, 1882, Karcher ordered the warships to be ready to do battle at sunrise and to land the first German troops on the island. "To give cover to the landing," reported Karcher, "five 15-centimeter and two 8.7-centimeter shells and 13 rounds from the revolver cannons were fired into the village." That was just from the *Carola*. The gunboat *Hyena* was firing from the opposite side. Only afterward did the German troops dare set foot on the island, where their orders were to "destroy villages, crops, and canoes" and "turn their weapons on anyone armed." Karcher was satisfied,

relaying back to Berlin: "All told during these days, 41 houses and eight canoes, the majority at least 50 feet long, were destroyed." The next attack followed two days later, "destroying eleven large canoes and seven houses."

Commandos had landed on both ends of the slender island in order to comb through it with maximum efficiency. On December 30, the commander of the *Hyena*, Lieutenant Captain Wilhelm Geiseler, reported about his part of the operation: "On the northern side of the island, six houses and five canoes were discovered, and they were all destroyed by fire." Three days later he ordered a small cannonade of nineteen shells. To prevent the islanders from escaping, search units were sent to the smaller outlying islands and reefs. After a Lieutenant Schneider had landed on the west side of one of these very small islands, on the east side, "where there was one hut, Geiseler fired two 3.7-centimeter shells to drive whatever inhabitants were there toward Schneider."[16]

One landing unit from the *Carola* was led by a Lieutenant Captain Finck. On December 27, in the first village he encountered, he had "25 houses and six canoes" burned and hacked apart. The unit then moved on to the next village, which was first subjected to a barrage from the *Hyena* to drive away the inhabitants. Finck and his men moved in, "destroying all the houses, about twelve in total" as well as "the taro crops located between the houses." Two days later, a similar operation was carried out deeper in the bush. There, "seven houses, eleven canoes," taro crops, and "hatchets, knives, and other household items were destroyed."[17]

A unit led by an Ensign Wahrendorff spied a large group of "natives," upon whom they immediately opened fire. "Because at any moment we could expect enemy fire from under cover," reported Wahrendorff, "our firing line successfully discharged their weapons and then, since our fire wasn't returned, we immediately

pursued them as planned, so that I could determine the number of enemy dead and wounded."[18] This and other individual accounts weren't recorded in the final report filed by Karcher. They provide incontrovertible evidence that the Hermit islanders did not fire upon the Germans, and that more innocent people were shot dead than had been officially reported.

We know that the German side suffered no losses whatsoever, but we can no longer reconstruct how many islanders died from gunfire or as a result of the Germans marauding through Luf. Alexander Krug estimates the number to be around fifty. The Australian officer Hugh Hastings Romilly, who spoke with Eduard Hernsheim and reported about the expedition some years later, wrote that the Indigenous population had been "reduced to about half what it used to be."[19]

One detail in particular attests to the untrustworthiness of Karcher's official report. He listed the number of inhabitants his troops had found on the island as "at most 100 heads," while also writing that sixty-seven intact houses and fifty-four boats had been destroyed. The inconsistency between these figures clearly undermines his credibility. Krämer, too, at the time believed that the number of islanders Karcher gave was "much too low."[20]

Some of the "canoes" that were destroyed would have been large boats similar to the one on exhibit today in Berlin as a unique artifact of a now dead culture. Karcher already wrote of the islanders in the past tense, as people who no longer existed: "In addition to those of normal length, they possessed a number of large canoes, some 20 meters long, with which they could travel the open sea." He noted the beautiful decorations on the boats his men systematically hacked apart and burned: "The [native] men occupied themselves catching fish, building huts and canoes, creating the decorations on the latter, and making various household implements."[21]

Although we cannot determine the exact number of those killed, we can assume that the victims of the German attack were young and middle-aged men—that is, the people who built the fishing boats. There can be no doubt about one of the intended effects of destroying the islanders' canoes and homes. "The idea," wrote ethnologist Otto Dempwolff, citing an eyewitness, "was that in the coming rainy season so many [of the inhabitants] would die of lack of food and shelter that the survivors would be unable to bury them all."[22]

As Dempwolff gleaned from Karcher's report, not just homes and canoes were destroyed during the punitive expedition, but "also all manner of small belongings"—household things, fishing equipment, and tools. Not everything was destroyed, however; some of it was "secured" for the Ethnological Museum in Berlin.

The channel between the reefs where the gunboat *Hyena* had launched its attack was later named the "Hyena Passage" on German nautical maps, and the spot from which the *Carola* had bombarded the island was subsequently christened Carola Harbor. A letter written by a sailor named Adolph Thamm to his family in October 1888 illustrates how Germans viewed such punitive expeditions. Thamm was a crew member on the gunboat *Boar* (Eber) and had taken part the previous month in an expedition of this kind to the Gilbert Islands, which had not yet been claimed by any of the colonial powers in the South Seas. That mission of destruction was also ordered by the Hernsheim company, which felt its trading interests were being disrupted. In a demonstration of German power, "we burned several villages and canoes along the length of coast before us," Thamm wrote. "The large war boats, which wouldn't burn, were destroyed with axes. . . . The same maneuver was carried out in the following days on the northern part of the island." Before landing, the navy "fired four shells which directly hit the village and destroyed it with their explosive force

and the ensuing fire." Concerning the three days of punishment, gunfire, destruction, and arson, Thamm remarked, "Hopefully all these measures have served to prevent further rebellions against the Germans by the subjects living on those islands."[23]

Back at the power center of the Wilhelmine Empire, Chancellor Bismarck also repeatedly and emphatically demanded a scorched-earth approach. In May 1883, he made it known via his deputy to the Imperial Navy that he wished further punishment, as severe as possible, to be meted out on the Hermit Islands. Most likely, he had no clear idea of how many people had already been killed in the massacre he had ordered five months previously.

The Imperial Admiralty noted the following after receiving Bismarck's oral instructions: Privy Councilor Rottenburg from the Foreign Ministry was just here to communicate on behalf of the Prince and Chancellor that His Highness finds it quite appropriate for actions to be taken against the inhabitants of the Hermit Islands at every opportunity presenting itself. The punishment meted out to the islanders by the expedition of the *Hyena* and *Carola* was, he said, only a mild one since the troublemakers had been able to escape. The islanders were to be constantly harassed until the most extravagant compensation was made for the crimes committed. 'For ten full years' [Bismarck ordered], the islanders in question were to have no peace. Repeated attempts should be made, by suddenly creeping up and attacking, to get our hands on the islanders themselves and make an example of them. This is the only means of subjugating this population and defending ourselves against their atrocities.

The man who transmitted Bismarck's orders, Vice Admiral Otto Livonius, further noted that he would immediately inform

Without knowing that his will had already been carried out, in May 1883, Bismarck again ordered a thorough and permanent destruction of human life on Luf.

the head of the admiralty, Leo von Caprivi, of the Iron Chancellor's "views and wishes." Three weeks later, Caprivi announced that this "mission" would be carried out "as soon as an opportunity presents itself."[24] Eduard Hernsheim also reported that the deeds of the murderous German soldiers from Christmas to New Year's Day 1882–1883 hadn't been enough to sufficiently pacify the island of Luf. He demanded that during future "visits" by German warships, actions "of further consequence" be taken against the unknown malefactors.[25]

As it happened, the attack of 1882–1883 had already permanently broken the will of the few surviving islanders on Luf. In 1906, Krämer would write, "In any case, the major [punitive] expedition, which was carried out carefully and with great relentlessness, had the effect that the Lufites gave up their resistance to the white men and became peaceful."[26]

## Turning Mass Murder into Population Decline

After three months at sea, in March 1883, navy troops from the *Carola* again landed on Luf to inspect the aftermath of the destruction. To their satisfaction, they saw only "25 to 30 men and 10 to 12 women peacefully going about their business," while "several huts were under construction."[27] If this account is to be believed, it would suggest that only around fifty of what had been three to four hundred islanders had survived the punitive expedition.

When Georg Thilenius visited Luf in 1899, he outlined how Europeans had brought ruination upon the cultures of the South Seas islands, starting in the mid-nineteenth century: "Native men were press-ganged into serving on merchant ships, and native women were up for grabs, as were all these people's belongings. The forced removal of the men reduced the number of people able

to work and thus the yield of crops." Thilenius speculated that when organized colonialism commenced in the 1880s, the islanders had "exacted revenge upon the newly arrived merchants for the hardships endured under their predecessors"; they were then "rewarded with punitive expeditions that were carried out according to the familiar pattern but displayed little planning."

Thilenius found on Luf only a "village of eight huts," noting bitterly, "That's it." From the "lines of coconut trees on the beach and the young forest behind it," he could make out the location of the "former villages" that his compatriots had razed in 1882. This led him to the conclusion that the major decline in the population was not the result of "physical or ethnic factors . . . but rather the intervention of foreigners." The lamentable condition of the survivors meant that the few who were "completely or partially capable of labor" had to gather, hunt, and fish for the rest. Amidst the misery that had resulted from the German campaign of destruction, the few survivors had to spend "a large portion of their day foraging for food"—on an island that had "previously sustained hundreds" and theoretically still could.[28]

The ethnologist Paul Hambruch, who traveled extensively throughout the South Seas, offered his views in 1906 about the population decline on the Hermit Islands and on Luf in particular. He began generally, writing that "the native with all his possessions and family was considered the property of the Europeans," and that the colonists carelessly "imported tuberculosis, venereal and other infectious diseases." Hambruch then enumerated the specific reasons why social and cultural life had collapsed on Luf: "One thing cannot be left unmentioned. German punitive expeditions, unfortunately carried out senselessly according to a rigid approach, bear the greatest blame for leading to the extinction of a small populace."[29] Hambruch would later be more explicit. In

1931, he wrote that "close contact with the Western world caused a collapse of the South Seas population of the sort that has never been recorded among any of the world's other peoples in such a short time."[30]

In 1950, Herbert Tischner, one of Hambruch's successors at Hamburg's ethnological museum, MARKK, published an essay entitled "A Tribal Chief's Burial on Luf." In it, he described the barbarism with which the German overlords had driven social and cultural life on the island to the brink of extinction. Tischner listed the "attacks and acts of violence of unscrupulous white people," "the introduction of diseases," "the kidnapping of a significant portion of the best of the male population for labor," and "the infamous punitive expeditions against the islanders."[31] All of this is a matter of public record. But the president of the Prussian Cultural Heritage Foundation, Hermann Parzinger, suppressed all of these inconvenient truths in 2018 when he spoke euphemistically of the "decline in the island's population."

Eduard Hernsheim, who had initiated the campaign of murder and arson on Luf from Berlin, made his authority felt again on the Hermit Islands in 1884 via his agent Carl Tetzlaff and an adventure-seeking Hamburg smithy named Reinmann. But Hernsheim's ire was now directed not at the native islanders, but at the "mostly drunken" merchants. These men, he believed, should be diving for sea cucumbers around Luf and processing valuable oil from "the great wealth of coconuts," which were "largely lying around rotting unused, due to the gradual dying out of the natives." To bolster the labor force, he had fifty workers shipped in from the distant Laughlan Islands.[32]

Hernsheim's logic was simple. After doing everything in his power to encourage the population to "die out," he was now faced with fallow land that had to be cultivated again. His acquaintance

Otto Dempwolff repeated this line of thought without a hint of criticism: "Where the population dies out, as on the Hermit and the Kaniet Islands, the old coconut supplies are unclaimed."[33] The land had to be taken into possession and subjected to an "orderly plantation culture." Profits would then flow automatically. The necessary labor could be procured from somewhere else.

# 5

# "Bastian's Network" of Thieves

Although official reports contain not a single word on the subject, the approximately three hundred troops who carried out the punitive expedition on Luf also stole a number of artistically and culturally valuable objects. We know this from records kept at the Berlin Ethnological Museum. In an 1886 document drawn up when the collections in the museum's new wing were catalogued, the museum director, Adolf Bastian, noted the provenance of the contents of a display case on the second floor: "From the German protectorate in the Bismarck Archipelago with the collections from the MS *Gazelle* / Hermit Islands / Australia (New Holland)."[1] In 1897, Felix von Luschan unveiled a carved bowl with the museum catalogue number "M.V.VI 5003 MS *Hyena*. Hermit Islands."[2]

The looting that took place on Luf was documented in the quarterly reports from the Prussian royal art collections. In one of them, Bastian showered the thieves with praise: "As far as Oceania is concerned, the commendable service of the Imperial Navy should be celebrated." In April 1884, he expressed his profuse gratitude to "Captain Karcher, Commander of the MS *Carola*," for "amiably taking scholarly interest into account during the expedition" to the Hermit Islands. In 1886, when the recently built Ethnological Museum opened, the concise guide through

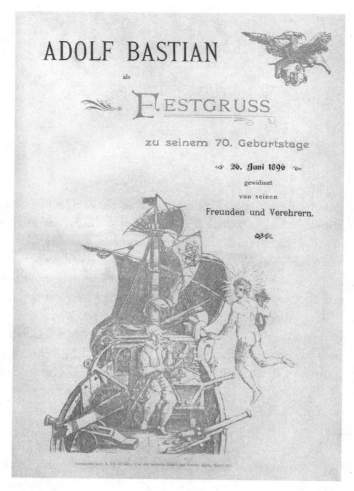

The frontispiece of the pamphlet honoring the seventieth birthday of Adolf Bastian. The detail from the 1594 engraving by Theodor de Bry shows the Portuguese explorer Ferdinand Magellan (Fernão de Magalhães) near New Guinea. Threatened by "savages," sea monsters, stormy seas, and fire-spewing volcanoes, he sails on—well-armed—to make his discoveries. Magellan died in 1521 in the Philippines in battle against the people who lived there.

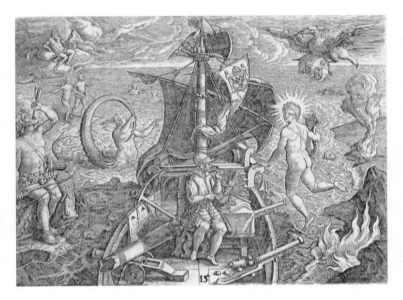

Heedless of danger, Magellan sails the South Seas.

the exhibit identified the contents of the central display case as originating from "New Holland, Hermit Islands (MS *Carola*), New Guinea."[3]

Bastian described the Hermit Islands as the ethnologically "most interesting islands in various respects" and lauded the "extensive" number of major objects "secured there for the Ethnological Department." He was particularly enthusiastic about the items brought back by the *Carola* because he favored ostensibly authentic articles made "before [the native people] were influenced and shaped by the West."[4]

Despite these unambiguous statements, the Prussian Cultural Heritage Foundation under Hermann Parzinger invented the myth that "Bastian distanced himself from the political ambitions of colonialism." And in the overarching conceptual plan for the

Humboldt Forum, written in 2008, the troops who had been charged with robbing and exterminating the islanders were described with disingenuous naivety as "Bastian's network."[5]

Bastian was indeed quite fond of talking up the "natural and beneficial alliance" between ethnology and colonial expansion. In 1885 he characterized the former as contributing to the "progress of colonial endeavors" insofar as it required securing "ethnological originals" from previously undiscovered regions.[6] The actions of the German troops on the island of Luf in the days after Christmas 1882 reveal what such "securing" often entailed.

On December 18, 1886, the new Berlin Ethnological Museum opened its doors at Königgrätzer Strasse 120 (today a parking lot at the intersection of Stresemannstrasse and Niederkirchner-Strasse in the heart of central Berlin). In his inaugural address, Prussian Minister of Culture Gustav von Gossler gushed about how the Imperial Navy had advanced the museum's cause "with its powerful and fruitful support."[7] Luschan went even further. In his final major published work in 1922, he glorified his museum as a mecca of colonialism, calling it "the most beautiful and grandest memorial to our protective forces, a true *monumentum aere perennius* [an iron and immortal monument]."[8]

In the same report in which Bastian celebrated the ethnographic treasures hauled away by the *Carola*, he expressed his gratitude for additions to his collection from another source: "It is my pleasant duty to articulate the thanks owed again to the name of Hernsheim, this time Mr. E. Hernsheim in Matupi, whose congenial efforts fulfilled our wish for two keenly lacking items before it was, once and for all, too late."[9]

Bastian, too, almost reflexively whitewashed the policy of exterminating islanders, referring instead to a "natural" extinction of "primitive" peoples and their cultures. Following a "punishment of the natives of Nusa" in February 1884, which included killings and

arson, the report filed by Captain Geiseler of the *Hyena* to the admiralty in Berlin included a "list of several curiosities we took the opportunity to bring on board and will forward from Matupi to the Ethnographic Department of the Royal Museum in Berlin." This act of murder and larceny also took place at the behest and in the presence of Eduard Hernsheim. The final tally of the damage inflicted was reported in sober numbers: "Around 30 houses burned, 10 large canoes on the beach, 10 various canoes on the beach, 6 canoes and several hundred spears captured. Numerous crops, betel nut and palm trees destroyed."[10]

## Plantations Instead of Ancient Culture

Richard Parkinson, an eyewitness intensely involved in colonialism in the South Seas, reported that the decline in population on Luf and the neighboring islands was the result not only of the punitive expeditions and the diseases imported by Europeans, but also of the "numerous laborers taken from here to harvest sea cucumbers in the Carolines, few of whom ever returned." Jakob Anderhandt noted that as early as 1890, the few island men still living on the Hermit Islands after the punitive expedition "were in badly damaged health" after being kidnapped and forced to work in the coconut and cotton plantations on Samoa that were run by the German Trade and Plantation Society.[11]

The ruthless commercial exploitation of the Hermit Atoll was later completed by the Hamburg merchant Heinrich Rudolph Wahlen, co-owner of a company called Hamburg South Seas Incorporated. Wahlen ran the Hernsheim trading post in the atoll starting in 1895, before striking out on his own in 1902 and earning a fortune. A 1906 report by Augustin Krämer paints a sad picture. The atoll's four largest islands, once "thickly forested," had been almost completely stripped of trees "to establish coconut

plantations." "Only Luf retained its original forest," wrote Krämer, "where on a narrow, sandy strip of land the sole village remains, with around ten huts, a large boathouse, and some fifty inhabitants. There is a tiny offshoot on the north side of [the island of] Maron. The natives, previously a wild tribe of primitives, are utterly peaceful and work as laborers. The time of punitive expeditions has passed, and no more are expected for the Hermits."[12] Of the former inhabitants of the atoll, "whose number may have approached a thousand," less than one hundred remained.[13]

One of Wahlen's management practices was to drive away with rifle fire any unknown Indigenous people who approached his trading post. When a critical visitor called this procedure "Australian brutality," Wahlen answered that "only by making the post off-limits was he able to avoid bloodshed."[14] Another traveler described Wahlen as a beer-addled drunkard who had enslaved "the freest people the Creator had ever left in the world."[15] In 1907, a German doctor and leader of a naval expedition, Emil Stephan, reported that the islands of Wahlen's empire were "entirely devoid of anything worth collecting." Nonetheless, Wahlen had no scruples about sending his ship captains out to other islands that promised greater ethnographic treasures. Stephan explained in a letter to Luschan how to get whatever one wanted from Wahlen: "Because he's a dandy and quite vain to boot, a medal from Berlin . . . would easily win him over." Wahlen had a track record of accepting status symbol bribes, including getting himself named a Swedish consul.[16]

According to a 1952 article in *Pacific Islands Monthly*, Wahlen encountered sixty-four natives in a dire state of health in the Hermit Atoll in 1895. He is quoted as saying, "I asked for advice from the medical authorities and the opinion was that it would not be possible to raise the population again, . . . so, I left them alone."[17] In other words, Wahlen abandoned those who remained

on Luf to their fate and decided against establishing a coconut plantation on the island. For his plantations on the atoll's other islands, he used imported labor.

In late September 1906, Krämer, who was on cordial terms with Luschan, explored the Hermit Islands for fourteen days, spending most of his time on Luf. Among other things, he wanted the islanders to interpret for him the colorful patterns on the boat that had been taken to Berlin. That was easily arranged, and he was able to reassure Luschan: "You can sleep peacefully at night as far as the Hermit boat is concerned. It's been defined down to the last detail of the ornamentation. I spent eight days with the still rather hardy Lufites in their only village of around fifty people. They won't be going extinct tomorrow. For the time being, younger people are there." Krämer also reported that Luf "had been, sadly, looted bare" of ethnographic treasures and that he had only gotten his hands on "a single wooden bowl."[18]

Two years later, in 1908, Captain Max von Grapow of the Imperial Navy, a veteran of numerous punitive expeditions, sailed through the Bismarck Archipelago. Along the way, he took everything there was to collect on behalf of the Linden Museum in Stuttgart. He wrote: "With the exception of the main island of Luf, the islands are all planted with the merchant R. Wahlen's coconut trees. The remnants of the once large population live on Luf. They consist of 35 people and are dying out due to degeneration caused by disease and incest." Grapow was full of admiration for the "residence complete with all the European comforts" that Wahlen had had built. Within a few years, thanks to his "sharp eye and hard work," wrote Grapow, Wahlen had succeeded in "establishing a lucrative coconut plantation on the almost uninhabited [Hermit] islands."[19]

This vision of productive Western industry reflected the recommendation of the high-ranking administrator Karl Warnecke, who

This photograph of "Wahlenburg" was taken by Jim Shortall when he visited Maron on the old "Coombah" in 1937. It was then in a pretty fair state of preservation, although getting along towards middle age, for a house in New Guinea. It appeared to have changed little from the time that a photograph of it had appeared in the Third Catalogue of Expropriated New Guinea Properties, in 1927. In the catalogue, in prosaic official language it was referred to as a "Two storeyed bungalow", and in these terms:
"85 ft. x 47 ft., on concrete foundations, with galvanised iron roof.
"First storey concrete throughout, containing 3 bedrooms, store-room, spare room, pantry, ironing room.
"Upper storey of wood, with 12 ft. verandah each side, 15 ft. porch in front, casement doors and windows throughout. Contains large dining room, 1 bedroom, office.
"Cement bathroom, connected with 200-gallon tank in tower, and water connections to bedrooms. Kitchen, 23 ft. x 22 ft., sawn timber and galvanised iron, attached."
(Now turn to page 95)

The extravagant mansion built by Heinrich Rudolph Wahlen, known as Wahlen Castle, on Maron Island in the Hermit Atoll.

had visited the northwestern islands together with Wahlen and Max Thiel in 1902. No doubt with the full support of those two men, Warnecke wrote about the Ninigo Islands, "The exploitation of this group can be significantly increased if we begin cultivating all 54 islands, which are mostly covered with brush."[20]

Wilhelm Müller, who took part in the scholarly Hamburg South Seas Expedition from 1908 to 1910 and visited Luf in June 1909, was devastated by the condition of the last remaining islanders: "After their objects of interest were carted off, no one was interested any more in researching them." Müller wrote of a

Newly constructed dwellings for the few inhabitants of
Luf who survived the murderous punitive expedition of
1882–1883.

"moral duty" on the part of the scholars to save the island's popu-
lace and culture but saw no practical means of doing so. Instead,
as his diary makes clear, he joined in the looting of cultural arti-
facts. Georg Thilenius charged him and the other participants in
the expedition with "emptying out" certain islands in the course
of their research.[21] Müller reported that all that remained of the
intellectual life of the natives of Luf was "a single legend about the

creation of coconuts by the giant Hamaloái." He was not able to discover any other signs of culture.[22]

In his memoirs, Eduard Hernsheim struck a self-critical tone, intended, as Jakob Anderhandt speculates, as a kind of "vague apology to the people of the Hermits." "On all of these calm and mysterious islands," wrote Hernsheim, "things happened in the past that have never seen the light of day. Quite probably they would show that the savages were better than their reputation and that they were actually ruined by the lawless, crude white men."[23]

# 6

## Deceit, Larceny, and Looting

During their imperialistic expeditions, European conquerors grifted, sought out, or simply stole hundreds of thousands of items: skeletons and skulls, butterflies, dead and live rhinoceroses, birds of paradise, carvings, sacred and everyday articles. In Berlin, the directors of the Royal Botanical Garden and the Royal Zoological Garden greedily awaited delivery after delivery, while their colleagues at the museums of natural science, arts and crafts, and ethnology demanded constant supplies of new objects, the more exotic the better. And the same was true for the German Colonial Museum, which had been established in 1899.[1] Colonial pioneers, as the looters called themselves, did a brisk business and were keen to keep the deliveries flowing, although they held on to especially unusual objects in order to brag about them, give them away as gifts, or sell them off as rarities for handsome profits.

### Trading with Tobacco

Most of the men and officers of the Imperial Navy were constantly on the lookout for material to loot whenever they made landfall. My great-granduncle Pastor Aly, for example, collected souvenirs that he paid for "with a generous tribute of tobacco and glass beads." As a report by the *Elisabeth*'s physician Harry Koenig

details, a variety of cheap items were loaded on board at the beginning of the voyage, to be used for barter: glass beads, small mirrors, whistles, and, above all, plug tobacco that was specially procured for the "natives" and was referred to using the derogatory American English term "niggerhead."

"They offered us jewelry and weapons," wrote the enthusiastic Koenig. "[In return they took] glass beads, preferably in pillboxes, plane irons, knives, an occasional vest or threadbare pair of trousers, or best of all a mirror." The captain of the *Elisabeth*, Rudolf Schering, boasted of having "acquired" around twenty of the "most splendid, artfully carved wooden masks" from a dealer in Kapsu on the island of New Mecklenburg (New Ireland). He gave several of these examples of Indigenous art to his officers. The dealer was Friedrich Schulle, an agent of the Hernsheim company. What did Schulle use to pay for these treasures, this man whom Eduard Hernsheim once described as "a binge drinker who brutally abused his underlings and the natives"?[2]

We have no way of reconstructing how Schulle came to possess such valuable items. But Koenig, who took part in flag-raising ceremonies in Kapsu and on the neighboring island of Nusa, described how he succeeded in getting what he coveted, even though the men of Nusa were very reluctant to part with their jewelry. "When I showed a native an old tie lined with red silk, I received several rings, and the tie's new owner proudly wrapped it around his neck," wrote Koenig. "I acquired many other interesting artifacts in similar fashion." Shortly beforehand, having landed on Matupi, Koenig gleefully noted that the "natives" had "handed over their arm rings, spears, etc." to him and the other officers of the *Elisabeth* "in return for our notorious niggerhead tobacco." Otto Finsch described similar scenes of barter: "the main articles are American plug tobacco (niggerhead), axes, knives, fishhooks, glass beads, and other trivialities."[3]

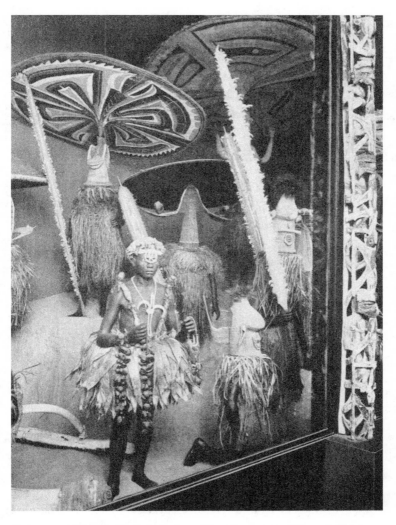

A diorama with the title "Masks from New Pomerania, Bismarck Ar-
chipelago." This is how the Berlin Ethnological Museum exhibited its
cultural treasures in the 1930s.

In 1906, a certain "Privy Councilor" Zimmermann (he was actually a legation councilor) gave the Berlin Ethnology Museum a couple of strange items that were an integral part of this colonial practice. "Two plugs of tobacco that serve as currency in the Bismarck Archipelago": that is how the donation was recorded in the museum's official register.[4]

The term "niggerhead" was used in American slang at the time to denote a variety of dark-colored, rounded objects including certain kinds of rocks, plants, and shells. When applied to tobacco it designated cheap chewing tobacco that was either twisted or pressed into plugs. The term can be traced back to 1833 and occurs in Mark Twain's *Huckleberry Finn*. It was produced by several tobacco manufacturers until 1943, when the American Tobacco Company withdrew the brand name.[5]

This cheap tobacco was commonly bartered in the South Seas colonial realm. In the *Deutsche Kolonialzeitung* (German colonial newspaper) in 1887, Finsch writes, "Plug tobacco (twist tobacco, niggerhead) is probably the most popular object of barter in the entire South Seas and the actual form of currency in dealing with natives. It's very practical because every plug can be cut into pieces to produce coins as small as are needed." A plug of this tobacco cost four or five cents in Sydney and could be exchanged for twelve to thirty-two cents' worth of the most common export product, copra. German South Seas merchants thus had a profit margin of 150 to 800 percent.

Richard Parkinson mentioned the "enviable life" of such merchants around 1885 and the rules of barter: "The natives handed over 25 to 30 coconuts for a stick of tobacco." Parkinson, too, had no objections to people getting hooked on tobacco, an addictive substance that they were unfamiliar with: "Because tobacco is a very important article for traders . . . the natives had to be gotten used to it."[6] Ernst Tappenbeck, who led an expedition along the

A plug of tobacco (17.2 × 1.9 cm) from the collection in the
Berlin Ethnological Museum, donated by Alfred Zimmerman
in 1906: "2 tobacco plugs, with a monetary value of five pfennigs."

Ottilie River (Ramu River) in German New Guinea in 1898, em-
phasized the health damage caused by tobacco, citing the "pitch
black color and poor incendiary quality . . . and the continual spit-
ting among smokers of it."[7]

The historian Jakob Anderhandt has shown how successfully
Hernsheim exploited "the targeted introduction of firearms and
addictive substances (alcohol and tobacco)," writing, "In obstinate
cases, Hernsheim's merchants established 'smoking schools' and
handed out weapons to tribes at war with one another."[8] Before
long, noted Parkinson, German merchants, ethnologists, and
sailors reported that tobacco had become a "necessity" that couldn't
be procured "without the white man."[9]

The seaman Adolph Thamm described trading on the island
of Matupi in the spring of 1888: "The women . . . fled when we tried

to touch them. Only after we showed them knives, mirrors, and above all tobacco did they become more trusting." On the next island, Thamm "horse traded" his churchwarden pipe, which had cost him two cents, for "two or three chickens."[10]

## Hernsheim, Thiel, and Islands "Stripped Bare"

From Matupi, Hernsheim & Co. ran several remote trading posts. Merchants had built houses on the long coast of the island, and in their small storerooms, they kept "the greatest and most diverse collection of goods, food, and coal." Securely in possession of exclusive contracts, the company supplied German and British warships and merchant vessels with water and fuel, foodstuffs of all sorts, and beer and other drinks.[11] Hernsheim exported copra and other goods to Europe, including tens of thousands of everyday artifacts, cult objects, skulls for anthropological collections, wonderfully carved and painted works of art and—last but not least—the Luf Boat.

The company was founded by Franz Hernsheim. It later passed to his brother Eduard, who handed it on to his nephew Max Thiel in 1892. Shortly thereafter, Thiel built an ostentatious villa on Matupi in which he hosted legendary parties with colonial officials, officers, adventurers, merchants, plantation owners, and planters. This house, which was open to all Europeans anchoring at Matupi, "was among the most frequently visited places in the Western South Seas."[12] Together with his guests, the lord of the manor enjoyed belting out the lyrics he had written to be sung to the melody of Victor Scheffel's 1848 "When the Romans Got Impudent," which was very popular in ultra-patriotic university fraternities: "When nothing more was going on in Germany / zim zerim zim zim zim zim / Because the competition was too tricky / zim zerim zim zim zim zim / We angrily lurched / tee te

ree te te te te / Into colonialism / vow vow vow vow vow / Into co-
lonialism. / Shetterengteng, shetterengteng."[13]

With the price of copra on the rise, Hernsheim & Co. and its
partner, the Jaluit Association, earned considerable profits. Those
merchants who paid the Indigenous people for their coconuts did
so using the currency of addictive intoxicants. In late 1878, Franz
Hernsheim wrote in his diary, "If only we can procure some to-
bacco and gin. Otherwise, it will be hard to complete the load for
the next ship in March or April."[14]

European visitors to Thiel's mansion on Matupi were able to
admire only a tiny fraction of the looted cultural treasures. In 1903,
the travel writer Johannes Wilda gushed over the gardens, palm
trees, foliage, lovely lawns and brightly painted, inviting main
house, guest house, servants' house, and bathhouse. He especially
noted the billiard house, where games continued throughout the
evening amidst an "extraordinary, wonderful collection of South
Seas artifacts" on the walls of the spacious room: "marvelous spears
from Buka Island, arrows with fishhooks, bows, clubs, dancing
masks, wooden drums, polished tortoise shells and woven shells,
wooden daggers featuring attached shark teeth with which jealous
women cut each other to ribbons, and a host of other interesting
things—all of them exquisite items."[15]

The derogatory tone, quite unlike Wilda's, with which other
German colonists spoke about "the natives" is abundantly evident
in the works of the author and South Seas specialist Stefan von
Kotze, a grandnephew of Otto von Bismarck. A swashbuckling
report entitled "Our Brown-Black Compatriots in New Guinea,"
authored by a physician named Paul Schnee, also provides a good
example of the imperialist German tone.[16]

In a 1904 letter to the Berlin Museum of Ethnology, Richard
Parkinson described how items were "bought" by Hernsheim
agents. The boundaries between exploitation, deceit, and larceny

were fluid: "Hernsheim & Co. has collected everything from the islands of Wuvulu and Aua, stripping them completely bare. This is ethnological pillaging of the sort I've never seen before." Parkinson himself, however, had called upon Luschan four years previously to name a "permanent agent" for the South Seas, who would have been responsible for acquiring as many "major, valuable collections" as possible before there was nothing left. Parkinson wrote: "It is astonishing how quickly everything is disappearing. Even the most routine things are gradually becoming rarities."[17]

This particular spree of pillaging had been carried out in 1902–1903 by the merchant Franz Emil Hellwig, a collector of "ethnographic items"—or, perhaps more accurately, a trained serial looter—on behalf of Max Thiel. Hellwig was paid for his services with a portion of the loot. He traveled aboard a Hernsheim commercial vessel, the *Gazelle*, loading it with whatever he could seize one way or another. Hellwig also stopped on the island of Luf.

In mid-1904, Hellwig returned to Germany with his commission of ethnographic items. In a letter to the former deputy governor of German New Guinea, Thiel related what Hellwig did upon arriving home. Hellwig had "wandered here and there" in the archipelago for "1 ½ years of study," wrote Thiel, but was now back in Germany, where he was "at the moment playing circus master for his gigantic collection, which took up 30 cubic meters of cargo space." In other words, Hellwig was palming off what he had "collected" as his commission during his looting mission for Thiel and Hernsheim, acting like an impresario in a circus.[18]

## A Flood of Ethnological Treasures

The items that Hellwig pillaged are still being bought and sold today—for example, in a public auction of a "museum-quality New Guinea figurine" that took place in 2014. The renowned

Vienna auction house Dorotheum—from 1938 to 1944 a leading seller of the property of Jews, who had been stripped of their rights, forced to flee National Socialism, or murdered—staged the auction, which featured the following catalogue description: "The top object of the Dorotheum Auction 'Tribal Art' on March 24, 2014, is a very rare and old figurine from a 'holy flute' of the Biwat [Mundugumor] people of the islands northeast of New Guinea. It was collected in 1904 by the German adventurer and merchant Franz Emil Hellwig. . . . Until recently, this 'museum exhibit' was privately owned by the Hellwig family. . . . Dorotheum expert Professor Erwin Melchardt has estimated the value at 160,000 to 200,000 euros."[19]

The Museum of Ethnology in Berlin also still possesses items privately "collected" by Hellwig, for example, a model of a seaworthy outrigger boat made by people in the South Seas. The information on the model's provenance reads simply, "Collector: Franz Emil Hellwig."[20] The Prussian Cultural Heritage Foundation maintains silence about Hellwig's legendary looting spree, even though it was described in a letter to Luschan, who was the foundation's South Seas expert. A rather derogatory statement by Luschan about his colleague Thilenius illustrates how fine the lines were between various forms of acquisition in this era: "I cannot completely share his views about his 'private collection,' 'purchased items,' and 'gifts from tribal chieftains and leaders.'"[21] Apparently museum directors had no faith at the time, either, in any of the information offered on how ethnological items were acquired.

Another model boat from Luf also ended up in the Berlin collection. Its provenance is listed as "Collector: Max Thiel." This object, too, was likely among those looted by Hellwig, most of which came into possession of the Hernsheim company.[22] Not surprisingly, the name Thiel also crops up quite frequently as a donor in the museum's inventories. Although Luschan himself

repeatedly and gladly accepted looted artifacts, in 1896 he expressed his disapproval of the "truly oppressive, sheer mass" of items collected by one of Thiel's colleagues, Captain A. F. V. Andersen, from Wuvulu Island. Andersen traveled aboard the Hernsheim schooner *Welcome* and was celebrated in the *Biographical Handbook of German New Guinea* as a "collector of spectacular ethnographic objects."[23] All told he assembled approximately two thousand items.

In fact, Luschan was upset not at Andersen's looting, but at his laziness concerning notes and documentation. He condemned Andersen's "massive plundering [of Wuvulu], unique in the history of ethnology," which "remained without scientific benefit."[24] If scientific progress was being served, however, Luschan was not bothered by offers such as the following from Thilenius in the Bismarck Archipelago: "With the same letter I am sending a list of the collections I have made from the warship, among which you will hopefully find some useful items."[25]

# 7

## Curators, Crusaders, and Cannons

In a publication from 1899, Felix von Luschan twice identified a collector he called "Seagull." The *Seagull* was a German gunship.[1] Fourteen years earlier, in 1885, Adolph Bastian had singled out Jakob Weisser, the purser on the *Hyena*, for special praise for having demonstrated "his interest in ethnology" during several voyages, in particular by collecting for the museums in Berlin and Dresden. A detailed list has survived from one especially impressive haul; it bears the title "Collection from the Easter Islands at the behest of Captain Geiseler, commander of the MS *Hyena*, compiled by Purser Weisser." When he acknowledged receipt of this ethnographic booty, Bastian expressed his regret that the *Hyena* had been too small to carry away one of the famous Easter Island head sculptures. He added that he hoped (in vain as we know today) that a "larger warship would visit [the island]" to rectify "what had been missed out on."[2]

The colonial aggressors didn't always "pay" for what they carted off with tobacco, beads, knives, and mirrors. Often, they just looted valuable cultural items while carrying out their punitive raids. In his 1904 book *Bilder aus der Südsee: Unter den kannibalischen Stämmen des Bismarck-Archipels* (Pictures from the South Seas: Among the Cannibal Tribes of the Bismarck Archipelago), the deputy governor of German New Guinea, a lawyer named

Heinrich Schnee (brother of the physician Paul Schnee), let that particular cat out of the bag. According to Schnee, "the natives of Pak Island," one of the Admiralty Islands, had "treacherously" murdered two merchants named Möller and Andersen in August 1893. In retribution, six years later, the crew of the gunboat *Seagull* embarked on a punitive expedition. On board were Governor Rudolf von Bennigsen, Schnee, and Max Thiel, as a representative of Hernsheim & Co.

The inhabitants fled to the interior of the island, whose difficult terrain was intimidating, and the Germans began to commit their usual crimes. "In order to teach the *Kanaken* a painful lesson," Schnee wrote in his memoirs five years later, "their canoes were destroyed" on both sides of the island. Before that took place, however, Schnee and Thiel had arranged for "particularly valuable objects from the natives' riches to be secured for transport to the Ethnological Museum in Berlin."[3]

Bennigsen, however, wrote in his official report to the Imperial Colonial Office that the Germans had committed everything, even the most impressive works of art, to the "sheaves of fire" ascending skyward: "The destruction of the beautifully built huts with their wealth of household effects, weapons and food, which give evidence of the natives' artistic sensibilities and diligence, was a very heavy blow and a long-term reminder not to approach European government representatives with hostility and betrayal."[4] Bennigsen was most likely trying to conceal his private acquisition of valuable cultural items. Stuttgart's Linden Museum still possesses more than 290 of the 348 items from the Bismarck Archipelago that Bennigsen "donated" in 1901. They include pieces collected from "New Guinea, New Mecklenburg, New Pomerania, the St. Matthias and Admiralty Islands, etc." For his services, Bennigsen was awarded a medal by the Württemberg royal family in 1902.[5]

Albert Hahl, governor of German New Guinea from 1902 to 1904, during an inspection tour of Pohnpei Island (Carolines). On the right, partially concealed, are three armed police soldiers.

Bennigsen's successor as governor, Albert Hahl, was also happy to keep the deliveries to Stuttgart flowing.[6] In 1912, he was awarded the Württemberg Friedrich Medal with Commander's Cross Second Class in recognition of having donated 460 items to the Linden Museum between 1899 and 1910. These were no ordinary objects: "The number of items may appear small, but most of the items sent in by Hahl were quite large and beautiful. Among them were first-rate carvings, dance implements, and masks. Hahl always placed great value on only sending lovely, large, unique things and not small everyday items." In addition, he had also

mediated in the museum's acquisition of a "great number" of other collections.[7]

Hernsheim & Co. ran a number of trading posts in the Admiralty Islands. As the 1920 edition of a German colonial lexicon explained, the behavior of the populace there "required various punitive expeditions by police troops, in part with the help of German Navy warships."[8] Schnee was present when the Hernsheim vessel *Mascot*, together with the small cruiser *Sea Eagle*, a nonarmored warship built especially for colonial punitive actions, launched a further destructive raid. (Other small, swift, nonarmored cruisers used exclusively against the barely armed Indigenous peoples of the German colonies were the *Buzzard* (*Bussard*), the *Falcon* (*Falke*), the *Condor*, the *Cormorant*, and the *Vulture* (*Geier*), all of which were built between 1890 and 1894.)

On this occasion, Schnee "rescued" several "artistically decorated supporting pillars" from an "especially lovely village on stilts."[9] The administration of today's Berlin Ethnological Museum is still particularly proud of its South Seas collection, including "architectural elements in their original dimensions," but its website provides no information about how these objects were acquired.[10]

The South Seas traveler Johannes Wilda, whom Schnee had invited along, reported on a further expedition by the crew of the *Seagull*, this time aimed at "disciplining ... the relatively wealthy" population of Buka, the northernmost of the Solomon Islands. As usual, the Germans secured "the ethnographically valuable things" before setting fire to all the huts they could find. In this case, the seizure of items on behalf of German museums was directly documented and was described as a punitive "repossession of property." Schnee personally saw to it that the islanders' canoes were hacked apart or burnt, whereas the "well-made fishing nets of breadfruit fibers" were carefully packed for transport to Berlin.[11]

Paul Boether, an imperial judge, did much the same when he led a campaign of murder and destruction against "natives" on March 9, 1901, in the vicinity of the Christian mission of Tumleo near Berlin Harbor (today's Aitape, on the north coast of the island of New Guinea). At the "special request" of the missionaries, the "old barracks, the embodiment of the natives' ancient cult of their gods and ancestors, was burned to the ground." Before setting the fire, though, Boether had his men collect valuable "decorations from these extremely original houses" on behalf of German museums.[12]

The ethnological collections in Berlin list Schnee as the source of a wide array of donations.[13] Moreover, the sparse online inventory of the holdings of the Foundation of Prussian Cultural Heritage includes under Thiel's name three valuable items that came from expeditions: a large carved wooden drum (89 × 262 × 75 cm; ID no. VI 21156), a carved, painted disk from a communal men's house (ID no. VI 30248), and an exquisitely made weathervane (ID no. VI 30252). Because the *Seagull* participated in many punitive expeditions, the name of the gunboat crops up quite a bit in the foundation's online list of holdings, specifically in the attribution "Max Braun, Collector, MS *Seagull*"—Braun having been the vessel's junior purser.[14] On July 31, 1899, the captain of the *Seagull* reported to the admiralty in Berlin that, in addition to the regular crew, "the agriculturalist Parkinson" was on board "at the behest of the Ethnological Museum."[15]

The Linden Museum lists the traveling researcher Bruno Mencke four times as the collector of objects that ostensibly originated from the Admiralty Islands. Mencke himself never visited the islands, but his fellow traveler Ludwig Caro did. Caro had served as Governor Bennigsen's secretary and was killed along with Mencke in 1901 on Mussau Island, in the St. Matthias Group. The affluent Mencke is also known to have purchased ethnographic

items from both Thiel and Parkinson.[16] Several months after Mencke and Caro's violent deaths, the *Cormorant* arrived to wreak vengeance. On board was Bennigsen, who was headed home. According to the official report, eighty-one "*Kanaker*" were killed in the attack. The unarmored *Cormorant*, which sported four guns, had been built especially for such punitive colonial missions. From 1900 to 1902, it was under the command of Max von Grapow.

Captain Grapow wrote of the forty objects in his "St. Matthias collection," which he donated to the Linden Museum in 1908, "The items were acquired in July 1903 in conjunction with the MS *Cormorant*'s punitive expedition, ordered by the Emperor in response to the murders of B. Mencke from Hanover and the ex-governor's secretary Caro." During his brief mission in the South Seas, Grapow commanded at least two other punitive expeditions, one in the Vitu Islands and one in Paparatava near Kokopo (New Britain).[17] The Berlin Ethnological Museum also possesses holdings that came from the *Cormorant*, although no further information about their provenance is given.

In 1902, after a "criminal tribunal" on Mussau, the *Braunschweiger Landes-Zeitung* newspaper offered this criticism: "It turned out that the murdered man, Bruno Mencke, and his companions were themselves quite culpable in the sad event, not only because of their incomprehensible carelessness but also because they ruthlessly destroyed the few remaining coconut trees."[18] The two Germans and their native companions, it appears, had attacked the islanders' very source of sustenance.

So much for the origins of many art works and collections, which are seemingly unproblematic but on closer inspection deeply dubious—at least as far as one can tell from the listings that individual museums make publicly available online. Such listings represent only a fraction of these institutions' total collec-

tions. The original records and inventories contain far broader and more detailed accounts of the valuable ethnographic items seized with the help of warships during punitive expeditions. For this reason, most museum directors still refuse to make the original handwritten records, the documentary basis of their holdings, broadly accessible in digital form.

## "Suddenly Everything Was Gone"

When they didn't simply steal things, European researchers engaged in what they called "anonymous purchases." The expedition diary of the ethnologist Wilhelm Müller, a student of Luschan and an employee of the Berlin Ethnological Museum, makes clear what this entailed. In 1908, when Müller's heavily armed group of scholars, accompanied by police troops, entered a village of twenty-six huts, they found that the inhabitants, whom they could hear "calling out not far away," had "fled." In the largest hut, Müller found three exquisitely carved dancing boards, which he took away, "leaving behind 20 plugs of tobacco" in return.[19] (During ritual dances, island men would wave through the air and overhead these thin, meter-long boards, adorned with open-work carvings and opulently painted.)

Hans Vogel, a painter and illustrator who was part of the research team, wrote in his diary, "We jokingly refer to this procedure as 'anonymous purchase.' It was used at the behest of the ethnological museums in Berlin and Hamburg." Describing the outrage villagers displayed at having their valuables taken away, Vogel added, "No sooner had we set off back to the boat, than the village behind us came alive. There was loud yelling, and a rock and spear thrown at us announced that the villagers had returned."[20]

Franz Hellwig described similar scenes after the inhabitants of a remote village mistook him and his companions for

a "recruitment expedition" and fled in fear of being abducted as forced laborers. Hellwig and his Hamburg researchers were actually after loot, which was there for the taking in the absence of the items' rightful owners. In the end, the team noted with satisfaction, "We paid the tab without the innkeeper after 'acquiring' 13 items." The quotation marks placed around the word "acquire" suggest that the things the interlopers left behind in exchange were considered worthless.[21]

On occasion, Thiel and Schnee also "purchased" items from islanders in person as part of typically one-sided deals. With palpable delight, Schnee described Thiel throwing "small, tinted glass beads on the ground as gifts" as a way of "dispelling the mistrust of the *Kanaker*." Schnee added, "It was heavenly to see the naked joy with which they received the colorful little beads." In return, the islanders gave the Germans, protected by their armed guards, some "lovely carved spears."[22]

Such were the "prices" of items of ethnographic interest around 1900. In 1908, concerning the acquisition of a coveted "lovely, large ceremonial canoe" on Little Mussau Island, Hellwig noted that the deal had initially fallen through "despite a substantial purchase price being offered." The offer rejected by the chieftain Kinalú consisted of "3 axes, a large knife, 5 loincloths, 6 mirrors, 30 plugs of tobacco, pipes, ½ pound of very valuable red oxide lead, produced only in small quantities." But the purchase later went ahead after the offer was increased by "around 50 marks' worth of items." (For comparison, a kilo of coffee at the turn of the century in Germany cost 4.15 marks.) The Germans toasted their success that evening with a glass of champagne.[23]

Otto Finsch's descriptions of bargaining with islanders were far less swashbuckling. Rather stuffily, he told of operating "in the service of scholarship" and harvesting those "fruits" that, "if all goes well, will later grace our museums." Such treasures, he added, were

"achieved and acquired by hard bargain thanks to the sweat on the brow" of people like himself. When the deal had been concluded and "the natives had been happily seen off," the "most important work still remained: registering the items and their place of acquisition and, last but not least, recording what had been seen and experienced in a journal."[24]

Islanders eventually began asking for higher prices for their valuables, but even by the standards of the day the trade was anything but fair, and collectors were always boasting of the bargains they had gotten. Augustin Krämer told of a deal struck with the men of the village of Wanimo on the island of New Guinea in September 1906: "In return for knives, tobacco, and red cloth (lava-lava), they exchanged everything they had on them. The only things they didn't want to give us were the carved ornaments on their boats."[25] Elisabeth Krämer-Bannow, Augustin's wife, experienced much the same in 1908 on New Mecklenburg: "To make our purchases, we used tobacco, beads, small bars of soap, perfume bottles, and similar items, but tobacco is always the best currency." Krämer-Bannow wasn't especially critical about the circles of collectors to which she and her husband belonged. Although she admitted that such people were "all too inclined to plunder the natives," to take the "genuinely fine things" off their hands, or simply steal them, this was excusable, since "if one person doesn't take them, another will."[26]

While Krämer-Bannow sought to assuage her intermittent guilty conscience, her husband was corresponding with his benefactor in Stuttgart, Count Karl von Linden, the patron and founder of the ethnological museum that today bears his name. The count should not lose hope, Krämer once wrote to him, although it was "difficult in Melanesia" to procure ethnographically valuable items because "officials and merchants were competing to build collections." He himself had amassed a large collection, and Max Thiel

in Matupi possessed "splendid things from New Meck[lenburg]" that he wanted to give to the Stuttgart museum. "Two large statues of women" were already in transit—"the last of their kind in existence."[27]

Indeed, Thiel promptly delivered 265 objects to Stuttgart, and in 1908 he was just as promptly rewarded with the accolade he coveted: the Württemberg Medal of Peace with Knight's Cross, First Class.[28] In presenting the medal, Count Linden emphasized that Thiel had recently donated valuable ethnographic objects to Stuttgart's ethnological museum, to wit a collection of "40 molded skulls used at commemorations of the dead" as well as several carvings.[29] In late 1912, a further "lovely large collection of South Seas items arrived from Counsel Thiel in Hamburg."[30]

This sort of ostensibly peaceable but completely one-sided trade took place in the wake of paroxysms of German violence, as ethnographers like Krämer were all too aware. In 1908 and 1909, when Krämer explored the almost 9,000-square-kilometer island of New Mecklenburg, he acknowledged that the punitive expeditions, despite all their negative consequences, were a precondition for his own scholarly work. In the years before he arrived on the island, Krämer wrote, the notoriously "difficult" natives "had to be repeatedly disciplined by [German] warships and the [German] government." In August 1897, the *Seagull* "had to" intervene. With heartfelt gratitude, Krämer recalled previous missions of the small cruisers and gunboats against the New Mecklenburg islanders who would become his objects of study. "How many punitive expeditions the *Sparrowhawk* (*Sperber*), the *Falcon*, the *Buzzard*, and the *Sophie* carried out from 1890 to 1900! It truly was a wild stretch of coastline!" Krämer knew whereof he spoke. From 1893 to 1895, he had served as a navy staff doctor aboard the *Buzzard* and had experienced first-hand how the ship's guns had "kept up a lively barrage."[31]

Herbertshöhe (today's Kokopo) in 1906. In his memoirs, the colonial doctor Wilhelm Wendland (*pictured*) reported: "A joyful, sociable life prevailed back then in the Bismarck Archipelago, to which the presence of the small cruisers *Falcon* and *Buzzard* greatly contributed. On Sundays, we often made excursions in horse-drawn carriages or picnicked in particularly picturesque spots."

In the aftermath of all the cannon fire, retribution, and raids of destruction, the small stretch of land that Krämer wrote about was in fact largely peaceful. By the turn of the millennium, scholars, looters, and plantation owners could go about their work with a degree of safety. Soon a Wesleyan Methodist mission was established, leading Krämer to sigh with relief, "The pacification that has long been coming thanks to the government should be concluded soon."[32]

# 8

## Ethnology, Child of Colonialism

Adolf Bastian, Felix von Luschan, Otto Dempwolff, Augustin Krämer, Emil Stephan, and Georg Thilenius were medical doctors, most of them for the Imperial Germany Navy, who developed an interest in non-Western cultures during colonial voyages of conquest. They began to collect, draw, photograph, and record what they saw. Once they had done this for several years, they lost interest in serving in the navy and began to call themselves ethnologists, ethnographers, and linguists.

A good illustration of how compulsive collecting was reconceived as scholarship can be found in an article commemorating Krämer's seventy-fifth birthday. Krämer traveled in the South Seas as a navy doctor for the first time from 1893 to 1895, and then again from 1897 to 1899. In that post he did not have much to do, but being an adventurous and ambitious fellow, he occupied himself studying coral reefs and plankton, rock formations and birds. When this was no longer enough, he "devoted his attention to the ethnography of the peoples he visited." Krämer's interest was thus transferred from exotic minerals, plants, and animals in nature to what were considered "people of nature." During his studies, which were at first a passionate hobby, he was assisted in 1897 by the somewhat younger navy doctor Thilenius, who had yet to undergo

his own ethnological awakening: it was "thanks to Krämer's enthusiasm for ethnography" and his own "personal development" that Thilenius went "from being a doctor and zoologist to an ethnologist."[1] Seven years later, in 1904, Thilenius became the director of the Museum of Ethnology in Hamburg, while in 1912, Krämer, after several other, purely ethnographic research trips, was named director of Stuttgart's Linden Museum.

In the beginning, there were no clear boundaries between anthropology and ethnology. Most travelers, field researchers, merchants, and colonial officials were just as apt to collect human skulls as dance masks. They photographed and measured unfamiliar peoples and divided them into separate groups—soon to be designated "races"—based on external characteristics. As a result, significant numbers of human skeletons, skulls, hair samples, and alcohol-preserved soft tissues found their way into European museums of ethnology and natural history. For example, on October 15, 1892, in the auditorium of the Berlin Anthropological Society, Luschan displayed the "cranium, lower jaw, heart and hand of a murdered person from Togo-Land" to members of the society.[2] These human remains are still in possession of the Berlin Ethnological Museum (catalogue number E 1044 / 1891). Described by Luschan as particularly unusual and noteworthy, they were given to the institution by Count Joachim von Pfeil, who served temporarily as German Reich commissioner in Togo.

This sort of collecting created a scholarly discipline that could be described as ethno-anthropology. It would take some time for universities in German-speaking Europe to distinguish between anthropology and ethnology, and little attention was initially paid to methodology or to the precise formulation of scholarly questions. At the start, travelers, who would later describe themselves as scholars, simply brought home crates and crates of skulls and

Information written on one of eleven skulls of people who lived on the Kaniet (Anachorete) Islands near Luf in the Bismarck Archipelago. In 1899, South Seas merchant Max Thiel gave them to the Museum of Natural History in Vienna, where they are still part of the anthropological collection.

other curiosities. The emphasis was on the thrill of discovery and, in the best cases, orderly categorization and description. Tellingly, in 1902, Dempwolff, who would later become the curator of the Museum of Ethnology in Hamburg, wrote this description of the "jovial, well-fed, and, in his own way, scientific collector for the Hernsheim company," Franz Hellwig: "He had already been an innkeeper, a farmer, a trader, a hunter of wild boar, a factory owner, a door-to-door salesman, a clockmaker, etc."[3]

## Felix von Luschan, Manic Collector

Much like stamp collecting, the accumulation and comparison of objects of ethnological interest constantly gave rise to new niches and specialties. Berlin's Ethnological Museum, for instance, specialized in boats and in models, photographs, and drawings of boats. These early efforts came in for some criticism. The Berlin philosopher William Dilthey, in his 1889 evaluation of the post-doctoral thesis of the physician, traveling scholar, and ethnologist Karl von Steinen, complained about the "methodologically half-baked state of ethnology" and the questionable "cavalier confidence of this global traveler in his powers of mental combination."[4] A few years later, the general director of Berlin's Royal Museums, Wilhelm von Bode, excoriated the first generation of little-trained and "unfortunately by no means consistently conscientious ethnographers" and their "unsatisfactory results."[5]

It was long unclear whether this newly invented field should be considered part of the natural sciences or the methodologically softer humanities. In the end, ethnology settled down among philosophical and social sciences departments, whereas anthropology, which was based on the ostensibly objective collection of data, remained closer to medicine and biology. Even today, scholars continue to measure various attributes of people. Whereas one hundred years ago they focused on external characteristics like limb length, nose form, hair color, body shape, and skull volume, today they assess genetic traits.

Questions of methodology notwithstanding, it is important to understand the political framework that enabled the rise of ethnology as an academic discipline. In terms of the history of knowledge, ethnology was a corollary to European colonialism that arose within universities and museums. Within the context of colonial

power struggles, ethnologists served the interests of their home nations by legitimizing those nations' colonial adventures—though not always in an uncritical and superficial fashion.

In 1995, the ethnologist Marion Melk-Koch described in gushing tones how this process played out in informal, well-heeled circles: "On Sunday evenings, colonial officials, farmers, and plantation owners, scholars, travelers, and missionaries would gather at the Luschans' to swap observations and tales of their experiences and to make new connections."[6] Bastian and Luschan were among the primary decision-makers for the First German Colonial Exposition, staged with great propagandistic pomp in 1896 in Treptow Park near what were then Berlin's city limits. It included "Negro villages," wild animals, and "human zoo exhibits."[7]

Felix von Luschan's career was not unlike those of the navy doctors, albeit his training was more academic. As a twenty-year-old medical student and keen-minded academic assistant in Austria, he was charged with organizing the collection of the Vienna Anthropological Society. After completing his medical degree, Luschan became a practicing physician, but he remained enthusiastic about collecting, digging, measuring skulls, and performing comparative research. His activities encouraged him to ask questions, whether during a supplementary course of study in Paris or as a head military physician in Bosnia, which was occupied by Austro-Hungarian troops in 1879. He followed these experiences by participating in and directing archaeological-anthropological digs in Asia Minor and publishing his first academic studies.[8]

The combination of an interest in early human history and ethnological, archaeological, and anthropological research, together with his dogged questioning about humanity's origins and developmental levels, made Luschan an engaging, interdisciplinary scholar. Sticking to a single topic was not in his nature. He was easily one of the most imaginative minds in his field. In the South

Seas, he continued to look for the "great connections" between the many groups of people still living in isolation in New Guinea, noting that "we know nothing about their earlier history and previous migrations."[9] In an effort to answer these questions, he compared skulls, types of hair, languages, the production of spears and fishing nets, and—insofar as he thought he could understand them—religious and cult customs. In 1914, having liberated himself from his museum duties, he set off for the South Seas, a region he had always dreamt of visiting and researching. He and his wife had already traveled to the United States and Hawaii, before the outbreak of the First World War forced them to return home.

## "The Greatest Museum in the World"

In 1873, at the zenith of colonialism and shortly after the founding of the Wilhelmine Empire, the royal court decided to remove its exotic curiosities from the Prussian Royal Chamber of Art. Thus was born the Royal Ethnological Museum in Berlin, whose founding director, Adolf Bastian, hired the multifaceted Luschan as his assistant in 1885.

In January 1900, the Prussian minister of education named Luschan to a professorship, and in June 1904, he was officially promoted to departmental director of the museum's Oceania and Africa collections. (He had been de facto head of the two departments from the very beginning.) In his first fifteen years in this post, he quadrupled the number of objects there. By 1906, thanks to better and better transport from the German colonies, he would increase the holdings tenfold. The staff of academic curators in the museum also grew, from five to twenty-six by 1904. In 1908, a delighted Luschan remarked, "Our museum is the richest by a wide margin, and particularly from Africa we have ten times the amount of any other institution." As Hans Virchow put it in his

obituary, Luschan was guided by a feeling of duty "to make his museum into the greatest and finest in the world."[10]

Luschan's determination was likely the reason that on February 21, 1889, the Reich's second chamber of parliament, the Bundesrat, ordered that "all scholarly deliveries from the German protectorates" should be offered first to the Royal Ethnological Museum. This order was only partially enforced, however, after it was met with "the most intense disapproval—and not just in southern Germany."[11] The south was arguably the country's second ethnological center, but curators of other institutions all over Germany felt slighted.

Luschan frequently represented the museum on official occasions after Bastian's death in 1905. Although technically only a department head, he presided over the institution's further expansion. Luschan's mania for collecting is evident in a letter to him from Governor Hahl, responding to a 1909 letter from Luschan that is now lost. Hahl's response makes it clear that Luschan was worried about Hahl's allowing Dutch and American collectors to acquire ethnologically and anthropologically significant items for themselves. Hahl assured him that the supply of objects "secured for our research" was "endless." He also sought to assuage Luschan's concern by underlining the preeminence of German collectors: "Our head start, especially for German New Guinea, in the realm of ethnography and in terms of recovering ethnic treasures, is so great that it can never be overcome."

In addition to his concern about the competition, Luschan had apparently asked Hahl to disassemble a painted, communal men's house on the island of Mushu and ship it to Berlin. Hahl answered, "I don't know the house in the village of Sup on Mushu, but I don't think a painted communal men's house of this type can be procured without using violence. . . . I will, however, contact Administrator [Georg] Heine, who I know is a great supporter of your museum."[12]

That project failed, but the museum already had the next-best alternative. In 1907, Luschan had spent 1,000 marks on a half-size carved replica of the house that was as authentic as possible. Augustin Krämer provided crucial support in that endeavor. The work was done by the native builder and artist Golageril from the island of Ngarkideu, part of the Palau Archipelago, which Germany had incorporated into its South Seas empire in 1899.[13]

After Bastian's death in 1905, Luschan's compulsive collecting encountered serious obstacles. As a result of his unrestrained hoarding, the museum suffered from a lack of space, which Luschan bemoaned as an "utterly indescribably calamity."[14] The museum's leadership structure was an even greater hindrance. The Prussian Royal Museums were run as a single institution, and as a result individual entities and their internal structural divisions were subordinate to a general administration. That was reflected in Luschan's title, "Departmental Director of the Africa and Oceania Collections," and in practical terms, it meant that Luschan was forced to constantly consult with the general director of the museums on all financial and physical expansion issues.

As of 1905, the office of general director was occupied by Wilhelm von Bode, who had had great success heading the Berlin Royal Gallery and later State Portrait Gallery from 1890 to 1922, and who had robustly developed the Islamic and Far Eastern divisions after his promotion—but who was also skeptical of ethnology. Bode strongly opposed what he considered unstructured collecting. With Bode controlling the purse strings, Luschan was reduced to repeatedly begging, in vain, for a larger procurement budget as well as for building expansions and additional storage facilities.

In his memoirs, Bode described in drastic terms his bewilderment at the "intolerable overfill" of the ethnology department. Taken aback by the clutter, he complained about the "senseless acquisition of objects, especially procurements that came to us

from the colonies.'""Hardly any of the directors sought to be moderate in their collecting or to store or sell some items," he wrote. "The director with the most bloated and worst affected collection, Professor von Luschan, freely admitted to procuring things in duplicate and was insatiable in piling up even the most modern products of native peoples, things which had been created entirely under European influence." As if that weren't enough, Bode accused the heads of the ethnographic departments of lacking "knowledge about museums in the modern sense."[15]

Even though Luschan threatened to resign in 1906, Bode never reversed his negative judgment or the restrictions he had imposed. In their budgetary debates, deputies in the Prussian parliament constantly criticized the ethnologists'"collecting mania" and asked whether"too much" was being compiled. Conversely, Luschan complained about "impoverishment and a beggar's economy, which has become intolerable" as well as lack of understanding, which, he claimed, would only yield an "unsatisfactory patchwork."[16]

Disappointed, and having learned that he would be given a professorship in anthropology at the University of Berlin, Luschan resigned his position as director of the Africa and Oceania departments in 1911. Yet his new post also required a lot of back-and-forth faculty discussions, and the university refused his lifelong wish to head the Anthropological Institute. Instead of fulfilling his costly requests, the Prussian state chose a more economical path, awarding the Austrian aristocrat the Red Eagle Medal Third Class with Ribbon and Imperial Crown in 1909 and naming him a privy councilor shortly thereafter.[17]

Bernhard Ankermann took over the Oceania Department, leaving Luschan to tend only the anthropology and anatomy collection, or more precisely, the skulls he had collected or had others acquire. His work from that point on took place at the university.

Soon after his death in 1924, the Ethnological Museum turned over this collection of human remains to the Medical Department of the University of Berlin. Luschan's heirs sold his large private collection of human skulls to the American Museum of Natural History in New York.

It is easy for us today to criticize the way Luschan built his collection. Nonetheless, the ethnological items he brought together are of significant value, and it is good that they still exist. There is nothing to be learned, however, from Luschan's enthusiastic measurements and comparisons of skulls from various peoples. This multifaceted and diligent scholar was a child of his time, and like the vast majority of his European contemporaries, he didn't question colonialism. Still, he deserves credit for resisting, wherever he was able, the reduction of anthropology to race studies. For example, he repeatedly displayed sympathy for Jews as "heirs to an ancient and honorable culture" and "allies in the battle for progress and intellectual freedom," and he vehemently rejected denigrations of Jews as a *race inférieure.*"[18]

Luschan scoffed at the "Teutonic and pan-Germanic goals of an [Arthur de] Gobineau or [Houston Stewart] Chamberlain" as completely unscientific, "poetic phrases."[19] And anyone who nattered on about Aryan or Jewish "races" was in his eyes a "terrible dilettante." What would soon congeal into the theory of racist nationalism, which held that various peoples were of intrinsically different value, was anathema to him. In the middle of the First World War, he proclaimed in a public speech, later published, "People of lesser value—I actually don't know a single one." One "should really not use" the concept of race "at all," he added, or even ask how many races there are. He considered race theory's constant assignment of attributes and drawing of borders scientific humbug, equivalent to "pondering how many angels can dance on the head of a pin."[20]

This was a completely different way of thinking, writing, and speaking than the cold scientific racism of the men who would soon become the twentieth century's leading "genetic and racial hygienists": Eugen Fischer, Richard Thurnwald, and Otto Reche. These men, too, initially earned their spurs as South Seas researchers, and all three would go on to help legitimize National Socialist thought and policy in "racial-theoretical" terms. The enormous, multilayered body of work that Luschan left behind when he died didn't suit the intellectual cosmos of anti-Semitic "race scholars" and state ideologues. Luschan fell into obscurity and, for that reason, is rarely cited today.[21] We should remember the honorable side of Felix von Luschan, especially as the rest of this book focuses on those aspects of his work that are currently coming in for (more or less justified) criticism.

## Luschan's Love of "Native" Boats

Again and again, Luschan's attention returned to Indigenous peoples' boats. In his voluminous, often revised and expanded work *Anleitung zu wissenschaftlichen Beobachtungen auf dem Gebiete der Anthropologie, Ethnographie, und Urgeschichte* (Introduction to Scientific Observations in the Area of Anthropology, Ethnography, and Prehistory), he included under the heading "Means of Transport" exact cross-sections, outlines and sketches, photographs of details and whole vessels, and observations concerning "decorations and large carvings on bows and sterns as well as samples of plank decorations." He was likewise obsessed with models, preferably made by the island boatbuilders themselves. "Under all circumstances," he instructed, ethnologically active missionaries, officers, officials, and merchants were to keep their eyes peeled for "outriggers, double-hulled sailing boats, and the multileveled structures atop them." Masts and rigging, sails,

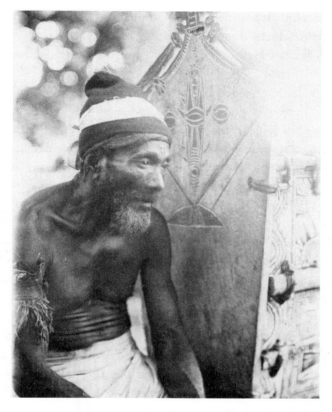

A boatbuilder from the Tami Islands, German New Guinea,
photographed by Hans Vogel during the Hamburg South
Seas Expedition of 1908–1909.

rudders, bailing devices, and anchors were to be "precisely de-
scribed." In addition, Luschan's volunteer assistants were to dili-
gently record the origins of every object and how it was used, in-
vestigate navigational techniques, and write down the native
words for individual boat parts and equipment. Last but not
least, Luschan ordered his amateur ethnographers to find out

and document the methods of production, the significance, and the names of the decorations with maximum accuracy.[22]

Ordinary travelers could not simply bring an original boat back with them to Europe, of course—specialists were needed to procure major booty of this sort. Luschan himself was one such specialist. In 1905, he grandiloquently and joyfully described stopping in a harbor in Mozambique during a voyage around Africa on a passenger steamship and personally "acquiring" a small sailboat for his collection back in Berlin.

As was common practice, canoes full of native people eager to trade approached the ship at anchor. The keen eyes of the collector immediately gravitated to a "quite lovely and typical" three-man sailboat "stitched together from tree bark and equipped with a mast and sails, three rudders, and the same number of bailers also made of bark." Luschan convinced its occupants to sell it to him for twenty-five British shillings and arranged for them to be taken back to shore. He paid ten shillings to the crew members who had to heave on board the vessel, which had been transformed from a mode of transport into a museum item. As Hans Virchow wrote in his 1924 obituary of Luschan, his long-time friend had a "constant urge to procure objects himself" and "an excellent ability to take advantage of opportunities."[23]

After concluding this transaction, Luschan proudly reported to Berlin that the "whole acquisition" had been carried out "within minutes" and that the mostly British passengers on board had applauded his purchase. "In any case," boasted Luschan, "I was congratulated from all sides, including formally by Professor Darwin, head of the British Association [for the Advancement of Science]." The man in question, George H. Darwin, was one of Charles's sons. He had invited Luschan to take part in the seventy-fifth meeting of the association, which had been held for the first time in Africa, in Cape Town.

Twenty-five British shillings was the equivalent of roughly five marks or about three dollars. Even adjusting for prices at the time, the sum was nothing compared with the material and overarching cultural value of boat. Luschan himself acknowledged as much by celebrating the fact that a couple of "natives" had fallen for his offer, made as always in the museum's service. Thanks to such practices— gently carried out in this case, but more often accompanied by violence—Berlin acquired "one of the most magnificent collections of boats in the world," the president of the Prussian Cultural Heritage Foundation bragged in 2010.[24]

Luschan had less success with his first attempt to transport a large-scale, "one-of-a-kind" boat from the South Seas back to Berlin. In early 1901, the imperial governor of German Samoa, Wilhelm Solf, reported to his superior in the Reich Colonial Office in Berlin that "Safune on Savai'i [Island] is where you can find the only remaining war canoe." The boat's ownership was not problematic. Solf claimed that the high chieftain Josefo Mataafa and a committee of local islanders had given Kaiser Wilhelm II the vessel as a gift, although he failed to discuss the background to this act of generosity. In February 1901, the colony of German Samoa had only existed for a year, and it had been necessary to subdue Mataafa, the previously hostile chieftain, with the award of a lofty sounding title and a tidy annual salary as well as permission to accompany the governor at all manner of symbolic events.

With Kaiser Wilhelm II unable to accept the twenty-meter-long catamaran in person, Solf recommended that the officials in Berlin contact the Ethnological Museum, whose custodian could decide whether to take possession of the cumbersome, but "apparently ethnologically valuable," piece. Delighted at the news, Luschan wrote that he felt "honored" and expressed his strong interest in the boat. The war canoe was a "highly desirable acquisition," and

he urged Sohl to check its condition and to collect "precise details in the native language" about all of its parts. His only scruple was the enormous shipping cost, for which a solution would have to be found.

The project was delayed, and it ultimately came to naught. A bill from May 1903 reveals that the German governor paid 2,780.37 marks for an 80 × 24–foot tin casing to protect the boat. Nonetheless, the boat began rotting, and a regretful Solf concluded, "It would be a shame if this remnant of the ancient Samoan art of boatbuilding was destroyed."

When Luschan bought the Luf Boat from Hernsheim in late 1903, he placed "great importance" on "acquiring for the museum"

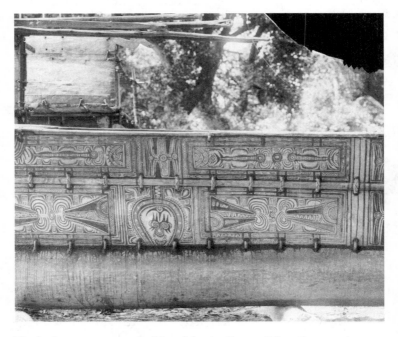

Planks from a canoe on the Tami Islands, German New Guinea, photographed by Hans Vogel in 1908.

the catamaran from Samoa as well. But he lacked the funds. While he was fighting bitterly, but unsuccessfully, for new annexes and storage halls and sniping back and forth with city authorities about the danger of fire and lack of exits in his completely overfilled museum, the highly coveted war canoe rotted away for good in Samoa. In an evaluation on July 5, 1910, the construction engineer Schaafhasen concluded that "white ants and weather influences" had significantly damaged all parts of the vessel, so that "it was not worth shipping it anywhere." Schaafhausen's final judgment reads, "I hereby advise not to take any further steps in this matter." By that point, the Colonial Office had "spent more than 5,000 marks for the storage and preservation of the war canoe." Now it categorically declared that "no further means would be allocated" for this purpose.

No sooner had Luschan resigned his post as departmental director of the Oceania Collection than General Director Bode assumed responsibility for the Samoan catamaran, telling the colonial administration, "The Museum for Ethnology would like several quality photographs or sketches"—and nothing else. In line with that policy, the officials were to "desist . . . from further steps toward the preservation and transport of the boat."[25]

# 9

## The Luf Boat Comes to Berlin

Luschan's failure to procure the Samoan catamaran stoked his desire for large, rare, exotic boats. His correspondence gives us insight into the transport costs for such objects. No sooner had the catamaran been offered to the museum than the Norddeutscher Lloyd shipping company said it was prepared to take the boat free of charge from Sydney to Bremerhaven, provided that it was first dismantled. Merchants and shipping companies did such favors as a discreet form of "you-scratch-my-back-I'll-scratch-yours" corruption. Hernsheim & Co. did the same as a way of preserving its trade privileges.

Although the Samoan catamaran could have been transported from Sydney to Bremerhaven for free and had been acquired without charge, the total cost for bringing it to Berlin would have been 12,000 marks. That was the March 1906 estimate for disassembling and packing the vessel, reassembling it at its final destination, and transporting it from Samoa to Sydney and Bremerhaven to Berlin.[1]

For the somewhat smaller Luf Boat, the Prussian finance minister noted in 1904, "Hernsheim, Hamburg, 1 boat from the Hermit Islands, 6,000 M[arks]."[2] If we take the slightly later estimate for packing, loading, and transporting the catamaran as a guide, Hernsheim's profit margin can't have been very great. This

conclusion is backed up by a report by Richard Parkinson in 1907: "Mr. Thiel in Matupi had this splendid item brought at great expense and effort to his main base in the Bismarck Archipelago, where I was able to make a number of photographic images of this rare piece, the last of its kind."[3] In 1922, the explorer Norbert Jacques described the boat as a "massive dugout with man-sized gunwales" and "colorful flat carvings," and the "last surviving witness" of a once mighty people. Jacques added that it was now "resting" in Berlin, in the Ethnological Museum.[4]

## Thiel, Hernsheim, Wahlen, and the Boat

Max Thiel decided to acquire the Luf Boat during a voyage that began in Matupi on January 4, 1902. According to the diary of the missionary Johanna Fellmann, a small group of men set off "with the *South Australia*, Mr. Thiel's charter vessel," to the Western Islands of the Bismarck Archipelago. Taking part in the trip were Thiel, his father Friedrich, Johanna Fellmann's missionary husband Heinrich, Heinrich Rudolph Wahlen (Hernsheim's procurement officer in Matupi), and the governor's secretary, Karl Warnecke.[5]

During the voyage, negotiations seem to have transpired about Wahlen's future as an independent South Seas entrepreneur and plantation manager and the intensive economic exploitation of the Hermit Islands and neighboring atolls. In any case, it wasn't long before Wahlen purchased "some 500 hectares of ownerless land" on the Western Islands from the Hernsheim company and built a mansion on Maron, the second largest island in the Hermit Atoll. The mansion was nicknamed Wahlen Castle, and Wahlen, who "ruled it like a king" until 1914, immediately had five thousand coconut trees planted, which generated a considerable income.

On May 1, 1933, Wahlen would join the Nazi Party in Hamburg, where he later lived at Adolf-Hitler-Strasse 16a. In 1939, Wahlen, who described himself as "the most successful German colonial pioneer," established contact with Hitler's colonial commissioner, Franz Ritter von Epp. After Germany's victories over France, Belgium, and the Netherlands in the Second World War, Wahlen suggested that Nazi Germany take over all of New Guinea, annexing the larger British and even Dutch portions of the island. In early August 1941, when he was forced to return to Germany from the occupied Soviet Union because of a "flaw in the heart," he wrote to SS Brigadeführer Walter Hewel, his trusted ally in the foreign ministry and a conduit to Hitler, "What a shame— I'll now miss out on my share of the caviar in Moscow."[6]

But let us return to Wahlen's past. On November 2, 1902, Max Thiel threw a going-away party on Matupi Island for his former employee, "at which things really took off . . . with the presence of several ladies" and which lasted until the wee hours. Seven days later, Wahlen set off for his new island territory on his ship, the *Stella*. It had "three whites and sixteen coloreds" on board and was accompanied by the fully loaded, motorized schooner *Gazelle*, which carried "eight Europeans and 150 coloreds," including Franz Hellwig, "the scholarly collector for the Hernsheim company." The "coloreds," whose number included several Chinese tradesmen, were to plant Wahlen's coconut trees on Maron and work there permanently. Otto Dempwolff, who was researching malaria at the time with the famed virologist Robert Koch, joined the group that would seize this new territory. The following details come from his *Tagebuch von den Westlichen Inseln* (Diary of the Western Islands), first published in 2019.[7]

The two ships reached the Hermits on November 24, 1902, initially anchoring at Pemei Island, where a Danish merchant named Petersen had set himself up in business with three hundred

Farewell party for Heinrich Rudolph Wahlen in Matupi, hosted by
Max Thiel on November 8, 1902.

coconut trees. There were no more "free natives" on the island. To replace them, Petersen had purchased fifteen workers from the notorious labor traders of the South Seas. They were now joined by sixty forced laborers, who were charged with building Wahlen's new base on Maron and fishing the reefs for trochus shells, whose mother-of-pearl was highly prized and easy to sell. In addition, Dempwolff noted, "Wahlen later wants to plant the island systematically with coconut trees." Immediately after settling in the future "governmental seat," Wahlen luxuriated in colonialist comfort. "All of this is mine!" he exclaimed. "Every grain of sand belongs to me. Do you hear that little bird singing. It belongs to me too!" He had acquired everything for a pittance— almost the entirety of "this truly quite lovely" atoll and several neighboring island groups. The exception was Luf, which Hernsheim had declared a "reservation."

The day after his arrival, Dempwolff had himself rowed over to the main island of Luf. He knew from his companion Hellwig that "hundreds of people" had lived there up until the 1870s and had then perished in great numbers as a result of epidemics. As an explanation for the high mortality rate, Dempwolff cited the "positively shameless engagement in sexual intercourse" he had observed. He made no mention of the British and German punitive expeditions or the deportations of men as forced laborers. Hellwig had told him none of this. Dempwolff, however, did not see any "signs of a severe epidemic." He counted "ten well-preserved huts" and "a new communal men's house," but he was struck by the "indolent" behavior and "stiff" movements of the approximately seventy people left on Luf. It was, he wrote, "as though they were burdened by great exhaustion."[8]

Several days later Dempwolff traveled to the nearby Ninigo Islands, where he met the Irish merchant Jimmy Devlin, who had long worked for Hernsheim and was prone to tell a story or two

"over glasses of beer and gin," preferring the latter to anything else. Plied by Dempwolff, he related an anecdote: "Around 1880, a merchant named Charlie was murdered on Luf by some of the roughly 600 natives. The retaliatory punitive expedition only killed two people but destroyed all the buildings and removed all equipment and tools (back then a lot of items were made of stone). The natives thereby rendered homeless had spent a difficult rainy season in the underbrush or in caves and died in such numbers from starvation and cold that it was impossible to bury all of the dead."

Devlin's account of the retaliatory action of the warships *Carola* and *Hyena* was accurate, as we have seen, and as Dempwolff was now forced to acknowledge. But the figure for the number of islanders killed immediately is far too low. One significant detail is the complete theft of the islanders' equipment and tools. It coheres with the effusive words of thanks the director of the Berlin Ethnological Museum addressed to the leader of the punitive expedition, Captain Karcher.

Devlin's assertion that the survivors on Luf had given up and chosen to go extinct ("They wish to die out!") was ridiculous.[9] And despite Dempwolff's observations during his visit to Luf, which he had documented in his diary, he chose to elevate the blather of an accidental acquaintance over scientific certainty. In his lecture "On People Going Extinct," delivered a year after his voyage at the invitation of the Berlin Society for Anthropology, Ethnology, and Prehistory, he invented a statement he attributed to Devlin, with which he "could not disagree." The punitive expeditions of the *Carola* and *Hyena*, he claimed, had not been the "cause of the islanders' dying out." Instead, "infanticide and abortion" had caused the population to rapidly decline. In all seriousness, he spoke of a mysterious, "voluntary self-destruction of a people in the wake of the conscious extinguishing of their will to live."[10] Admittedly, this

ribbon of lies wasn't new. After his murderous 1882–1883 expedition against the Luf islanders, Captain Karcher had already spread the falsehood that "all natives of the Hermits ... had decided to kill themselves ... once they could no longer see a way out." As witnesses, he cited "two women" whom his men had captured on Luf and presented to him.[11]

The unhappy phrase "voluntary self-destruction" is used to this day. It paints a version of events that has always been the most comfortable one for German colonial masters, thieves of cultural treasures, custodians of ethnological museums, and later generations deriving their own benefit from historical acts of larceny. The assertion that the Luf islanders longed for their own demise or disappeared due to a natural "decrease in the population" is clearly a lie born of necessity. In 1908, the Hamburg ethnologist Paul Hambruch, who had done three years of research in the South Seas, published a clarification concerning Dempwolff's star witness, Jimmy Devlin. Hambruch revealed that the latter had "lied to" Dempwolff and, previously, to Thilenius, as a "complete joke."[12] A drunken Devlin had also convinced Dempwolff that several years after a great famine on Luf, "four fully manned canoes" had set out on a slave raid to the Ninigo Islands, during which three had sunk. Only one canoe had managed to reach its destination, and "he, Devlin, had brought eight of the nine shipwrecked men back home to Luf." Dempwolff subsequently utilized Devlin's tall tales of the South Seas for a scholarly article, and with that, comfortable stories about the Luf Boat, based on lies, were invented.[13] As late as 2020, those tales were still being told by Berlin museum curators in tones of deep conviction, and they formed the core of a Wikipedia article on the Luf Boat. In 2021, the ethnologist Brigitta Hauser-Schäublin stubbornly repeated these assertions.[14] They deviate from the account in an essay by the 1920s South Seas exhibit curator August Eichhorn, who proposed that not three,

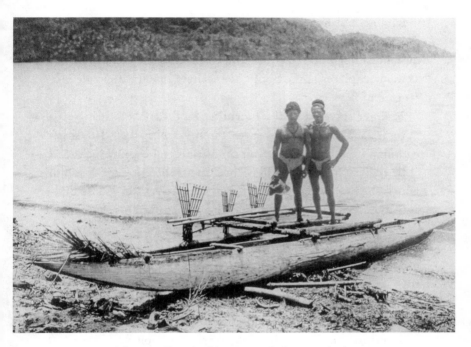

A remnant of the art of boatbuilding on Luf, photographed in 1906
during August Krämer's visit.

but merely one of the boats had sunk, with a crew of sixty, none
of whom returned from the voyage. There is no even partially re-
liable evidence that either version of the story is true.[15]

By contrast, Thilenius, Hambruch, and Krämer saw through
Devlin's and Dempwolff's falsehoods straight away. After visiting
Luf, Krämer wrote: "As far as the question of the suicide of this
race is concerned, in which the populace decided to die out," all
manner of skepticism was justified. In 1906, Krämer had counted
and recorded the names of fifty-two island inhabitants, in-
cluding seven children aged between one and fifteen. He added
pessimistically, "Even if I too believe the Lufites will die out, it is an

inevitable and not a voluntary phenomenon. Punitive expeditions, wars, our campaigns against them, introduced diseases, and moral disintegration have brought forth the same condition here as in many places in the South Seas. There is no race suicide present here."[16]

Krämer traveled to the Hermit Islands as the leading ethnologist aboard the imperial research vessel *Planet*. The ship's commander, Lieutenant Captain Wilhelm Lebahn, informed "His Majesty the Kaiser and King" about the poor condition in which the few natives on Luf found themselves. "It will be difficult to determine what blame earlier, unscrupulous merchants bear for these conditions and what culpability the natives themselves have," Lebahn wrote. "In any case, the disappearance of this race, which is no longer capable of culture, is no loss for the protectorate."[17]

There is no doubt that the Luf Boat had already been taken to the Hernsheim base on Matupi before November 1902. As Dempwolff claimed in Berlin, he had found a "decrepit boathouse" on Luf, but not the boat itself. By that point, the vessel was already "on sale in Matupi."[18] Contradicting the claims he passed on to justify his actions, Dempwolff himself had photographs made of an intact communal men's house on Luf, the same building that served as the boathouse, which was by no means falling apart. On the contrary, as late as 1906, it was still used to "store boats and accommodate bachelors and outsiders," reported Krämer, who was the last person to comprehensively document the final boathouse on Luf.[19] Like the splendid vessel itself, it had been rebuilt after the punitive expedition of 1882–1883.

In Matupi, Eduard Hernsheim initially tried to sell the boat, packaged with some less valuable items, to the Rautenstrauch Joest Museum in Cologne. On June 25, 1902, he sent the following inquiry to the museum's director, Willy Foy: "Would you be

interested in a fifty-foot-long splendidly painted canoe, covered in carvings, from the Hermit Islands, which is one of a kind and a legacy of the artisanship of these soon-to-be extinct islanders?" He added, switching to the past tense: "The canoe was kept as a holy object and main attraction on the [Hermit] islands."

Hernsheim followed up a few months later: "Moreover, I am sending you and would be pleased to receive back seven photos of the large Hermits canoe, whose dimensions are given on the reverse side. . . . If you have more money and are able to secure this unique item, I would ask you to send word quite soon, since there will undoubtedly be people interested in it."[20]

When no deal materialized, he turned to Felix von Luschan in Berlin, who noted on April 28, 1903: "Mr. Eduard Hernsheim has sent seven photographs of a 15-meter boat from the Hermit Islands." The price, which included transport to Hamburg, was 6,500 marks. A few days after Hernsheim's offer, the purchasing committee in Berlin declared the boat's acquisition "especially desirable," and Luschan immediately wrote back, "We would be pleased to purchase the Hermits boat you kindly offered for the price of 6,000 marks, presuming it arrives here undamaged and can be reassembled properly. It is particularly important to us that the artful connection between the bridge and the outriggers not be destroyed."[21]

Hernsheim and Thiel advertised their item as a miracle of the high seas that its creators considered a "holy object and an attraction." Is it likely that a society would just hand over something it considered holy? One might answer: possibly, if the society had been driven to ruin by thirty years of lethal military raids, deportations of its members into slavery, imported diseases, and pitiless economic commercialization, which were all part of colonialism. This is what Hernsheim and Thiel had wrought upon the island of Luf.

Once Hernsheim and Luschan had concluded the deal, the boat was "disassembled and sent in numerous bundles and crates in November 1903 with [postal] steamship *Prinz Waldemar* to Hamburg."[22] Hernsheim pocketed the entire purchase price. The craftsmen who had built the vessel received nothing. In his memoirs, Eduard Hernsheim wrote of the Luf Boat as "passing into my hands." Usually, one would expect somewhat more precise language to describe the purchase of such an extraordinary object.

Luschan wasn't interested in such niceties. His sole concern was crowning his collection with a much-coveted item. Soon after the boat arrived in Berlin, in February 1904, he delivered a lecture as part of his series "Ethnology of the South Seas," in which he discussed the Luf Boat, calling it, with reference to the outmoded name of the Hermit Islands, the Agomes Boat. His bullet-point notes for the talk, dated April 26, 1904, include, "Seafarers: sailors, wanderers, fishermen—boat building—Agomes."[23] Two years later, he put his room-filling new attraction on display in the courtyard of the Royal Museum of Ethnology, describing it in the museum guide as "as large, painted outrigger from Agomes with sails and complete equipment."[24]

# An Artifact of an Ancient Culture

The boatbuilders of the South Seas enthralled ethnologists, photographers, and painters. The islanders' creations were evidence of the cultural achievements of people otherwise considered primitive and savage. One look at the ocean-going sailing vessels, constructed without a single metal fastener, was enough to impress even supercilious Europeans with the fact that thousands of years ago, the ancestors of the South Seas islanders had traversed enormous stretches of the Pacific Ocean and settled these distant plots of land.

Although the peoples of Oceania did not develop a written language, they did have highly developed cultural practices that allowed them to live well and securely with limited effort. The riches of the local vegetation and the sea meant that the islanders didn't need to toil away constantly to stay alive. As a result, their skills in building houses and boats flourished, as did their fine arts, religious dances, ceremonies, and death rituals.

The many visible signs of high culture and knowledge passed down over generations bewildered European researchers, who were convinced they had discovered a population of "primitives," whose development remained at the level of Stone Age humankind. Scholars saw the South Seas as a kind of time machine they could use to better understand the lives of cave dwellers in

Central Europe twenty-five thousand years ago. The splendid large boats and corresponding nautical skills of the South Seas islanders contradicted this working hypothesis, revealing it to be based on prejudice and ignorance.[1]

European ethnologists described groups they deemed to be without history as "people of nature," or "natural peoples," that is, people untouched by civilization. The implication was that such peoples were incapable of development and remained frozen and unchanging, outside general human evolution and progress. Adolf Bastian posed a number of arrogant rhetorical questions about the way of life of natural peoples: "What does old mean here, or young, given the limitlessness of old age and youth in nature?"[2] Underlying these questions was the idea that people of nature would forever reproduce themselves, like a blade of grass, in ever-repeating cycles. The opposite of natural peoples was cultured peoples, with their progress and development. Needless to say, colonists and ethnologists defined themselves as members of cultured peoples.

Paul Schnee, who practiced medicine in German New Guinea, put the matter like this: "These people" shouldn't be understood as "rational adults," but rather as "the children they are and will always be."[3] Otto Dempwolff, also a doctor, was of much the same opinion. In his considered medical judgment, "rational consideration" and "conscious, long-term reflection" were foreign to natural peoples. Instead, their members followed their "urges and moods" and affirmed "life naively and joyfully," like children. "Advanced calculations and retrospective concerns cannot be expected of them," Dempwolff proclaimed.[4] Augustin Krämer wrote of the inhabitants of the Admiralty Islands, "Fear and superstition rule people in a childish state and give their survival instincts a hostile and dark character."[5]

But how could such childish people build such splendid boats, maintain an ancestral cult, pass down beautiful songs over genera-

tions, and create unique works of art? Felix von Luschan, one of the few representatives of his discipline who occasionally questioned received wisdom, including his own convictions, asked himself these questions. Early on, he arrived at the insight, which he repeatedly reconfirmed, that "there is no border separating with clarity and certainty ['natural peoples'] from 'cultured peoples.'"[6]

## Nemin and Xelau's Magnificent Creation

In 1906, Krämer boarded the *Planet*, a ship equipped expressly for research, for a two-year voyage whose most important stops were in the South Seas; he was the expert in charge of ethnological and anthropological research. The results, which included meteorological, biological, and oceanographic measurements, were published in five thick volumes in 1909. Krämer edited volume five and wrote all but two of the articles in it. The fourth chapter was a sixty-five-page, carefully illustrated section entitled "Contributions to a monograph on the Hermit Islands (Luf Archipelago)," which Krämer had written after a fourteen-day visit there. At Luschan's request, he had made inquiries about the Luf Boat, which was already on display in Berlin, asking several older men how the vessel had been built and decorated.

The islanders told him the boat was made of sturdy, usually fire-hardened wood from breadfruit trees. The core was a carefully hollowed out trunk with planks laid on top that were tightly secured to the hull and the frame with woven rope. The builders had used the "oily kernel of the putty nut ... ground on a piece of mushroom coral" to produce a caulk of oil and lime (calcium oxide) to seal the joints. Finally, they painted the boat's exterior, using white, grated coral, and a special kind of red soil.

Krämer found out that the boat had been built by two men named Nemin and Xelau together with the tribal chieftain Sini,

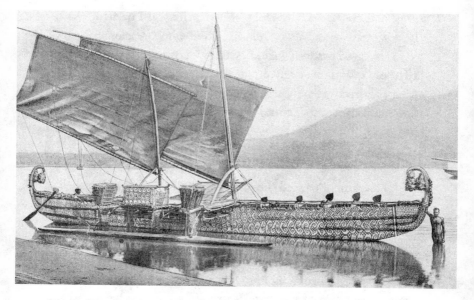

The Luf Boat in Matupi Bay, photographed for Max Thiel by Richard Parkinson. Eduard Hernsheim used this photo to offer the boat for sale to clients in Europe.

who was still alive on Luf. The vessel was called *don tinan*, which basically meant "big boat." Two other men, Karai and Xaighud (Sini's father), had also worked on the boat but were no longer alive.

Whereas Georg Thilenius, who had first described the boat lying at anchor in Luf, had been fascinated by the "phallus-shaped" ornamentation, Krämer concentrated on the painted, running fish motif. He had one of the old men draw the pattern and describe it in his own language, including the word for the fish: *lau*. The species of fish is quite flat, which fit well with Krämer's discovery that the word also meant "leaf" in the native language of the Hermit Islands.

Krämer couldn't make out a fish in the old man's drawing and said as much. This apparently offended the man, who proceeded to draw an image "that left nothing to be desired in terms of obviousness." "The horizontal part in the middle is actually the fish," wrote Krämer. "The rhombus indicates the body with the head, followed to the rear by knotty protuberances, *xuin*—bones, apparently the vertebrae, stripped of skin, and then another rhombus, a cross-section representing the fish's flesh. Farther back are a couple of vertebrae and the tail fins (*kävin*). The fins above and below are painted on and ornamentally lead the eye to new bones and bodies, as the illustrations of the large boat show so beautifully. . . . Where the tail fin rolls in on itself, it creates a spiral whose point is called *samoén*, as is also the case with the 'fat fin' of the bonito." In addition to the main motif of the fish / *lau*, there are further ornaments and carved decorations on the boat's body. They include recurring patterns like stylized turtles, stars, and a double human figure. Of particular ethnological interest was a dwarf-like human figure at the bottom inside end of the figurehead, which reminded the classically educated ethnologists of a Phrygian cap—a soft cap with the top curled over, originally made of the tanned scrotum of a bull with the surrounding fur. Early on, Otto Finsch had seen and documented this form in a tattoo he observed on a Luf islander named Darchoi.

The Phrygian cap form can also be found as a head covering of a well-known statue of a South Seas islander that was distinguished by an especially elaborate support. For Krämer, the cap's purpose was to guarantee the stability of the figure and "nothing more" (see the illustration on page 107, *below*). In fact, this figure and the Phrygian cap form decorating the bow and stern of the Luf Boat are likely an explicit symbol of masculinity, possibly with the insignia of the chieftain, comparable to the papal miter, crown, and scepter.[7]

Krämer's caption from 1906 reads: "Original drawing by an elderly Lufite. The legendary *lau* fish, the main ornament on the sides of the Great Boat of the Hermit Islands in never-ending repetition."

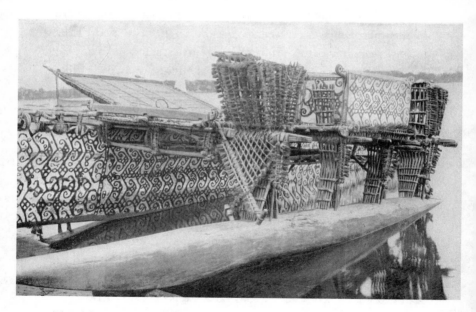

The elaborate ornamentation of the Luf Boat, showing the serial painted *lau* fish.

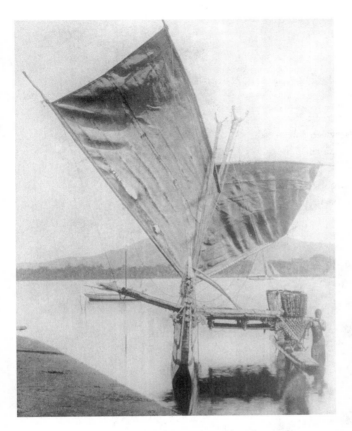

Krämer's caption from 1906: "The great sailing boat of Luf, with sails hoisted in Matupi, now in Berlin."

Incised skin decoration on the forearm of a man named Darchoi on the island of Luf, sketched by Otto Fisch (1888). The basic shape of these decorative scars mirrors that of the Phrygian cap form on both ends of the Luf Boat.

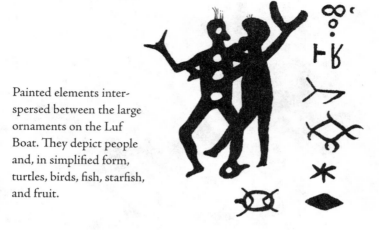

Painted elements interspersed between the large ornaments on the Luf Boat. They depict people and, in simplified form, turtles, birds, fish, starfish, and fruit.

Lime applicators from the Western Islands and implements for consuming chopped betel nuts. The third figure from the right in the top row is the rather phallic one from the Hermit Islands, described by Krämer and collected before 1888.

In 1931, Luschan's protégé Paul Hambruch summarized in the journal *Der Erdball* (The Globe) what was known about seafaring in Oceania. Hambruch had taken part in the Hamburg South Seas expedition to learn more about the nautical knowledge of the South Seas islanders and their ability to cover huge distances over the ocean. Not surprisingly, but worthy of note in relation to the Luf Boat, Hambruch concluded that the more developed the coastal regions were, the "worse-built" the boats were and the more "meager" the nautical knowledge was. The opposite was true of small, widely dispersed islands: "Here, boat building and nautical understanding made the greatest progress." The easy-to-sail outrigger had become the standard. It had a shallow draft, allowing it to maneuver well between the atolls' reefs, but it was stable enough to sail in open waters. The sails were made of the very tough fibers of pandan leaves. When the outriggers capsized, they didn't sink, and it was relatively easy for their crews to flip them back over.

Large long-distance traveling boats like the one from Luf "contained comfortable huts on the platform." Nonperishables, coconuts, and gourds filled with water were loaded aboard for longer voyages, as were weapons and fishing implements. To cook fish, long-distance sailors had fire boxes filled with sand in which a "permanent flicker of fire" was maintained. During tropical storms, seafarers could collect fresh water, but they also knew how to skim lighter fresh water from the ocean's surface before it mixed with the salt water. "Every boat is a treasured possession," concluded Hambruch. "Many of them have names." They were never left in the water, but rather dragged onto the beach "to protect their hulls from burrowing worms." On land, islanders covered the ocean vessels so crucial to their survival with mats to protect them from the sun, since "otherwise the planks would completely dry out" and the "joints would loosen."

If the boats went unused for some time, "they were stored in large, open halls, boathouses," which, as on Luf, doubled as "meeting places or communal men's houses."[8]

## Georg Thilenius and the Last Big Traveling Boat

In March 1899, when the physician and ethnologist Georg Thilenius from Breslau (today's Wrocław) arrived at the port of Matupi, he enjoyed "the hospitality of the Hernsheim company." Max Thiel "most kindly" invited him to take part in a commercial voyage to the Western Islands.[9] Thus did Thilenius come to spend almost a week on Luf. In 1903, he shared his impressions of the island in a volume published by the German Academy of Sciences Leopoldina in Halle. This publication contains Thilenius's first writings about boatbuilding on Luf, which I quote here in slightly abridged form:

> Today, boats provide the last remaining evidence of the natives' appreciation for large ornaments and shapes and their ability to produce them. Of course, ... the punitive expeditions have had an all-too-lasting effect. To replace the large traveling boats that were customary back then, only one new one was ever built. The other boats that still exist are smaller dugouts. ...
>
> Larger boats are ... as tall as a man, and thus, the dugout is essentially a tall keel, hewn on the exterior so that the multiple rows of carvel-built straight planks forming the hull give it an angular trapezoidal, not a round, shape. In addition, the dugout isn't sufficient to provide the bow and stern, which are attached as independent pieces (*bunbun*), unlike in the case of smaller boats. The uppermost planks of the hull are lined with wooden seats (*nbut*), which are kept in

place by a running lengthwise stringer (*darei*). Attached directly to them are loops of vines, in which the oars are placed and used in the European fashion. . . . The wooden transverse spars (*iet*), three or four in number, attach the outrigger to the hull at the center of the boat. Often the first and last of these—and occasionally all of them—extend through the boat to the exterior of the opposite gunwale, where they are kept at a constant distance by a pole (*kai*) mounted on the outside of the boat. The central *iet* often extends only to the interior of the gunwale. With a nine-meter ship, the distance to the approximately four-meter-long outrigger (*sjam*) is about two meters.

The *iet* are connected to the outrigger in a particular fashion. Four (or for the middle *iet* often only three) fifty-centimeter-long thin rods (*kiawei*) are tied together so that their sharpened points converge at one end. The pointed ends of two such bundles are positioned in the outrigger so that they cross one another. The upper end of the *iet* rests in the upper part of the resulting X, while a spar (*bulen*) emerging from the underside of the *iet* and stretching almost to the hull presses onto the lower part and acts like a buffer. Bindings secure the place where *iet* and *bulen* come together with the *kiawei*.

A narrow but sturdy rectangular platform of canes or sticks (*bedad*), on whose side a square frame is attached (*wa*), rests atop the *iet* . . . serving to reinforce the *iet*, to stabilize the platform, and to enlarge it, should the frame, too, be covered with staffs. That is the essence of the boat. For longer voyages or larger crews, a further platform (*balawa*) can be added, which can be mounted or removed at will. It consists of a frame covered with staffs whose narrow ends protrude on the inboard side. These protruding ends catch when the

movable platform is inserted, between the outside of the boat and the *iet*, so that they lie under the fixed platform and press against its underside.

This second platform rests outside the boat proper above the water, diagonally alongside the hull. Its interior borders on the fixed platform. This creates a large surface covering the entire center of the boat. The boat also possesses a second construction attached to the *iet* directly between the central groups of *kiawei*. The upper ends of the staffs that face one another, and sometimes all the staffs, are shortened and create a kind of box, whose walls consist of woven strands or further staffs. The box can be used to store equipment or temporarily accommodate a man. The only such ship still in existence on Luf has been lying for years in the boathouse because the few men on the island lack the strength to move it. Unfortunately, I only got a fleeting glimpse, but I could see that the bindings were extraordinarily well made, not just cut off at the surface of the planks. Instead, their free ends had been separated and twisted into knots. In addition, the boat was painted.

The entire body of the vessel has first been whitened with lime, with geometric, remarkably small figures painted thickly in red over the entire surface area. Because of a lack of time, it was not possible for me to get an explanation of such paintings. All the tiny circles, ellipses, etc. . . . represented animals or other objects. In particular, two adjacent circles of equal size seem to signify a bird, while trapezoid figures represent fish.

It only makes sense that this open-sea boat is bigger than the one for sailing the lagoon and that all of its wood has been worked and cut with extraordinary precision. The boat's decoration reflected the effort that had gone into

making it. This was true of both the paint and the carvings. . . . The decoration contained few or no figureheads; instead, there are lime-filled reliefs that bear a resemblance to them. On the upwardly curved ends of the bow and stern a piece of wood was vertically attached so that it towered steeply in the air. The motifs of the entire carved decoration were based on the phallus figure. The only other motif used was the spiral, for instance, on the free outside ends of the *iet*.

The equipment of the boat included the mast, oars, and bailers. . . . The steering paddle consists as a rule of a single piece of wood and has a pointed, lancet-shaped blade. The oars consist of shafts with round blades attached. As in Taui, the oars can be used not just for paddling but for rowing, in our sense. To this end, loops of vines are attached to the boat's railing, in which the oar shafts rest. Here, too, we see that rowing must have been known before Europeans arrived.

The boats may have one or two masts. Masts are mounted at an angle between the deck and the *iet* in a becket extending outboard around the free end of the *iet* and the *kai* and sometimes the railing. There are four ropes extending from the top of the mast, and a diagonal forked staff offers additional support. All masts end in a fork integrated into a point over which the halyard passes.

The rectangular mat sail is attached between two booms, the upper one with free, smooth ends, and the lower with an integrated fork, by means of which the boom slides along the mast. The position of the hoisted sail is the same as in Taui or Kaniet. With two masts, little changes in the operation of the sail. If the sail isn't needed, it's rolled up and stored on the platform of the *iet*. Finally, the bow and stern

of the fishing boat has a trapezoidal frame of sticks, in which the fisherman finds stable footing.[10]

That was how Thilenius described the boat in a 1902 lecture in Berlin about the remarkable art works on the Hermit Islands in general and on Luf in particular. It is entirely possible that Luschan was in the audience and spoke with Thilenius afterward. By way of introducing his topic, Thilenius had remarked that he could only describe what was left of the vessel's grand ornamentation due to the "vandalism of the punitive expeditions."[11]

## From Lapita Culture to the Luf Boat

During his three expeditions to the Pacific, the British explorer James Cook was baffled at how so many people had been able to spread out across remote islands. Yet before most Europeans had even asked themselves such questions, they had already begun sorting the islanders into groups based on external characteristics. Although the criteria were arbitrary, they at least divided up these peoples in a way that allowed an overview. The French naval officer and naturalist Jules Dumont d'Urville came up with one such classification system. Based on cultural-anthropological hypotheses, his distinction between Melanesia, Micronesia, and Polynesia remained in use for quite some time.[12]

Later, the idea of clear cultural and ethnic divisions was discredited. Melanesia was "at best a geographical territory," argued the archaeologist Patrick Kirch in 2010, one which explained "nothing about the origins of the people living there and their genetic relationship to other human groups." Today, following Kirch's fellow archaeologist Roger Green, we use the terms Near Oceania (including Papua New Guinea, the Bismarck Archipelago, and the Solomon Islands) and Remote Oceania (the islands farther

east). These two concepts designate geographical units, not peoples, tribes, or races, curly or straight hair, or any particular dominant skin pigmentation.[13]

How and when did people arrive on such remote islands? What were the origins of the Lufites who built such splendid boats? The Western Islands group of the Bismarck Archipelago, which includes Luf, is located close to the equator. Thanks to the winds and tides, Malayan and various Oceanic cultures encountered one another there for millennia. But as Thilenius stressed, without boats capable of sailing the open sea, there could be no exchange of people, experiences, knowledge, and handicrafts.[14] In Thilenius's day, scholars compared languages to trace older migrations, intermixtures of different human groups, and the cultural transformations they brought about. Modern scholarly methods have confirmed and refined some, if not all, of these early ethnologists' hypotheses.

These hypotheses include the speculations about maritime travel by Thilenius and, somewhat later, by his more geographically and linguistically oriented colleague Georg Friederici. As limited as the conclusions we may draw from this are, they are nonetheless central to our understanding of the history and significance of the Luf Boat. Although this magnificent vessel, now on display in Berlin, may have been built only 130 years ago, it exemplifies a type of boat that must have existed for millennia. Ben Finney, professor of anthropology at the University of Hawaii, contended that "the development of the sailing vessel was one of the most important inventions in human history." Finney was explicitly referring to early sea voyages in the Pacific, not ancient Mediterranean and pre-Columbian ocean travel. Finney also asked how the Polynesian and other Pacific islands could have been settled using wooden outriggers, thousands of years before Europeans first sailed in these waters.

Finney posed these questions amidst a scholarly controversy in the 1950s. Archaeologists, ethnologists, and linguists hotly debated the question of the nautical skills of the original Pacific islanders. Was the early human penetration of the Pacific the result of planned colonization or of accidents, such as boats and rafts being driven off course by wind and ocean currents?

The debate commenced with a remark by the Norwegian researcher Thor Heyerdahl, who achieved international fame in 1947 by undertaking a 7,000-kilometer voyage from Lima, Peru, to Polynesia on a three-masted raft made of freshly cut balsa wood, the *Kon-Tiki*. The trip was an experiment intended to prove that the ancestors of the Polynesian islanders could have made the same journey, with the trade winds at their backs. Heyerdahl built his raft exclusively using materials and techniques that existed at the time among the people of the Peruvian coast. The basic hypothesis of this experiment rested on an analysis of the prevailing winds and sea currents. Because of the constant easterly direction of the trade winds, Heyerdahl believed it was impossible for Polynesia to have been settled from the Asian mainland, in the opposite direction.

In 1975, Finney countered that thesis with an experiment of his own, launching a twin-hull boat that he had had built. Coincidentally or not, it had the same dimensions (19 × 5.5 meters) as the Samoan war catamaran that Luschan had so desperately tried to acquire between 1901 and 1910 (see Chapter 8). Finney christened his replica *Hōkūlea*, and with it he proved that Polynesians could have sailed over great distances against the trade winds. "They are extremely seaworthy craft, in the sense that their slim hulls cut through rough seas with a minimum of pitching and rolling," he wrote. "They sail well, running before the wind, reaching with a beam wind (sailing approximately 90° off the wind), and can beat

to windward (sailing less than 90° off the wind) to a limited though significant extent."[15]

The boats and the outriggers common on Luf thus would have had no problem sailing upwind, though they would not have been able to attain speeds close to those of modern craft, and some of them probably sank in the attempt to reach new islands. Finney's experiment undermined the thesis that this part of the Pacific was settled accidentally: "Setting sail against the wind, or at least against the direction of the prevailing winds, requires intentional choice."[16] Yet Heyerdahl's assumption that the islands had been settled from the east wasn't completely disproven. It is entirely possible that people came to the Pacific islands from various directions and in different sorts of boats.[17]

Georg Friederici had already reached conclusions similar to Finney's in 1914. On the basis of linguistic studies of the migration of peoples, he speculated that populations from the region of Indochina had migrated to the South Seas "in the main slowly and gradually, not as the result of some catastrophe." Friederici assumed that the prevailing "southeasterly trade winds" wouldn't have kept "the bold seafarers of prehistoric times" from traveling east. During his expeditions to eastern Polynesia, the Indigenous people repeatedly assured him, "We prefer to sail against the prevailing winds so that if something happens on the voyage, we can make it back home." Friederici surmised that the large, open-sea boats were of Malaysian-Polynesian origin, and he assumed that the captains were trained in "maritime schools." He also described large two-masted outriggers very reminiscent of the boat from the island of Luf, which is located between Malaysia and Polynesia.[18]

Since the 1980s, genetics, computer simulations, and increasingly sophisticated chemical and physical dating techniques have

greatly enriched our knowledge of prehistoric times. But the questions have remained the same. Who were the seafarers who around four thousand years ago began to conquer the Pacific and who today are described as members of the Lapita culture? Although the debate continues, there is agreement on several major points. The traces of these early pioneers lead from Polynesia to the South Seas—and the Bismarck Archipelago.

In the Pleistocene Era, the geography of the South Seas was dominated by two land masses, Sunda and Sahul. Sahul corresponds to present-day Australia and New Guinea. Sunda corresponds to the Indochinese Peninsula, including today's Indonesian islands, which at that time were still connected to the landmass and thus to one another. It wasn't until the last ice age, some 12,000 years ago, that rising ocean levels separated the islands. But even before that, there was likely no land bridge between Sunda and Sahul, although there were islands between today's Borneo and Australia in a region known as Wallacea.

Most of the people who settled Sahul / Australia from 40,000 to 60,000 years ago must have been capable of crossing the water between the land masses. Patrick Kirch considers this migration the earliest example of intentional sea travel in human history: "Herein lies one of the most exciting and intriguing aspects of Pacific prehistory: we are likely dealing with the earliest purposive voyaging in the history of humankind." James O'Connell, an American anthropologist, and Jim Allen, an Australian archaeologist, describe the migration that marked the start of human history in the South Seas as a "deliberate" act of colonization: "Migration was provoked by demographic pressure on Sunda and facilitated by the relatively favourable climatic and environmental conditions."[19]

The earliest inhabitants of the South Seas exploited the short distances between islands to spread out across the Bismarck

Archipelago in the 25,000 years that followed. The area between the islands of Southeast Asia, the coast of New Guinea, and the Bismarck Archipelago became something of a "voyaging nursery," to use a phrase of the New Zealand archaeologist Geoffrey Irwin.[20] This was an idea that had also occurred to Friederici.

An important aspect of human expansion in Polynesia was a later migration of people in the Bismarck Archipelago. To the best of our knowledge, cultural and genetic exchange with a new migrant group that had arrived from the island of Taiwan began around 3,500 years ago. Archaeologically, this period is characterized by simple clay pots with various types of ornamentation that were presumably made outside over an open fire. Particularly interesting is that the forms and ornaments of these clay vessels remain the same in remnants discovered hundreds of kilometers apart, all over the Pacific.[21] This culture has been named Lapita after the island in New Caledonia where the first site was discovered. It soon emerged that there are an impressive number of linguistic and genetic commonalities in the gigantic cultural realm circumscribed by these ceramic artifacts.

Whereas older research assumed that people of the Lapita culture suddenly invaded the independent population of the South Seas, conventional wisdom soon began to hold that a cultural and biological exchange had taken place. Green proposed a "triple i" model to better understand the development of Lapita culture: "intrusion—innovation—integration."[22]

Even before the arrival of Lapita culture, complex social networks existed between members of the Papuan cultural complex, as researchers have been able to show on the basis of stone and obsidian tools. Scholars concluded that the already extensive connections within this massive island territory later significantly helped the Lapita culture to spread so quickly. A recent research project of the Max Planck Society that combined genetics and

linguistics demonstrated how close relations were between the Lapita Austronesians and Papua.[23]

The oldest archaeological site in the Bismarck Archipelago that is relevant to this cultural context dates back to around 1500 BCE. The easterly sites on Samoa and Tonga are approximately three hundred years more recent. That suggests that Lapita culture spread over an area 4,000 kilometers in diameter in only fifteen to twenty-five generations.[24] The expansion was accomplished by settlers used their *waga*, or sea-faring canoes.

To the best of my knowledge, there are no European descriptions of the Luf Boat sailing against the wind, but a similar boat was depicted as doing precisely that by the physician Otto Schellong. Schellong lived for several years in the German South Seas colony and observed around 1887 that "marvelous boats" were built in the Tami Islands.[25] Lying off the northeastern coast of New Guinea, these islands are around 500 kilometers from the Hermit Islands. A delighted Schellong was allowed to take a trip aboard a two-master, and he was full of admiration for its easy handling and its "ornamented and brightly painted planks." The crew consisted of seven men, who could "make the vessel go forward or backward by simply adjusting the sails," tacking into the wind without difficulty. Concerning the production of the large settee sails, Schellong wrote, "Four men work on a sail. Their weaving went quickly. Using a rope, a square frame was stretched upon the ground, each of whose corners was secured by a peg. The material was broad swathes of pandanus leaf (*mē*)."

The christening of the boats described by Schellong on Tami was likely conducted more or less the same way on Luf: "The completion of a new canoe is a festive occasion, during which members of related tribes in neighboring villages are given food and drink. The finished boat is put on display in a storage hall. The completion of a sail is also celebrated. It is spread out on the

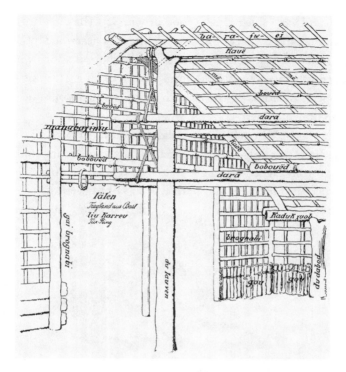

The beam work of the Luf boathouse, rebuilt after 1883 and
still fully intact in 1906.

ground and covered with fresh foliage." (The ethnologist Bronisław
Malinowski would later describe boatbuilding on the Trobriand
Islands in similar terms.)[26]

The square sails used on the Tami Islands resemble the ones
on the Luf Boat. Likewise, the construction of the vessels is sim-
ilar. Two-masted outriggers did not have a bow and stern, but
rather two identical ends. The double ends of the vessel's body al-
lowed it to easily change direction and sail against the trade
winds. The bow became the stern, and vice versa. Seafarers sailed
this sort of craft at a specific angle to the wind, changed direction

often, and were able to make good progress.[27] The intricate orna-
mentation and boat-completion celebrations described by Schel-
long in 1887 attest to how dependent island populations were on
these invaluable vessels. And it was correspondingly terrible when
European intruders destroyed such crucial elements of South Seas
island life. Such destruction was a lasting and often intentionally
deadly way of "disciplining" the islanders. The Luf Boat on display
in Berlin is not only the final remaining example of its kind. It is
the last fully rigged outrigger that gives a genuine impression of
how people, for millennia, were able to sail to even the most re-
mote South Seas islands.

# Islands Stripped Bare

Max Thiel was lucky enough to constantly be offered good business deals. But he also knew how to make useful connections and secure societal esteem with generous gifts. In Wilhelmine Germany, such esteem could be achieved by means of medals and titles, and Thiel's donations to the museums of ethnology in Berlin, Stuttgart, Dresden, and Oslo ensured that he got what he desired.[1] He was hardly alone. It was established practice in both the colonies and the homeland for German officials, merchants, and military men to "exchange ethnographic material for royal medals."[2] One example is the strategy Felix von Luschan pursued in 1906 to raise money for the transport of the Samoan war catamaran he coveted. Although he was ultimately unsuccessful, his plan was to win over "some wealthy man" to cover the costs in return for "some honor or another."[3]

In return for generous donations to the ethnological museum in Oslo, Thiel was named Norwegian consul in 1907. Six years later, the Norwegian government awarded him the Knight's Cross First Class of the Royal Order of St. Olav. In 1910, similar largesse brought him the Royal Saxon Medal of Albrecht with Knight's Cross First Class in Dresden.

On January 25, 1909, Kaiser Wilhelm II awarded the well-known looter of art and destroyer of culture the Red Eagle

Schnitzereien, etwa ¼ nat. Gr.

1 Kopfbank            5 + 10 Bootverzierung        9 Ölgefäß            17—18 Schnitzereien.
2 Hauspfosten        6 Obsidianaxt               11 + 12 Wasserflaschen
3 Windfahne          7 Rattenbrett               13—15 Löffel
4 Tanzfigur          8 Kalebasse                 16 Schwimmer

Verlag Friederichsen, de Gruyter & Co. m. b. H., Hamburg.

For years Hans Nevermann was the director of the South Seas
Department of the Berlin Museum of Ethnology. This 1934 illustration
displays the treasures of his collection from the Admiralty Islands.
The merchants, missionaries, officials, and soldiers who collected them
spoke of "native curiosities."

Medal Fourth Class for his "social and societal importance" and the "significance of the trading company he represented in the South Seas." Thiel was lauded for having shown the Ethnology Museum of Berlin "his lively interest for many years and contributed to it by donating valuable ethnological collections from the South Seas." The total value of these gifts was put at 10,000 marks. They included "large painted carvings from New Ireland" (New Mecklenburg), a "valuable collection of 20 so-called skull masks," and the "loveliest slit drum known thus far" from the Admiralty Islands.

Thiel was directly involved in the acts of violence and subsequent looting of works of art in this group of islands. Often, together with his uncle Eduard Hernsheim, he had prompted them. The laudation indirectly referred to this aspect of his activities. He was praised for his "contributions to the development of the protectorate," his "patriotic mindset," and his constant advocacy of "the interests of the protectorate of New Guinea"—those were the words chosen by the state secretary of the Reich Colonial Office, Bernhard Dernburg.[4] Thiel never succeeded, despite his largesse, in acquiring a commensurate accolade from the emperor of Austria-Hungary. But the Vienna Museum of Natural History still possesses eleven skulls from the Kaniet Islands labeled as "gift of Max Thiel, Matupi."[5] Thiel also gave gifts to the Museum of Ethnology in Hamburg, "primarily of masks and skulls from New Pomerania," along with hundreds of items from his private South Seas collection.[6]

## A Papuan Skull for Four Marks

To understand why people would collect skulls, we need to recall that during the time in question, the new disciplines of ethnology, anthropology, human genetics or eugenics, and comparative race

studies weren't clearly distinguished. Men like Luschan, Otto Dempwolff, Augustin Krämer, and many others saw themselves not just as ethnologists but also as full-fledged anthropologists.

In acquiring "found" items for European anthropological-ethnological collections of skeletons, Thiel "injured the most sensitive religious feelings of the natives."[7] This behavior led, for example, to the death of Otto Reimers—the head of the Hernsheim base on the island of Aua, near the Hermit Islands. In 1903, Reimers had systematically robbed island graves to satisfy the insatiable demand of German museums. According to the report by Governor Albert Hahl, Reimers had committed acts of sacrilege to "procure valuable wares for trading"—human skulls and burial objects.[8]

Hahl and the imperial judge in the region subsequently banned "digging up skulls" because it "unnecessarily agitated the natives." The most important supplier of skulls to the Berlin Ethnological Museum, Richard Parkinson, described this measure in a letter to Luschan as the "pretense" and "nonsense" of an "unhappy stickler for the law" who had no clue about the region and its people: "Otherwise he would know that the natives don't care about the skulls of their dead but, on the contrary, are only too happy if Papa and Mama can raise a small sum of money after their deaths." Parkinson ignored the new prohibition and mocked the fines for being unenforceable. He immediately shipped Luschan a crate with ninety skulls of "natives of the Gazelle Peninsula [New Guinea]," acquired for four marks apiece.[9] Luschan, too, knowingly broke the law and ordered his doctoral student Wilhelm Müller to scientifically process the freshly arrived human remains.

In his 1905 dissertation, "Contributions to the Craniology of the New Britons," Müller wrote that Parkinson had delivered "three sets of well-formed skulls." Müller proudly stressed that the Berlin

museum possessed "the largest unified collection" of skulls that had ever "made their way from Melanesia to Europe." By 1905, Parkinson had sent around 350 skulls from the South Seas to German collections. The "large sets" of comparable examples formed the core of all the research done in craniology, Müller claimed, and allegedly provided the only possible basis for achieving valid results. He was largely correct. While Luschan gladly received individual skulls, they were only "building blocks that can first give us a true and solid basis together with thousands of others."[10] Today, scientists at places like the Max Planck Institute for Evolutionary Anthropology in Leipzig examine museums for these sorts of skulls as representative samples, from which they extract DNA for archaeogenetic research. The best preserved human DNA is usually contained in the petrous bone—the hardest bone in the skull—or in teeth.

Despite the official prohibition, profiteers constantly dug up skulls and whole skeletons and shipped them back to Germany during the entire Hamburg South Seas expedition of 1908–1909.[11] The anthropologist Otto Reche, who had traveled along with the expedition for this express purpose, later became one of the leading race researchers and propagandists of Nazi Germany. Along with skulls, Parkinson also supplied numerous museums with ethnological items. In January 1900, for instance, a crate he sent arrived at the Vienna Museum of Natural History. It contained ninety-one carvings and tools.

Thiel carried out his business in far grander style. In 1903 and 1904, he and Eduard Hernsheim sold "cultural treasures unique in the world" collected by Franz Hellwig at their behest. In the spring of 1904, acting as his son's agent, Thiel's father Friedrich, who ran a bookstore in Berlin's Charlottenburg district, sold the Vienna Natural History Museum various "especially lovely pieces." At the time, this museum held ethnological collections with artifacts

from "savages" and "primitives"—in other words "peoples of nature."[12]

Part of the loot that Thiel and Hernsheim had taken from the South Seas was sold for 20,000 marks and ended up in the Museum of Ethnology in Hamburg.[13] At around the same time, these two men were delivering the Luf Boat to Berlin.

## Fear, Revenge, and Science

Despite their brazen displays of arrogance and demonstrations of superiority, the European intruders upon the South Seas lived in constant dread. They were only too aware of what they were doing, and as a result they feared resistance from the islanders whom they had subjugated and robbed, both materially and culturally. Heavily armed, they were always on their guard. They must have felt as though they had their backs to wall, as one example among many shows.

On August 13, 1904, not far from Matupi and the town of Herbertshöhe (Kokopo), in the region inhabited by the Baining people, five nuns, three monks, and two priests at the St. Paul missionary station were murdered. The victims had tried to radically re-educate the natives and form a colony of model "Christian villages," seeking to eradicate the "primitives'" ancestor worship and their unruly sexual life—unruly by Catholic standards, that is. Using a catalogue of punishments, the missionary invaders began to literally beat the "heathen" customs out of people. And it goes without saying that they constantly threatened the subjects of their missionizing with the worst that Hell could mete out.

The anti-missionary rebellion was led by a man named To Mari(a), who was considered a shining example of Christian conversion. He was alleged to have yelled during his carefully

planned attack that he refused to tolerate "any missionary, any brother or any sister" above him anymore, proclaiming himself "the king of Baining."[14] The rebels were clearly inspired by their desire for self-determination and cultural autonomy in the face of Christian re-education.

It is striking how disturbed the otherwise cocky Thiel was by the killings. He wrote to Heinrich Schnee, the former deputy governor who had just been recalled to Germany, "We have all recovered from our agitation over the Baining affair. We know how unfounded the fears of a general rebellion are, as trumpeted by the Australian newspapers. Nonetheless, the feeling that one could be horribly slaughtered out of personal revenge by one's own servants is not exactly pleasant, particularly for ladies who, like my sister, live on a remote island. And the prospect of punishment and bloody penitence do nothing to lessen it."[15] Thiel's sister Charlotte was married to the Hernsheim base manager August Frings, who ran a coconut plantation on the island of Nusa.[16]

The swiftly launched punitive expedition went on for two months, and those who took part in the murderous revenge received a battle clasp with the words "Suppression of the Baining Rebellion."[17] Numerous island men were rounded up and taken to Herbertshöhe to be court-martialed. The legal proceedings ended with six death sentences, which were carried out on the spot. After their execution, these men would "at least be of service to science," as the government physician Wilhelm Wendland put it in his memoirs. He told of having "the heads of the executed men severed" immediately. He then sent two of the "freshly preserved heads," well packed and placed in alcohol, to the anatomist Eugen Fischer at the University of Freiburg. Fischer, a specialist in comparative race studies, had previously requested that the Colonial Office

"have government physicians in the protectorates send him heads of natives, preserved in spirits, for study."[18]

After Fischer received the delivery he had requested, he examined the soft facial tissue of the executed men in line with the ideas of comparative race studies, presenting the results to his colleagues in August 1905. He introduced his lecture this way: "I would like here to again express my gratitude that I was able, through the great solicitude of Mr. Hahl, the imperial governor of German New Guinea, to come into possession of two Papuan heads, which were immediately preserved in alcohol and formaldehyde after the execution of two middle-aged men from New Guinea (Baining people)."

His scientific examination, Fischer told his colleagues, had revealed that the cheek muscles of the two Papuans were the same as those "found as a rule in prosimians and certain apes." Fischer would later become a pioneer and perpetrator of Nazi biological policies. He was already espousing this pseudoscientific racism in his lecture concerning the two executed New Guineans: "As a whole, there is such a concentration of primitive traits that we can correctly assume that chance has not delivered up two particularly primitive individuals for examination, but that examination of these two individuals shows that the race they belong to is a primitive one." Despite Fischer's hasty generalizations, he emphasized the need for more detailed research. (Scholars have a natural interest in intellectual and above all material support and thus tend not to achieve their final results too quickly.) Fischer then asked his listeners to ensure that "not only the skulls of the rapidly disappearing primitive races fill the collection shelves but that soft tissues also be examined and processed in light of race studies, before it's too late."[19] Like the ethnological collectors, Fischer believed that the peoples who had been subjugated and declared "primitive" by Europeans would "go extinct" or "disappear."

## Cultivate, Profit, Exterminate

With so-called disciplinary measures and punitive expeditions, Germans destroyed the means of subsistence of hundreds of thousands of men, women, and children in their African and Oceanic colonies. Another major element of German policies of violence was forced labor. Since the 1870s, the German Trading and Plantation Society (DHPG) had been doing business in the South Seas. It had captured thousands of people, often from distant islands, to work in its palm plantations on New Guinea to produce copra for export.

In 1904, Thiel complained that it had become very difficult to replenish his "labor stocks" because "in addition to the increasing rarity of influxes of whole villages, individual young men can seldom be recruited."[20] The historian Jakob Anderhandt has determined that the few men who returned to Luf after serving as forced laborers "had suffered severe damage to their health as a result of their work on the DHPG plantations on Samoa."[21]

Heinrich Rudolph Wahlen, who worked for the Hernsheim company from 1895 to 1902 and subsequently became an independent tyrant exploiting people in the Western Islands, recalled in 1952, "Quite a lot of natives, who had been in Samoa, suffered from elephantiasis and other infectious illnesses in the Hermits." His response was to acquire "stronger natives from New Britain and Buka" to do the "heavy work" in the new plantations he established.[22]

Writing of the Nuguria Islands (also known as the Abgarris or Fead Islands), the travel writer Johannes Wilda described how the populations of whole island groups were exterminated as part of the colonial process: "The water in the atoll is still and green. Characteristic, if not pleasant to behold, were the many barren trees on many of the islands. They were intentionally destroyed

by fire, so that they would die away to provide cultivated palm trees with more sunlight and space. The atoll used to be heavily populated. Now the population has shrunk, and almost all of the remaining people have syphilis." European men had infected the Indigenous women, often as a result of rape, with this previously unknown, deadly disease.

To reconcile their indirectly genocidal actions with their Christian conscience and the idea of universal human rights that was increasingly popular in Europe, European scholars developed theories explaining why it was acceptable to exterminate the "primitive, primeval" populations. Among them were racial theories that divided humanity into superior and inferior groups and turned justice on its head.

The colonial subjugation of South Seas islanders was aimed at encouraging modern modes of production, economic exploitation, and profit. As Wilda was told during his conversations with German merchants, plantation managers, and missionaries, it was forbidden to kill islanders without reason, although reasons could be easily invented. Economic motivations were the primary rationale for the punitive expeditions, kidnappings, and burning of forests and villages. The colonists were constantly telling themselves not to "lapse into sentimentality," since "a people unwilling to work loses its right to land according to the standards valid today all over the world."[23] What was really meant by "right to land," though, was "right to live."

The men who ran German museums knew all too well about the atrocities that were going on. Many had themselves been navy doctors (Dempwolff, Krämer, and Thilenius) or merchants (Finsch, Parkinson, and Hellwig) and had personally taken part in the military and economic destruction of the region. That was the reason behind the urgency with which they went about their

tasks. If their museums were to be filled with ethnographic objects, it would have to be soon, before everything was destroyed.

## "Seize the Chance Immediately"

To take one typical example: As early as 1883, the director of the Royal Ethnographic Museum in Dresden, Privy Councilor Adolf Bernhard Meyer, sent assistance to the crews of German naval vessels to help collect cultural artifacts from remote parts of the world, while urging them to act with maximum swiftness. "The danger exists that the destruction of the original population will suddenly deny us the opportunity to attract new customers," he wrote (by "customers," he meant museums interested in ethnographic items). In light of the fact that "tribes of the earth are in the process of going extinct," it was advisable to "procure" ethnographically interesting objects "as quickly and voluminously as possible."

While the objects in question were being collected hastily and with the help of members of the military, who knew nothing about ethnography, Meyer issued urgent instructions to label the plundered goods as precisely as possible. He also demanded that functionally identical objects be collected from various places, for one, so that they could be compared, and, for another, because they would be "particularly beneficial to collections." Meyer took a relaxed attitude toward the issue of payment. "In general, any price may be paid (in the form of either cash or barter) since the natives don't put excessively high price tags on objects based on their intrinsic value or the time and effort spent on them." Meyer reiterated his interest in "human skulls" and "complete skeletons" ("highly desired"), be they from "individuals who have just died or from graves."

Meyer highlighted the Hermit Islands among other places in the South Seas as "insufficiently known territories" that could be "made useful to science" quickly and with the help of German warships. He then drew up a wish list that extended from images of gods, decorated skulls, musical instruments, "entire boats," and spears and shields, to masks and carved house pillars.[24]

Luschan also saw his pursuits "endangered" by European civilization in the form of "the current plantation economy with foreign workers brought in from the outside." He considered the gold discovered on various islands as "particularly pernicious" because it would attract "rabble from all parts of the world." "In only a few years," he lamented in 1888, "all the unique developments that came about over the stretch of millennia will be destroyed and irrevocably lost." He concluded: "The upshot—seize the chance immediately."[25]

In 1904, Krämer wrote to Luschan, his friend and colleague, about the long-planned extension of the Ethnological Museum: "[Ethnology] is concerned with peoples of nature who have no historical documents or written language, who have already gone extinct (prehistory) or are living representatives of prehistory: natural peoples who have given themselves up to their own demise." He put all the peoples of Oceania in this category. More generally, Krämer considered the collection of artifacts among "peoples of nature" to be largely over, which meant that the space needed for this part of the museum in the future was "definitively" set. As a result, the amount of room needed for areas like "Eskimos," "people of the steppes," and the aboriginal populations of Africa, Australia, and Indonesia could be calculated with "near mathematical certainty."[26]

Like most Europeans who had spent time in the German colonies, Krämer held the "demise of the peoples of nature" to be inevitable—whether as a result of "extinction" or "civilization." It

was thus urgent to preserve the cultural treasures of these pur-
portedly uncivilized people. In 1904, in the final sentences of an
essay written after consulting with Luschan about the extension
of the Berlin Ethnological Museum, he pleaded with Prussian po-
litical representatives and budget-setters to approve additional
funds for a long planned "Museum of Peoples of Nature": "The
greatest haste is needed . . . because the final remnants of the
natural peoples are disappearing before our eyes. . . . Our descen-
dants will judge us harshly if we do not take full advantage of this
final hour."[27]

# 12

## *Where Does the Luf Boat Belong?*

Even if it may not always seem to be the case, I have no intention in this book of issuing a blanket condemnation of museum curators. A positive example of how to deal with troubled legacies from the past was provided over three decades ago by Waldemar Stöhr, a scholar and researcher at Cologne's Rautenstrauch-Joest Museum. In 1987, Stöhr wrote the description for his institution's Clausmeyer Collection, which includes a 1.42-meter-tall religious statue from Luf Island. Stöhr noted that this object had been taken by a navy lieutenant named Henning von Holtzendorff, a crew member aboard the *Carola*, during a "punitive raid that had devasting effects on the population" in 1882–1883. Stöhr also wrote of a "senseless blow" from which "the population never recovered."[1]

There is no such forthright clarity from today's Humboldt Forum, even though its namesakes, Wilhelm and Alexander von Humboldt, felt honor bound to constantly expand the wisdom of humanity. The colonial ethnographers, curiosity hunters, merchants in stolen goods, adventurers, and soldiers who, heavily armed and sometimes backed by warships, overran foreign lands in the 1880s were nothing like well-traveled Alexander von Humboldt from the previous century, who had been hungry for knowledge. He explored worlds that had yet to be visited by Eu-

ropeans, unarmed and accompanied by a single companion, following this maxim: "The main thing is the interaction of forces, the influence of inanimate creation on the lively world of fauna and flora." "I should never lose sight of this harmony," he reminded himself.

When applied to ethnology, the world of human beings was added to this maxim. As a matter of course, Humboldt repeatedly asked questions of Indigenous people and recorded what they told him about their lives. In his book about Mexico, he described the culture of the inhabitants and how it had evolved from their dependence on the conditions of their natural environment. In Peru, he devoted his attention to the culture and language of the Incas.

The curators of the current ethnological attraction in Berlin display ignorance toward Humboldt's methodology of observation, collection, and investigation of deeper contexts. The exhibition in the Humboldt Forum has nothing to say philosophically, scientifically, or historically. In the cold concrete mausoleum where the splendid Luf Boat is interred, visitors learn next to nothing about how the vessel functioned, how sophisticated its construction is, what its ornamentation means, how the caulk was produced, how its builders lived, what nautical skills they possessed, or how, for millennia, they were able to sail hundreds of miles upwind across the South Seas. The oared ships of the Phoenicians, Ancient Greeks, and Vikings, with their single, large square sails, seem crude in comparison. The Luf Boat should by all rights be recognized as part of the world's cultural history.

As of this writing, visitors to the Humboldt Forum are told nothing about the German colonial world or the larceny of the Hernsheim trading company and its co-owner Max Thiel. Instead, when visitors enter the building where the Luf Boat is displayed, the curators direct their attention to the misdeeds of others.

Xelau, one of the final living builders of the Luf Boat, in 1906.
Together with Nemin and Sini, he provided Augustin Krämer
with information about the meaning of the ornaments and the
names for the individual components of the last large outrigger.

A plaque in grammatically incorrect German informs them that
from 1948 to 1958, the United States carried out atomic weapons
tests in the Marshall Islands and that Australia maintained, and
de facto still maintains, a refugee camp on the island of Manus,
which human rights organizations have criticized as inhumane. No

mention is made of the crimes of German colonialism. Manus and the Marshall Islands were the sites of brutal colonial expeditions.

## Tight-Lipped Institutions

The approximately 65,000 South Seas objects in Berlin museums are the final artifacts of an ancient culture. Most of them were brought to what was then the capital of the colonialist Wilhelmine Empire between 1880 and 1914. In view of this history, the former royal ethnological collection, now the property of the Prussian Cultural Heritage Foundation, must be considered a monument of shame.

Every one of these items carries the legitimate suspicion of having been acquired at an unfair price or with deceit and violence by hunters, collectors, and traders of ethnographic valuables. Berlin might be tempted just to get rid of the collection. On the other hand, this shameful legacy of colonialism consists of marvelous achievements, like the Luf Boat. The tension between these two facts needs to be recognized. For that reason, we should ask and debate questions concerning origin, culture, and artisanship, the problem of colonial appropriation, and the proper location for such artifacts.

European collectors and colonial marauders felt no pangs of conscience. On the contrary, convinced that they were acting justly, they proudly recounted their misdeeds in journals, travelogues, and memoirs—and not just in Germany. In general, European destroyers of foreign cultures saw themselves as bringers of civilization, humanity, and enlightenment, as well as economic and technological progress. Newspapers and journals were happy to publish extensive, detailed reports about the punitive expeditions.

By contrast, today's owner of these looted treasures, the Prussian Cultural Heritage Foundation, is much tighter lipped. Although

the representatives of the body that holds this trove of cultural marvels are less apt than before to conceal their guilty consciences, they nonetheless refuse to make all existing data about dubiously acquired objects from the colonial era accessible to the general public without restriction. They also still use innocuous words like "expedition" in conjunction with the acquisition of their holdings, such as those from the small island of Pak, which was attacked by the crew of the *Seagull*. Even following the whitewashing jargon of the time, the description for such an item should include the term "punitive." A more precise description would be a murderous, larcenous raid or attack. The records also make no mention of the *Seagull*.

## "Source Communities" and "Translocation"

In 2019, the chair of the foundation, State Minister Monika Grütters, justified the policy of keeping the public at arm's length with a series of offhand excuses, including vague assertions about possible inventory mistakes, and a reference to "especially sensitive objects, about which the source communities do not want information to be made available without restriction."[2]

Where did she get this idea? Why do official statements always talk about "source communities"? What does that nebulous concept even mean? On the one hand, it could reflect a laudable attempt to find an alternative to loaded terms like "aborigines," "natives," "islanders," or "tribes." On the other hand, though, since the original source communities no longer exist, the use of the term renders the issue of responsibility toward descendants of the people in question reassuringly moot. European invaders subjected source communities to ruthless foreign domination and denied them any chance of influencing ongoing economic, social, and ethical disruptions. Members of these peoples were treated as objects of

the European-dominated epoch that opened up the world. The conquerors, colonists, and modernizers destroyed these peoples' ancient, highly sophisticated cultures. Nonetheless, there remain some descendants of the people who once inhabited German New Guinea. Today, they live primarily in the nation of Papua New Guinea.

There is no way of making restitution to the source community in the Hermit Islands. Precolonial societies have been replaced by nation-states created under colonial conditions and in anticolonial wars. Questions of restitution, conservatorship, and the sharing of the treasures in European museums have been explored with the representatives of those states and the region in which they're located. This will be a complicated undertaking, sometimes painful, sometimes liberating.

To improve the basis for those conversations, the original registries, inventories, and correspondence need to be published without delay. Quite often, a single look at these documents reveals which objects were seized when, where, and by whom, and how they were sold by unscrupulous merchants, palmed off by collectors, swapped, stolen, or in rare exceptions, fairly acquired. Those involved included navy seamen and officers, adventurers, and dozens of more or less unsavory South Seas traders and hired looters. The missionaries and state officials, who were also attracted to what they could take back home and profitably sell, lent a sheen of legality to their constant plundering. Take, for example, the avid collector and Methodist evangelical missionary Heinrich Fellmann, who was stationed in the Bismarck Archipelago and who delivered lectures in Stuttgart in 1903 that were full of prejudice. According to a printed summary of one of his talks, Fellmann "described character traits of these highly splintered tribes as thoroughly negative: laziness, mendacity, greed, and thievishness predominate."[3]

Today's responsible museum curators indicate, at least, the racist, colonial, and criminal contamination that pervades their collections. Many use tortured language, however, speaking of "sensitive," "difficult," and "controversial" legacies. Occasionally some will admit to "coercive acquisition" and acknowledge the need to "explore" solutions "multivalently," "reflexively and critically," and of course "cooperatively."[4]

Such nebulous terminology notwithstanding, the museums' underlying interest is in retaining ownership of collections regardless of how they were originally acquired. To this end, in the summer of 2019, Hermann Parzinger, president of the Prussian Cultural Heritage Foundation, tried—with very modest success—to defend himself by going on the offensive. "The restitution [of cultural artifacts] to their countries of origin," he proclaimed, was "far too little." He understood his own function as being the head of an institution that, "thanks to a fully new role," has become a "player in foreign cultural and academic policy," adding, "and that is about far more than restitutions alone."[5] But Parzinger's slick self-reassurance and half-truths won't hold up for long.

For several years, with relatively little fanfare, ethnological museums have been deaccessioning and returning human remains such as decorated skulls. Museum presidents, directors, and communications specialists try to depict this as an act of restitution—a demonstration of respect that reflects anticolonial due diligence and awareness of the problematic nature of their collections. For instance, on October 12, 2020, the Prussian Cultural Heritage Foundation "repatriated" to New Zealand two tattooed skulls that had been added to the Berlin Ethnological Museum's collection in 1879 and 1905. During the ceremony marking the occasion, Parzinger said in the presence of New Zealand's ambassador to

Germany, "We are always learning new things from our provenance research ... and we will do everything in our power and continue down this path." State Minister Grütters hastened to add, "The restitution of human remains has the highest priority in the investigation of the objects of colonial collections."[6] Public ceremonies in which human skulls are returned are one way that curators, officials, and politicians divert attention from the question of who legitimately owns the wonderful works of art and everyday items from distant lands and cultures that make up European collections.

The hypocrisy is all too evident in an official statement released at the 2019 annual conference of the directors of ethnographic museums in German-speaking countries, which was held in Heidelberg. The statement was an attempt by museum directors to find refuge from the problem of the long-term disposition of all the looted items in their possession. They briefly touched upon the issue of "ethical responsibility" toward the source communities—not, it should be noted, nations existing today. But the statement is quick to clarify: "Above all, however, our museums preserve cultural heritage from highly differentiated contexts of acquisition and collecting and, therefore, represent much more than colonial heritage. Thus, it is equally evident that the relations which have been entered into during the acquisition of the objects oblige us to [do] much more than merely return objects."[7] This is a complicated way of coldly refusing serious discussion of the return of major objects.

The Heidelberg Statement raises several issues. First, its authors fail to specify what the "much more" to which they feel an obligation actually entails. Second, it is worth asking whether the encouragement earlier curators provided for the looting of cultural artifacts should be whitewashed by using the innocuous-sounding

phrase "acquisition of objects." Third, the statement doesn't define what it means by "highly differentiated contexts of acquisition and collecting." There are obviously big differences between purchasing items in return for glass beads and tobacco, taking away belongings that had been "abandoned," hiring professional thieves and fences, and using raw violence. But all these "contexts" remain reprehensible, no matter how "highly differentiated" they may appear in the eyes of today's museum directors.

The Heidelberg Statement is entitled "Decolonising requires dialogue, expertise, and support." The underlying message of the document could be fairly paraphrased as: Let's talk. We're experts. And until we get more money and positions, we can't do anything about it anyway.

Notwithstanding the statement, it must be suspected that all items in all collections from the former German colonies were acquired illegally—by violence or in an ethically questionable manner. Given the relations of power and domination in the colonial era, the burden of proof should rest on those currently in possession of such objects.[8] They should have to disprove the reasonable assumption that their collections were acquired by means of abuse of power, threats, punitive expeditions, dishonest dealing, and the exploitation of desperate people with no alternatives. Today's possessors of ethnological treasures know that they could never provide such legal assurances, so they take refuge in a wide variety of excuses, deflect attention elsewhere, and maintain a sometimes insulted, sometimes dogged silence.

For years, representatives of the Prussian Cultural Heritage Foundation and the Berlin Ethnological Museum maintained that the Luf Boat had been procured legitimately. There is not a shred of evidence for this. The journalist Moritz Holfelder was laboring under misinformation, whatever the source, when, in his 2019

book *Raubgut* (Our Loot), he fell for this lie, writing that the prized vessel "had been legally purchased in the South Seas region in 1904." He didn't even get the year right—the vessel was in fact taken from its rightful owners in 1902. Holfelder, who enjoys the reputation of a critical author with notable credibility, added, "As far as its colonial origin is concerned, the Luf Boat is unproblematic."[9] Holfelder provides no source for this assertion.

To get around bothersome questions and debates about provenance, museum directors have created a new category for their ethnographic, colonial holdings: translocation. The word signifies nothing more than transfer from point A to point B. Not all, but many current owners of older Oceanic, African, North American, or Chinese works of art use this and other euphemisms, which cast a historical shroud over less pleasant-sounding phenomena like robbery, dispossession, immoral and unfair exchange, the fencing of stolen goods, and deceit.

In a sense, the Heidelberg Statement is correct to speak of ethnological museums representing "much more than colonial heritage." Truth depends on one's perspective. Every historical event and every museum collection admits of countless questions and answers, including those that go beyond provenance. But let us imagine that by law all objects acquired in the context of colonialism had to be permanently removed from German museums by the end of the year. The country's ethnological museums would have to close immediately. And the basis of the curators' objection that they have more to offer than a colonial legacy would be removed completely, too.

Without doubt, curators have great expertise, and their museums contain a wealth of accumulated knowledge. They ensure the preservation of often very fragile items and conduct research on a broad range of cultures. Since the 1980s, whether boldly or

hesitantly, many of them have increasingly confronted the crimes of colonialism upon which large parts of their collections are based. For professional reasons alone, many curators maintain contact with the descendants of the people who were robbed.

There is a widespread belief that many, perhaps most, of the ethnological treasures we have today would have rotted away or been lost had they not enjoyed protection and preservation in European museums. Curators also hold this opinion, although they rarely press it with any vehemence. The argument is dubious but also carries a measure of truth. Nonetheless, it cannot be used to justify claims to permanent rights of possession. When Europeans "rescued" these ethnographic treasures, in order to sell them and use them to decorate their living rooms, monasteries, and museums, those same Europeans—coldheartedly and for the sake of profit—dealt an irrevocably fatal blow to the societies and cultures that had produced such impressive examples of artisanship and art.

One collector during the colonial period, the navy staff doctor and self-taught ethnologist Emil Stephan, was conscious of the ambiguous nature of his activities. In 1907, he headed the German naval expedition to the island of New Mecklenburg (New Ireland), where after a short time he would die of a tropical fever. In his book on the art of the South Seas, which was published a few months before his death, he admonished his readers that it was "high time to rescue what is still to be rescued." The reason for his urgency was expressed in a general yet at the same time precise way. Because "peoples of nature" were "rushing ever faster toward their demise," wrote Stephan, "their ancient abilities and knowledge" would fade away even before their physical death as a "race"—once the "iron culture" of Europeans was exhaled upon them "like a poisonous breath."[10]

## A Thought Experiment

In her speech at the opening of the ethnological exhibit in the Humboldt Forum on September 22, 2021, the Nigerian writer Chimamanda Ngozi Adichie posed a series of questions. "Who tells the story?" she asked. "Who is the teller, and who is told about? Who decided that African art should be labelled 'ethnological'? Who has the right to exhibit the other?" She described seeing a headline in a German magazine that read, "Where Do Africa's Treasures Belong?" She challenged the audience: "Imagine if it said, 'Where Do Germany's Treasures Belong?'"[11] So let us transfer that thought experiment to the South Pacific and imagine that the power relations of Papua New Guinea and Germany were reversed. The resulting reality would be something like this.

In Port Moresby, the capital, there is an impressive Museum of European Ethnology located adjacent to the Papuan National Museum. In its section on Germano-Slavic settlement areas, visitors admire the famous Celtic Nebra sky disk, described as a "metal plate with sun, moon, and stars." A couple of steps farther on hangs one of George Grosz's bordello paintings from the 1920s. A wall plaque reads, "Germano-Slavic fertility ritual, oil on canvas." Imaginative Papuans tell their children: "They must have been amusing, these primeval tribes of Germanoslavia. Some of their artifacts really do display considerable skill, given the extremely primitive means at their disposal and the terribly cold climate. The Indigenous people of what is now Germany weren't untalented, but they've gone extinct."

Analogous to the Luf Boat in Berlin, the main attraction in the entrance hall of the Papuan Museum of European Ethnology is the only surviving work of the gifted Late Gothic woodcarver Tilman Riemenschneider. It's a piece of an altar from a small village

church in the town of Rothenburg ob der Tauber. Papuan colonial troops took the artifact with them 150 years ago and later sold it to the museum. Its exquisitely carved, partially damaged figures depict the crucifixion. The description on the wall reads, "Carving, depicting a cult of human sacrifice, pre-1870; North-Central Europe (Germanoslavia), linden, height 174 cm, width 113 cm, depth 47 cm; weight: 94.3 kg."

Let's assume that in the year 2030, the director of the Rothenburg Town Museum politely inquires of the Museum of European Ethnology in Port Moresby if it might be possible to return the only surviving artwork by the sculptor Riemenschneider, who plays such an important role in local history. In 2036, after many follow-up enquiries, the director receives a letter that reads:

> As you will see from our International Bulletin, five years ago, we renamed our museum after a series of comprehensive discursive processes. It is now called GLOBAL. Human Arts. Heritage. In keeping with the narrative of equally privileged diversity we formulated on this occasion, we understand ourselves as actors in transglobal and transepochal cultural and academic policy. Considered thus, the questions you raised concerning the translocations of major objects and the possibility of so-called "restitution" to the Middle Franconian source society in Rothenburg ob der Tauber come up far short of doing justice to the complexity of the situation. We conceive of our collection as parts of a global inheritance open to all visitors and researchers as part of shared heritage. Of course, we would be happy to fly you to Port Moresby. We would be very grateful if we could succeed, with your help, in integrating your indigenous-Europoid perspective sustainably, dialogically, and inclusively in our project "Mosaics of Humankind." Our experts

on Middle Franconia and our commissioner for ethics are
most enthusiastically looking forward to your visit and to
doing cooperative research with you as a person from the
source region.

## The Conservators and Trustees of the Luf Boat

Parzinger and his colleagues always pay lip service to the issue
of restoration of museum objects only to drown it in verbiage—
it's a self-defensive reflex. But the question remains: Under
what political, commercial, military, and sometimes homicidal
circumstances did most of the extraordinarily rare and splendid
items in our contemporary ethnological museums find their
way there?

We need to start answering this question precisely. Curators
should consistently label and explain objects so that exhibition vis-
itors can confront their colonial background, instead of seeking
to exhibit only those objects considered, often baselessly, to be
without the stain of having been potentially acquired by force. The
provenance research that experts are currently engaged in aims to
remove objects with problematic or horrific histories from the col-
lections on display, but this approach does more to hinder than
to serve public enlightenment. Above all it expresses a fundamental
unwillingness to publicly engage with the provenance of collec-
tions as a whole.

Leaving aside some symbolic gestures, those in charge of the
Humboldt Forum have yet to show any interest in a thorough rev-
elation of the truth. An illustrative example of this was a Sep-
tember 2017 discussion group featuring Parzinger. Unimpressed
by known historical facts, he proposed that ethnological museums,
in a "purely legal" but "clear" sense, could claim to have acquired
their collections in "good faith." They were the "rightful owners of

their holdings" insofar as it had never been proven that they were acquired illegally.

Here we have to ask: Did Parzinger consider it legal to trade plugs of tobacco for cultural treasures? Did he view "anonymous purchases" of the sort described in Chapter 7 to be in accordance with the law? Apparently, it didn't contradict his notion of "good faith" for the former director of the Berlin Ethnology Museum to thank the captains of German warships, resoundingly and officially, for their ethnographic booty.

Especially confusing is Parzinger's argument that "if the legal situation were the only criterion, we also wouldn't have to give back art looted by the Nazis." In this case, Parzinger contended, there is a "moral duty" toward the descendants of persecuted and murdered Jews, which is why restitutions were made "independently of the legal situation." In other words, Parzinger saw no legal or moral duty to give back items taken from colonially subjugated and plundered peoples. In the face of all historical evidence, he claimed that cultural artifacts, of which the vast majority were stolen, had been "acquired in good faith."[12] Such statements suggest how long it may take to install as a norm in Germany's museums a determination to investigate the past.

In this book, I have sought to shed light on the cultural treasure that is the Luf Boat, which was immorally taken to Berlin. It is a story of how German merchants, plantation managers, officers, and navy men destroyed the culture and society that created such a technological and artistic marvel. The history of this boat illustrates the destructive nature of colonialism and the greed of the Germans who wielded power at the time.

It would take a great effort to compile documentary evidence for tens of thousands of museum objects. For several thousand of them, I have tried over the course of these pages to point the way. The names of the men listed in the museum registries as

collectors—be they Hernsheim, Hellwig, Thiel, or Parkinson—are themselves indications of how brutal the process of "acquisition" was.

On November 14, 1907, Emil Stephan wrote a "top secret" missive from Matupi to his mentor, Felix von Luschan. It began with the statement that Stephan wanted to openly discuss a number of unpleasant things, which were to be treated with "discretion." He characterized "at least" 99 percent of the Germans working in New Guinea as "creatures of self-interest for whom, insofar as they cared about anything aside from earning money, the life and activities of the filthy *Kanaker* came in dead last." Max Thiel complained to Stephan about being accused of stripping individual islands of everything of value in questionable fashion and not documenting where ethnologically interesting objects had been acquired. By way of explanation, Thiel remarked, "Do you think I can give my captains ethical lectures about human rights before I send them on their journeys? (As I know these loyal skippers, God no!)"[13]

Some Berlin museum inventories do in fact gratefully list the *Hyena, Cormorant, Seagull,* and *Gazelle,* but without any mention that these were warships: gunboats, corvettes, and small cruisers. There is also no information about the crimes carried out during punitive expeditions and disciplinary missions directly connected with these warships and their ethnological raids of plunder. Such information is readily available in existing literature and well-preserved documents from the Imperial German Navy. All of this could be made transparent if the original record books and inventories were made public. Only then could we speak of a genuine effort to shed light on the provenance of museum holdings. This is also true for other objects from the colonial period, for instance, treasures taken from China during the colonial wars going on at the time. These objects, however, are part of the

department of East Asian art and not the ethnology / ethnography division.

It is possible that the government of Papua New Guinea, or activists and social groups, could one day express an interest in seeing the items looted by Germans returned. Then, and only then, would it be necessary to talk about restitution. Until that point, the Prussian Cultural Heritage Foundation should see itself as a conservator of all of its South Seas treasures, including the Luf Boat.

Why not negotiate with the descendants of the creators of Luf Boat, represented by the state of Papua New Guinea? In light of the claims they might raise, they could be recognized as (involuntary) trustees and acknowledged as owners. As such, they could decide in good time whether the curatorship of Berlin museums should continue or come to an end. They could take possession of the Luf Boat, put it in a museum, sell it, or give it away. Possessors have power over objects, but those objects legally belong to their owners. A stolen car or one purchased from a fence can be possessed and driven, but the owner is still the person whose name is listed on the vehicle's registration. This is precisely the situation of the ethnological holdings of the Prussian Cultural Heritage Foundation.

In 2019, to delay any such considerations or actions, Minister Grütters opposed making the documentation of museum holdings generally accessible. As a bromide, she talked about "dialogue on an equal level" while claiming that "A release [of data], as is now being demanded, might lead to confusion, which all of us want to avoid."[14] Who are "all of us?" Who other than the current possessors of what was looted in the past would be "confused" by the publication of original receipt books and inventories instead of selectively edited data? Certainly the descendants of "source com-

munities" wouldn't be. But perhaps the descendants of those communities involved in the larceny and looting would.

A quick look at the website of the Papua New Guinea National Museum (http://www.museumpng.gov.pg/) reveals gaping holes in its permanent collection. Curators there have to make do with replicas. In contrast to that humble museum, the Prussian Cultural Heritage Foundation boasts of possessing 65,000 objects from the South Seas.

Smugly, it declares that its "world-renowned" and particularly comprehensive collection contains "especially high-quality examples," a legacy of "targeted expeditions" that allowed for a relatively rare, "quite exact documentation" and unusual "historical depth." The foundation's 2018 self-description goes on to say that the collection focuses on "boats as well as originally sized architectural elements and ethnographic objects from Northeast New Guinea" and the Bismarck Archipelago. On top of that are several objects from Pacific islands that "weren't part of the German colonial area."[15]

## Living Spirits with Fixed Abodes

With the revival of a political and emotional discussion about cultural treasures seized during colonialism, representatives of the Prussian Cultural Heritage Foundation have been at pains to stress the intense relationships it has maintained "for quite some time" with source societies, including Papua New Guinea. But the fact that such relations aren't very old at all is evident from a permanent exhibition catalogue for the Papua New Guinea National Museum produced by the Australian ethnologist and curator Barry Craig some ten years ago. Craig writes extensively about the problems that the mass larceny of cultural masterpieces caused for

the museum. But he mentions no contact with German museums whatever.

The museum's budget doesn't allow it to buy back looted items on the international art market. Stolen works of South Seas culture are expensive. The museum possesses photographs of Melanesian boats and the odd paddle or decorated prow from such vessels. But you won't find in its collection an outrigger anywhere near as artistically constructed and well preserved as the Luf Boat.

According to a 2010 inventory, there were only 190 items in the museum from Manus Province, to which the Admiralty and Western Islands, including the Hermit Atoll and Luf, belong. German ethnological museums and in particular the one in Berlin possess thousands of artworks, religiously significant masks, and tools, as well as marvelously decorated everyday items from the province. These items would immediately close the obvious gaps in the collection of Papua New Guinea's national museum.[16]

The Prussian Cultural Heritage Foundation continues to insist that there have been no requests from Papua New Guinea for the return of cultural treasures held in German museums.[17] That's untrue. Immediately after Papua New Guinea became independent in 1975, its prime minister, Michael Somare, called upon the international community to repatriate artworks and objects looted from his country: "We now have a National Museum and Art Gallery. These house our heritage. Some of our most valuable pieces of artwork are outside our country. I would ask you all to cooperate with us in returning our ancestral spirits and souls to their homes in Papua New Guinea. We view our masks and our art as living spirits with fixed abodes."[18]

Australia responded by returning some items, but none of Germany's many ethnological museums heeded Somare's call. That can and must be changed, perhaps not for complete collections, but certainly for thousands of items that are highly signifi-

cant for the cultural memory of Papuans. In contrast to the situation with Nigeria (to which Germany has agreed to return some artworks), communication and dialogue with the national museum in Port Moresby and the Papuan national authority have only just begun. A country like Germany should support Papuan social initiatives that are working to regain major artifacts of their own history, strengthening the cohesion of their fragile state in the process.

Europeans should signal their readiness to cooperate without conditions and paternalistic presumptions. One crucial first step is to make inventories of German museums publicly available on

On May 28, 2018, the Luf Boat was hoisted inside a gigantic, climate-controlled container into the Humboldt Forum. The vessel could be taken back out in the same way and, with similar ceremony, be transported back to Papua New Guinea.

the internet, initially in their original handwritten form and as soon as possible as an easy-to-read, searchable digital database. English translations need to be made and a key created for variant geographical names. The Prussian Cultural Heritage Foundation has at least committed to this sort of transparency. The appearance of this book in English makes me particularly happy, since it will allow interested Anglophone readers in Papua New Guinea to learn how many of their cultural treasures were once removed to Berlin, where they have—hopefully—been well kept and preserved.

Because of its size, the Luf Boat had to be transported to the Humboldt Forum while the building was still unfinished. The vessel was hoisted through a gap that had been left in the shell of the building, which is an external reconstruction of the former Hohenzollern palace with a thoroughly modern core. Before it was moved, experts had carefully restored this invaluable object and packed it in a specially constructed, climate-controlled container. Should the boat be taken back to Papua New Guinea in the future, the building's wall would have to be reopened. But this would hardly be an insurmountable obstacle. After all, the city of Berlin has fond memories of walls being opened.

BRIEF BIOGRAPHIES

ABBREVIATIONS

NOTES

BIBLIOGRAPHY

SOURCES AND
ACKNOWLEDGMENTS

ILLUSTRATION CREDITS

INDEX

# Brief Biographies

*Gottlob Johannes Aly* (1855–1938) was born in Burg, near Magdeburg. He served as a Protestant military chaplain, his last post being aboard the *Elisabeth* in 1884–1886. In 1887 he became pastor of the St. Petri Church in Hamburg. He was praised for his work in Hamburg's poverty-stricken Gängeviertel neighborhood during the cholera epidemic that claimed almost ten thousand lives in the summer of 1891. He was strongly opposed to National Socialism.

*Adolf Bastian* (1826–1905) studied medicine and then traveled around the world for eight years as a ship's doctor. During that time, he became fascinated with and began to study and document the various peoples and cultures he encountered. Bastian developed into a well-rounded scholar who is regarded as the father of German ethnography. In 1873, he was one of the founders of the Royal Museum of Ethnology in Berlin, which he then headed until his death.

*Rudolf von Bennigsen* (1859–1912) became finance director in German East Africa in 1893, where he developed a reputation as a hard-hearted collector of taxes. He served as governor of German New Guinea from 1899 to 1901. In that post, he strutted around as a "colossally dashing gentleman" (according to Johanna Fellmann),

promoting the collection of ethnologically interesting cultural arti-
facts and repeatedly calling for the "disciplining" of "natives" with
the help of German warships.

*Otto Dempwolff* (1871–1938) began his professional life as a naval
physician and became interested in ethnology and tropical medi-
cine. In 1904–1905, he served as a military doctor in the war against
the Herero people in German Southwest Africa. After that, he
was sent to German East Africa. Dempwolff studied the various
languages spoken in the German colonies, and from 1919 until his
death, he taught in the department of African and Melanesian
Languages at Hamburg University. In July 1937, he applied for
membership in the Nazi Party.

*Otto Finsch* (1839–1917) traveled to the South Seas numerous times
starting in 1879. In 1884–1885, under Captain Eduard Dallmann,
he took part as a navigator and guide in the voyage of the *Elisa-
beth* and *Hyena* to claim various South Seas islands as German
protectorates. His career as a self-educated ethnologist and
zoologist had begun when he worked as an assistant at the
Rijksmuseum of Natural History in Leiden. In 1868, Bonn Uni-
versity awarded him an honorary doctorate, and in 1910, he was
named professor. In 1883, he offered 4,000 objects from the
South Seas to the Berlin Ethnological Museum, 1,665 of which
were accepted.

*Albert Hahl* (1868–1945), an administrative lawyer, began his
career in 1895 in the colonial department of the German Foreign
Ministry, after which he was posted several times to the South
Seas. In 1901, he became governor of German New Guinea, an of-
fice which he retained until April 1914. Hahl's tenure was charac-
terized by a mixture of violence and patronage, and he helped

German ethnological museums procure a large number of items. In 1939, he became an expert on the South Seas in the Nazi Colonial Policy Office.

*Franz Emil Hellwig* (1854–1929) was a merchant, hotelier, adventurer, collector, and dealer in ethnographically valuable art and everyday objects. He came from Halle an der Saale and set off for the South Seas in 1895. There, he was employed by the Hernsheim company for two years, with remarkable success, as a collector of ethnographic items. He took part in the Hamburg South Seas expedition in 1908–1910 as a photographer and expert in regional geography. He subsequently worked as a storage and inventory manager at the Museum of Ethnology in Hamburg.

*Franz* (1845–1909) and *Eduard Hernsheim* (1847–1917) were brothers from Mainz. Franz became a merchant, working in Manchester, Le Havre, and Mexico. Eduard went to sea and earned his navigator's and then captain's licenses as a young man. In 1874, he purchased land on the island of Malakal (Palau) and on Pemei, one of the Hermit Islands. The following year, Franz joined his brother's business, which quickly expanded its bases, plantations, and profits. In 1880 and 1882, the brothers were named German consuls responsible for various South Seas island groups.

*Guido Karcher* (1844–1905) was an Imperial German Navy officer. Between 1881 and 1883, he commanded the *Carola* in the South Seas. In late 1882 and early 1883, he led the punitive expedition against the people of Luf, which destroyed their material basis of existence. The following year, as the commander of the *Bismarck,* he helped put down rebellions in Cameroon. Kaiser Wilhelm II promoted him to the rank of admiral and awarded him the Red Eagle Medal, First Class.

One of the obituaries for Eduard Hernsheim. The text reads, "The Hamburg founder of German colonial ambitions in the Bismarck Archipelago has died at the age of 69."

Guido Karcher, captain of the *Carola,* who presided over the destruction of Luf in 1882–1883. He is pictured here as an admiral in the Imperial Navy in 1899.

*Harry Koenig* (b. 1858) was a head navy physician on the *Elisabeth* in 1883. After assignments in Zanzibar and Tsingtao, he was promoted to navy physician. In 1907, he became the head physician at the Tegel Palace Sanitorium near Berlin. He wrote uncritically about the punitive expeditions in his 1926 book *Über See!* (Over Seas!).

*Augustin Krämer* (1865–1941) was a German navy physician who became an anthropologist and ethnologist. As a member of the South Seas expedition aboard the surveying vessel *Planet*, he visited the Hermit Islands in 1906. He described conditions there and interviewed the surviving builders of the Luf Boat, which had already been taken to Berlin, about details of the boat's ornamentation.

*Elisabeth Krämer-Bannow* (1874–1945) grew up in Berlin and was trained as a draftsperson and painter. In 1904, she married the ethnologist Augustin Krämer. She became his photographer and made drawings, watercolor paintings, and notes about the ritual and social customs she observed during their mutual travels. In 1916, she published the book *Bei kunstsinnigen Kannibalen der Südsee* (*Among the Art-Loving Cannibals of the South Seas*). Her husband, who greatly profited from her observations and organizational and artistic talents, had no scruples about including on the cover of that volume the line "Including Scholarly Observations by Prof. Augustin Krämer," even though his contributions were minimal.

*Felix von Luschan* (1854–1924) was an Austrian doctor who as of 1885 worked in Berlin as a physician, anatomist, anthropologist, and ethnologist. He was the long-time, enormously influential curator of the Oceania Department of the Berlin Ethnological Museum and was responsible for procuring the Luf Boat.

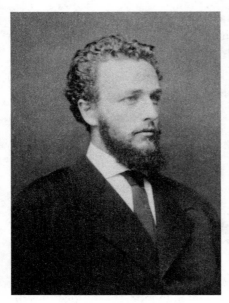

Felix von Luschan, the purchaser of the Luf Boat, wanted to make "his" Berlin Ethnological Museum into the largest in the world. Although he never achieved this goal, he got close. The collection today owes most of its significant items to his efforts. Along with the Luf Boat, they also include famous bronze sculptures from Benin.

*Richard Parkinson* (1844–1909) was born in Denmark and worked in the South Seas as a plantation manager, writer, and collector of ethnographic treasures and human skulls. He photographed the Luf Boat before it was transported from the island. "He had plenty of opportunity to cross the protectorates on sailboats, steamers, and warships," wrote Max Thiel in his obituary, and was able to observe "the particularities of many South Seas peoples."

*Heinrich Schnee* (1871–1949) served from 1898 to 1900 as imperial judge and deputy governor of German New Guinea, and from 1900 to 1904 as a regional officer and deputy governor of the new colony of German Samoa. In 1904, he published the book *Bilder aus der Südsee. Unter den kannibalischen Stämmen des Bismarck-Archipels* (Pictures from the South Seas: Among the Cannibal Tribes of the Bismarck Archipelago), which had great influence

upon later colonial officials and travelers to the South Seas. After the First World War, he lobbied for the reacquisition of the German colonies. From 1922 to 1945, he was a deputy in the German Reichstag, first for the conservative nationalist People's Party, and then, as of May 1933, for the Nazi Party.

*Max (Maximilian) Thiel* (1865–1939) traveled to the South Seas in late 1883 and worked in the trading post of the Jaluit company on the Marshall Islands. In 1886, he joined the company of his uncle Eduard Hernsheim on the island of Matupi (New Guinea), which was well located for trade and became the Hernsheim company's main base in the South Seas. In 1892, Thiel became a shareholder. In 1910, he returned to Hamburg as the director of the Hernsheim company. On his seventieth birthday, the *Ostasiatische Rundschau* (East Asian Review) praised him as "one of the most commendable and longest-serving pioneers who worked to benefit Germany's position in the South Seas."

*Heinrich Rudolph Wahlen* (1873–1970) began his career in 1895 as a Hernsheim employee on Matupi, before striking off on his own in 1902. He built an opulent mansion, nicknamed Wahlen Castle, on an island in the Hermit Atoll, established coconut plantations, and earned a fortune. In return for generous bequests of South Seas artworks to the Stockholm Ethnological Museum, he was named Royal Swedish Consul in German New Guinea in 1907. He joined the Nazi Party in 1933 and argued vehemently for the reestablishment and massive expansion of the German colonial empire in the South Seas.

# Abbreviations

| | |
|---|---|
| BArch | Bundesarchiv |
| GStA | Geheimes Staatsarchiv |
| HStA | Hauptstaatsarchiv |
| KML | Korrespondenzmappe im Linden-Museum Stuttgart |
| MARKKArch | Museum am Rothenbaum—Kulturen und Künste der Welt, Archiv |
| Nl. | Nachlass |
| NHM-Wien | Naturhistorisches Museum Wien |
| PA AA | Politisches Archiv des Auswärtigen Amts |
| RM | Reichsmarine |
| SBB | Staatsbibliothek zu Berlin |
| Slg. | Sammlung |
| SPK | Stiftung Preussischer Kulturbesitz |
| StA | Staatsarchiv |
| StAHbg | Staatsarchiv Hamburg |
| ZA-SPK | Zentralarchiv der SPK |

# *Notes*

## I. THE SCENE OF THE CRIME: GERMAN NEW GUINEA

1. Hahl, *Deutsch-Neuguinea* (1936), 53–55, 76–77, 85–90.
2. Speech by Bismarck, July 26, 1884; see Kuhn, *Deutschen Schutzgebiete* (1913), 5–6.
3. Wendland, *Wunderland* (1939), 215.
4. For more on the geography and nomenclature, see "Geography of the Western Islands," Wuvulu Web Site, https://www.wuvulu.com /geography.shtml#H.
5. *Amtliche Berichte* 25 (1904), no. 4.
6. See Humboldt Forum dossier, Stiftung Preußischer Kulturbesitz, https://www.preussischer-kulturbesitz.de/newsroom/dossiers-und -nachrichten/dossiers/dossier-humboldt-forum.html.
7. Quoted in Anne-Catherine Simon, "Wer darf die Kunst zerstörter Völker besitzen?" Die Presse, May 11, 2021, https://www.diepresse .com/5978182/wer-darf-die-kunst-zerstoerter-voelker-besitzen.
8. Thilenius, *Ethnographische Ergebnisse*, vol. 2 (1903), 190, 192–193.
9. Buschmann, *Oceanic Collections* (2018), 197–198.
10. Grimme, "Provenienzforschung" (2018), 94–95.
11. See also Lichtenstaedter, *Kultur und Humanität*; Götz Aly (ed.), *Siegfried Lichtenstaedter* (2019), 29–41, 109–115. Lichtenstaedter was one of the few people of the time to critically engage with the topic of European colonial crimes. His writings helped convince me to investigate the Luf Boat.

## 2. WITH PASTOR ALY'S BLESSINGS

1. The work in question was about Johannes Aly's cousin, my great-grandfather Friedrich Aly: Götz Aly, "Nulla dies sine linea" (2021).
2. Gottlob Johannes Aly, "Nach allen fünf Erdteilen" (1936). This is the source of the following quotes.
3. Koenig, *Über See!* (1926), 16, 108.
4. Krug, *Hauptzweck* (2005), 6–48; Finsch, *Samoafahrten* (1888), 136–140.
5. Finsch, *Samoafahrten*, 135–139; Thilenius, *Arbeiterfrage* (1900), 71; P. Schnee, "Schwarzbraune Landsleute" (1899), 118; see also the detailed account in Parkinson, *Bismarck-Archipel* (1887), 15–35, 40.
6. The songs were "Heil dir im Siegerkranz" and "Ich bin ein Preuße / Kennt ihr meine Farben." Finsch, *Samoafahrten*,140; Koenig, *Über See!* 35–36, 47, 68.
7. Krug, *Hauptzweck*, 49; Finsch, *Samoafahrten*, 140–141; F. Hernsheim, *Südsee-Schriften* (2019), 49.
8. Krug, *Hauptzweck*, 43–44.
9. Krug, *Hauptzweck*, 48–49. (Der Staatssekretär im Auswärtigen Amt, Paul v. Hatzfeld zu Wildenburg an den Chef der Kaiserl. Marine, Vizeadmiral Leo v. Caprivi, 19.8.1884, BArch RM 1, 2901, Bl. 46.)
10. F. Hernsheim, "Erinnerungen," 16, PA AA Nl. Hernsheim.
11. Kuhn, *Deutschen Schutzgebiete* (1913), 24–25.
12. See Krug, *Hauptzweck*, 92–98.
13. Koenig, *Über See!* 50.
14. Nuhn, *Kolonialpolitik* (2002), 308–312. (Denkschrift zum Immediatvortrag betreffend Überfall auf einen Teil der Besatzung von S.M.S. Möwe und Bestrafung hierfür, gez. Eduard von Knorr, 18.5.1897, BArch RM 5, 915, Bl. 54–63.)
15. Baumann et al., *Biographisches Handbuch* (2002), entry for Curt v. Hagen, 125–126.
16. Finsch, *Samoafahrten*, 100–104.
17. On the culture, language, and mores of the inhabitants of Ali Island, see Schmidt, "Ethnographisches" (1899), which is based on a text published by Vormann in 1896, before the massacre, in *Katholischen Familienblätter*.

## 3. THE LUF BOAT AS MUSEUM ATTRACTION

1. "Südseeboot schwebt ins Humboldt Forum," press release, May 29, 2018, https://www.preussischer-kulturbesitz.de/pressemitteilung/artikel/2018/05/29/suedseeboot-schwebt-ins-humboldt-forum.html. The article erroneously gives the year as 1903.
2. Sebastian Bauer, "Startschuss für das Humboldt Forum," *B.Z.*, May 29, 2018.
3. Deterts in Deutschlandfunk radio, August 13, 2015.
4. Nevermann, *Schiffahrt* (1949), 27. The text erroneously gives the year as 1911.
5. Nevermann, "Agomes-Boot" (1954).
6. Koch, "Hundert Jahre" (1973), 146.
7. Koch, *Südsee* (1969), 67, 134.
8. Mönter, "Krämer" (2010), 104–106.
9. Krämer, *Forschungsreise* (1909) 5, 84; Parkinson, *Südsee* (1907), 444.
10. E. Hernsheim, "Erinnerungen," StAHbg 622-1 / 334, no. 1, pp. 38, 106.

## 4. THE 1882 LUF MASSACRE

1. Luf-Boot, Wikipedia, August 8, 2019 version, https://de.wikipedia.org/wiki/Luf-Boot.
2. Krämer-Bannow, *Kunstsinnige Kannibalen* (1916), 260.
3. Baessler, *Südsee-Bilder* (1895), 104.
4. Report by Karcher, February 12, 1883, BArch RM 1, 2424, Bl. 91.
5. Dempwolff, "Malaria-Expedition" (1904), 111; Baumann, *Franz Hellwig* (1994), 16–17.
6. Parkinson to Luschan, February 6, 1904, SBB Nl. Luschan.
7. Hambruch, *Wuvulu* (1908), 23.
8. Sapper, "Bedrohung" (1916 / 1918), 291–292.
9. F. Hernsheim, *Südsee-Schriften* (2019), 91.
10. Luschan, "Ziele und Wege" (1903), 166.
11. F. Hernsheim, "Erinnerungen," 18, PA AA Nl. Hernsheim.
12. Anderhandt, *Hernsheim* (2012), vol. 1, 95–109; vol. 2, 22, 60–67, 576–577; E. Hernsheim, "Erinnerungen," StAHbg, 622-1 / 334, no. 1, pp. 34–37; F. Hernsheim, *Südsee-Schriften*, 288.
13. Report by Karcher, February 12, 1883, BArch RM 1, 2424, Bl. 92–93, 101.

14. Hambruch, *Wuvulu* (1908), 8.
15. Krämer, *Forschungsreise* (1909), vol. 5, 54−122, esp. 58−59, 67−74.
16. Report by Karcher, February 12, 1883, and report by Geiseler, January 11, 1883, BArch RM 1, 2424, Bl. 93−98, 109−111.
17. Daily reports by Finck, December 27−30, 1882, BArch RM 1, 2424, Bl. 112−116.
18. Report by Wahrendoff, December 30, 1882, BArch RM 1, 2424, Bl. 117−118.
19. Krug, *Hauptzweck* (2005), 40; Romilly, *Western Pacific* (1886), 121−124.
20. Report by Karcher, December 12, 1883, BArch RM 1, 2424, Bl. 89; Krämer, *Forschungsreise*, vol. 5, 71.
21. Report by Karcher, February 12, 1883, BArch RM 1, 2424, Bl. 90.
22. Dempwolff, "Über aussterbende Völker" (1904), 391, 395−396.
23. Thamm, *Samoa*, 85−87.
24. Krug, *Hauptzweck*, 40−41: Aufzeichnung v. Vizeadmiral Otto Livonius, Direktor der Kaiserlichen Admiralität, über das Gespräch mit dem Leiter der Reichskanzlei, Franz v. Rottenburg, am 25.5.1883 und Vermerk Caprivis v. 13.6.1883, BArch RM 1, 2424, Bl. 124−125.
25. Anderhandt, *Hernsheim*, vol. 2, 64.
26. Krämer, *Forschungsreise*, vol. 5, 59.
27. Report by Karcher, cited in Dempwolff, "Aussterbende Völker," 415.
28. Thilenius, *Ethnographische Ergebnisse*, vol. 2 (1903), 162, 267, 342.
29. Hambruch, "Anthropologie" (1906), 23.
30. Hambruch, "Schiffahrt" (1931), 381.
31. Tischner, "Häuptlingsbestattung" (1950), 52.
32. E. Hernsheim, "Erinnerungen," StAHbg 622-1 / 334, no. 1, p. 118; Romilly, *Western Pacific* (1886), 121.
33. Dempwolff, *Tagebuch* (2019), 14.

5. "BASTIAN'S NETWORK" OF THIEVES

1. *Original-Mittheilungen* (1885−1886), iii (epilogue).
2. Luschan, *Beiträge* (1897), 86.
3. *Königliche Museen* (1886), 9.
4. Buschmann, "Exploring" (2000), 57.
5. "Konzept zur Präsentation" (2012), 122, 141.

6. Kamp, "Museen" (2002), 208–212.
7. "Einweihung des Museums für Völkerkunde," *Vossische Zeitung,* December 19, 1886.
8. Luschan, *Völker* (1922 / 1927), viii; Zimmermann, *Anthropology and Antihumanism* (2001), 154–158.
9. Bastian, "Ethnologische Sammlung," *Amtliche Berichte* 5 (1884), xxii.
10. Report by Geiseler, March 15, 1884, BArch RM 1, 2901, Bl. 5–6.
11. Anderhandt, *Hernsheim,* vol. 2 (2012), 241; Parkinson, *Südsee* (1907), 436.
12. Krämer, *Forschungsreise* (1909), vol. 1, 81–82.
13. Thilenius, *Ethnographische Ergebnisse,* vol. 1 (1902), 161; also Parkinson, *Südsee* (1907), 435–436.
14. Buschmann, "Exploring," 57.
15. Jacques, *Südsee* (1922), 14–15. Thanks to Rainer Buschmann for alerting me to this. The Etnografiska Museet in Stockholm possesses a large Wahlen collection.
16. Stephan to Luschan, November 14, 1907, SBB Nl. Luschan. Thanks to Rainer Buschmann for alerting me to this letter.
17. Wahlen, "How I Repopulated the Ninigos," 71, 77.
18. Krämer to Luschan, October 13, 1906, SSB, Nl. Luschan.
19. Grapow to Linden (ca. 1908), KML Grapow.
20. [Warnecke,] "Nordwestliche Inselgruppen" (1902), 221.
21. See Jürgen Zimmerer, "Interview," *Die Zeit,* July 3, 2017.
22. Müller, "Religionen" (1913), 200; Fischer, *Hamburger Südsee-Expedition* (1981), 115–124; on Hamaloái, see Krämer, *Forschungsreise,* vol. 5, 73–74.
23. Anderhandt, *Hernsheim,* vol. 2, 240.

## 6. DECEIT, LARCENY, AND LOOTING

1. BArch R 1001, 6228, Bl. 22–23; Erstes Verzeichnis der aus den Deutschen Schutzgebieten eingegangenen wissenschaftlichen Sendungen, 25.7.1887, gez. die Direktionen der Berliner Museen f. Völkerkunde u. Naturkunde, des Botanischen Gartens u. Botanischen Museums, KML Korrespondenz Berlin.
2. E. Hernsheim, "Erinnerungen," StAHbg 622-1 / 334, no. 1, p. 132.
3. Finsch, *Samoafahrten* (1888), 24.

4. *Amtliche Berichte*, 27 (1906), no. 4, column 86.

5. Kell, "Folk Names" (1966), 594; Mencken, "Designations" (1944), 168–169.

6. Finsch, *Naturprodukte* (1887), 19; Parkinson, *Bismarck-Archipel* (1887), 85; Finsch, *Samoafahrten* (1888), 24, 58–59.

7. Tappenbeck, *Deutsch-Neuguinea* (1901), 70, 100.

8. Anderhandt, "Abenteuer" (2006), 45.

9. Parkinson, *Bismarck-Archipel*, 87–88.

10. Thamm, *Samoa* (1994), 46–49.

11. Anderhandt, "Statt im Großen" (2014), 68.

12. Hahl, *Gouverneursjahre* (1937), 147; Krämer, "Volkskunde" (1939), 354.

13. Anderhandt, "Abenteuer," 53. I made some slight corrections to the chorus with the help of my grandfather Wolfgang Aly.

14. F. Hernsheim, *Südsee-Schriften* (2019), 200. It would be decades (October 1, 1909) before the governor of German New Guinea would issue an ordinance "banning the administration of spirits to natives." See Kuhn, *Deutschen Schutzgebiete* (1913), 110–130.

15. Wilda, *Reise auf S.M.S. "Möwe"* (1903), 112–115.

16. Stefan von Kotze was one of Germany's most popular colonial authors. See P. Schnee, "Unsere schwarzbraunen Landsleute" (1899 / 1900).

17. Parkinson to Luschan, February 6, 1904, SBB Nl. Luschan; Buschmann, "Exploring" (2000), 66–72; Parkinson to Luschan, April 19, 1900, ZA-SPK Ethnolog. Museum, Film 215 (I / IB-Südsee), no. 58.

18. Thiel to Schnee, April 10, 1904, GStA VI. HA, Nl. Schnee, no. 54.

19. "Museale Neuguinea-Figur Unterm Hammer," findart.cc, Spitzen-Objekt der Dorotheum-Auktion "Stammeskunst / Tribal Art," auction date March 24, 2014, http://www.altertuemliches.at/termine /auktion/museale-neuguinea-figur-unterm-hammer-27607.

20. "Modell eines Auslegerbootes," Franz Emil Hellwig Collection, inventory number VI 24517, Ethnological Museum of Berlin, https://smb.museum-digital.de/index.php?t=objekt&oges=60118.

21. Luschan to Linden, November 4, 1898, KML Luschan 1.

22. "Modell eines Auslegerbootes," 1903, collected by Max Thiel, inventory number VI 23117, Ethnological Museum of Berlin. On the islanders' construction of model and toy boats, see Hambruch, *Wuvulu* (1908), 116.

23. Baumann et al., *Biographisches Handbuch* (2002), 11.
24. Luschan, "Völkerkunde" (1897), 259–260; see also Buschmann, "Exploring," 57–60.
25. Thilenius to Luschan, April 24, 1898, SBB Nl. Luschan.

## 7. CURATORS, CRUSADERS, AND CANNONS

1. Luschan, "Ethnographie" (1899), 486, 505.
2. *Original-Mittheilungen* (1885), vii, 2–4; "Affirmativ: Wilhelm Geiseler erforscht die Lebensgewohnheiten der Rapa Nui," http://www .osterinsel.de (website under construction).
3. Schnee, *Bilder aus der Südsee* (1904), 170–171.
4. Report by Bennigsen August 8, 1899, BArch R 1001, 2987, Bl. 108ff., cited in Krug, *Hauptzweck* (2005), 155.
5. Grimme, "Provenienzforschung" (2018), 96; Liste "Sammlung v. Bennigsen Südsee," KML Bennigsen; Sammler- und Stifterliste für A. Krämer 1910, StA Ludwigsburg EL 232, Bü 686. The rationale for Bennigsen's being given a medal has not been preserved, only a reminder from Count von Linden to the head of the Royal Württemberg on December 19, 1901, about his recommendation (HStA Stuttgart E 40 / 34, Bü 209, 210). Thanks to Albrecht Ernst for this information.
6. Grimme, "Provenienzforschung," 96.
7. Herzog Wilhelm v. Urach, Vorsitzender des Württembergischen Vereins für Handelsgeographie, an den Chef des Königl. Württ. Kabinetts, 12.5.1912, HStA Stuttgart, E 14, Bü 380.
8. H. Schnee (ed.), *Deutsches Kolonial-Lexikon* (1920), vol. 1, 12ff.
9. Krug, *Hauptzweck*, 157; H. Schnee, *Südsee* (1904) 166–167, 182, 193, 202.
10. "About the Collection," Südsee und Australien Collection, Ethnologisches Museum, Berlin, July 6, 2018, https://smb.museum-digital .de/index.php?t=sammlung&gesusa=12&cachesLoaded=true.
11. Wilda, *Reise auf S.M.S. "Möwe"* (1903), 177–178, 184.
12. Bericht Boethers, 19.4.1900, BArch R 1001, 2988, Bl. 27ff.; Krug, *Hauptzweck*, 190–192.
13. See, for instance, "Nachweisung der den königlichen Museen im Etatsjahr 1902 überwiesenen Geschenke," GStA I. HA, Rep. 89, no. 20462, Bl. 184ff.

14. On Max Braun, see Zimmermann, "Kolonialismus" (2012), 178.

15. Cited in Margarete Brüll, "Die deutschen Kolonien in der Südsee," 12, http://www.freiburg-postkolonial.de/Seiten/Adelhauser-Bruell1 .pdf (BArch RM 2, 1592).

16. Grimme, "Provenienzforschung," 50.

17. Grapow to Linden, 1908, KML Grapow; Baumann et al., *Biographisches Handbuch* (2002), 118.

18. Poser and Baumann (eds.), *Heikles Erbe* (2016), 69.

19. Müller (December 20, 1908) quoted in Fischer, *Hamburger Südsee-Expedition* (1981), 122.

20. Vogel (*Forschungsreise* [1911]) quoted in Fischer, *Hamburger Südsee-Expedition*, 122; see also Carstensen and Dörfel, "Andenken und Trophäen" (1984), 97.

21. Hellwig, "Tagebuch der Hamburger Südsee-Expedition" (November 30, 1908), 105, MARKKArch., Süd 17.

22. H. Schnee, *Südsee*, 174.

23. Hellwig, "Tagebuch der Hamburger Südsee-Expedition," 18.u.26.9.1908, MARKKArch., Süd 17 (62, 66–67.). On the value of the mark, see https://wiki-de.genealogy.net/Geld_und_Kaufkraft_ab_1871.

24. Finsch, *Samoafahrten* (1888), 330–331.

25. Krämer, *Forschungsreise* (1909), vol. 1, 79–80.

26. Krämer-Bannow, *Kunstsinnige Kannibalen* (1916), 94, 261.

27. Krämer to Linden, July 1907, Mönter, "Krämer" (2010), 126.

28. Grimme, "Provenienzforschung," 105.

29. Linden an den Chef des Königl. Württ. Kabinetts, 18.12.1908, HStA Stuttgart E 14, Bü 378.

30. Krämer an Wanner, 23.12.1919, StA Ludwigsburg EL 232, Bü 682.

31. See Baumann et al., *Biographisches Handbuch* (2002), 206; Fischer, *Hamburger Südseeexpedition* (1981), 65–66.

32. Krämer, preface to Krämer-Bannow, *Kunstsinnige Kannibalen* (1916), vii.

## 8. ETHNOLOGY, CHILD OF COLONIALISM

1. Nevermann, "Augustin Krämer" (1941).

2. "Verhandlungen der Berliner anthropologischen Gesellschaft, 15.10.1892," in *Zeitschrift für Ethnologie* 24 (1892), 465.

3. Dempwolff, *Tagebuch* (2019), 22.

4. Kundraß, "Zwischen" (2009), 100.

5. Bode, *Mein Leben* (1930), vol. 2, 369.
6. Melk-Koch, "Zwei Österreicher" (1995), 132–136. Other authors contend that the gatherings took place on Friday evenings.
7. Luschan, "Völkerkunde."
8. Luschan, "Anthropologische Studien" (1889), 198–226.
9. Luschan, "Ethnographie des Kaiserin-Augusta-Flusses" (1911), 116.
10. Knoll, "Felix v. Luschan" (2004), 60–61; Tunis, "Erfülltes Leben" (2009), 46.
11. Graf Linden an Bennigsen, 23.2.1902, KML Bennigsen.
12. Hahl an Luschan, 9.11.1909, SBB Nl. Luschan.
13. Mönter, "Krämer" (2010), 127.
14. Luschan an Graf Linden, 30.12.1900, KML Luschan 1.
15. Bode, *Mein Leben*, vol. 2, 175. Bode began writing this volume of his memoirs in 1907 and would have jotted down his impressions of Luschan early on.
16. Laukötter, "Kultur" (2007), 159, 188.
17. Preuß. Unterrichtsmin. (MinDir. Th. Althoff) an Luschan, 12.7.1904, SBB Nl. Luschan, K 23, 2 / 1–3; Schreiben des Königl. Geh. Civil Cabinets an Luschan, 27.1.1909, SBB Nl. Luschan, K. 23–24; Schott, "Geschichte" (1961), 61–64.
18. Luschan, "Anthropologische Stellung der Juden" (1892), 630.
19. Luschan, *Völker, Rassen, Sprachen* (1927), 57, 191.
20. Luschan, "Rassen und Völker" (1915), 3–4 16, 18.
21. Rusch, "Der Beitrag Felix von Luschans" (1986), 449–453.
22. Luschan, *Anleitung* (1910), 73–74, 97.
23. Virchow, "Gedächtnisrede" (1924), 114.
24. Laukötter, "Kultur" (2007), 142–143; Parzinger cited in König and Scholz (eds.), *Humboldt-Forum* (2012), 55.
25. The correspondence concerning the Samoa boat can be found in the file "Geschenke für S.[eine] Maj.[estät] den Kaiser u. Gegengeschenke" des Reichskolonialamts, BArch R 1001, 2780, Bl. 5–82.

## 9. THE LUF BOAT COMES TO BERLIN

1. Schnee, Staatssekretär im Reichskolonialamt, an Gouv. Solf (Zt. Dorf Kreuth), 5.8.1914, nebst Kostenvoranschlag, 12.3.1906, BArch R 1001, 2780, Bl. 50–51.
2. Übersicht der 1904 für die einzelnen Abteilungen der Königl. Museen gemachten Ankäufe, GStA I. HA, Rep. 89, no. 20463, Bl. 182.

3. Parkinson, *Südsee* (1907), 444.

4. Jacques, *Südsee* (1922), 12–13. Thanks to Rainer Buschmann for pointing out this source.

5. Fellmann, *Von Schwaben in den Bismarckarchipel* (2009), 185.

6. Wahlen an Ritter v. Epp, 30.5.1939; Wahlen an Hewel, 12.8.1940; Wahlen an Hewel, 31.8.1941, PA AA R 27474 (Handakten Hewel). On June 5, 1939, the Nazi Colonial-Political Office referred Wahlen to the "Administrator for South Seas Question, his Excellence Dr. Hahl." Wahlen was well acquainted with Hahl from the latter's tenure as governor of German New Guinea from 1901 to 1914.

7. Dempwolff, *Tagebuch* (2019), 11–15.

8. Dempwolff, *Tagebuch*, 36–40, 44–45.

9. Dempwolff, *Tagebuch*, 54–56.

10. Dempwolff, "Über aussterbende Völker" (1904), 395–396. Dempwolff gave his talk in Berlin on November 28, 1903.

11. Karchers Bericht, 12.2.1883, BArch RM 1, 2424, Bl. 99.

12. Hambruch, *Wuvulu* (1908), 11.

13. Dempwolff, *Tagebuch*, 56; Dempwolff, "Über aussterbende Völker," 396.

14. Brigitta Hauser-Schäublin, "Warum das Luf-Boot im Humboldt Forum bleiben kann," *Die Zeit*, July 15, 2021; Götz Aly, "Die alten Lügen leben noch. Eine Antwort auf meine Kritikerin," *Die Zeit*, July 29, 2021; Hauser-Schäublin, "Dieses Blut gehört dem König," *Frankfurter Allgemeine Zeitung*, January 17, 2020.

15. Eichhorn, "La mort d'une tribu."

16. Krämer, *Forschungsreisen* (1909), vol. 5, 70–71.

17. Militärpolitischer Bericht v. Kapitänleutnant Wilhelm Lebahn, 26.10.1906, BArch RM 3, 3021, Bl. 34–35.

18. Dempwolff, "Über aussterbende Völker," 391, 396.

19. Dempwolff, *Tagebuch*, 52 (photo); Krämer, *Forschungsreisen* (1909), vol. 5, 78–80.

20. Hist. Archiv Köln, Best. 614, A 308. Thanks to Rainer Buschmann for pointing out this information.

21. Vermerke Luschans, April u. Mai 1903, ZA-SPK Ethnolog. Museum, Film 215, no. 0586–0588. As above, thanks to Rainer Buschmann.

22. Nevermann, "Agomes-Boot" (1954), 35–38.

23. SBB Nl. Luschan, K. 10 (Colleg Oceanien, Neu-Holland).

24. *Führer durch das Museum für Völkerkunde* (1908), 116.

## 10. AN ARTIFACT OF AN ANCIENT CULTURE

1. Thilenius, "Bedeutung der Meeresströmungen" (1906), 2.
2. Bastian, *Zur Kenntnis Hawaiis* (1883), 12.
3. Zimmermann, "Kolonialismus" (2012), 173–174; P. Schnee, "Schwarzbraune Landsleute" (1899), 28.
4. Dempwolff, "Erziehung der Papuas" (1899), 4.
5. Krämer, *Forschungsreise* (1909), vol. 5, 83.
6. Luschan, "Ziele und Wege" (1903), 169.
7. Krämer, *Forschungsreise*, vol. 5, 85–91.
8. Hambruch, "Schiffahrt" (1931), 383–385.
9. Thilenius, *Ethnographische Ergebnisse*, vol. 1 (1902), 5.
10. Thilenius, *Ethnographische Ergebnisse*, vol. 2 (1903), 190–194; Nevermann, *Admiralitäts-Inseln* (1934), 282–294. Many thanks to Anne Di Piazza, researcher at the CREDO Maison Asie-Pacifique, Université d'Aix-Marseille, for reviewing the technical description of the Luf Boat. The English translation is partly based on Haddon and Hornell, *Canoes of Oceania*, vol. 2, 172–174.
11. Thilenius, "Ornamentik" (1903), 181.
12. Kirch, *On the Road* (2017), 13–14.
13. Kirch, "Peopling of the Pacific" (2010), 133; Green, "Near and Remote Oceania" (1991).
14. Thilenius, "Bedeutung der Meeresströmung," 2, 11–12, 14.
15. Finney, "Voyaging Canoes" (1977), 1277.
16. Finney, "Voyaging Canoes," 1279, 1284.
17. See Joannidis et al., "Native American Gene Flow" (2020).
18. Friederici, "Malaio-Polynesische Wanderungen" (1915), 201, 207.
19. O'Connell and Allen, "The Restaurant" (2012), 12.
20. Irwin, *Prehistoric Exploration* (1992), 31.
21. Kirch, *On the Road*, 79, 94.
22. Green, "The Lapita Cultural Complex" (1991), 298–299.
23. Torrence and Swadling, "Social Networks" (2008).
24. Posth et al., "Language Continuity" (2018).
25. Kirch, "Lapita and Its Aftermath" (1996), 61.
26. Schellong, "Bemerkungen" (1904), 176–177; Schellong, *Alte Dokumente* (1934), 128–131; see also Malinowski, *Argonauten* (1984), 266.
27. Helferich, "Boote aus Melanesien" (1985), 53–54; Koch, "Boote aus Polynesien" (1984), 28–29.

## 11. ISLANDS STRIPPED BARE

1. For an overview, see Buschmann, "Illuminating" (2016), 37.
2. Zimmerman, "Kolonialismus" (2012), 178.
3. Vermerk des Reichskolonialamts über eine Unterredung mit Herrn v. Luschan, 13.2.1906, BArch R 1001, 2780, Bl. 45.
4. On Thiel's various honors: GStA I HA, Rep. 89, 20491, Bl. 212–214; 20492, Bl. 1–3; Ordensverleihungen an den Mitinhaber der Firma Hernsheim & Co in Matupi, Maximilian Thiel, 1908–1913, StAHbg 132-1 I_698.
5. NHM-Wien Anthropologische Slg., Inventarbuch, Osteologische Slg., Skelette, Bd. 3, no. 3331–3341.
6. Laukötter, "Kultur" (2007), 166; Thilenius, *Hamburgische Museum für Völkerkunde* (1916), 14.
7. Hambruch, *Wuvulu* (1908), 11.
8. Hahl, *Gouverneursjahre* (1937), 179–180.
9. Parkinson an Luschan, 6.2.1904, SBB Nl. Luschan. The Gazelle Peninsula was named after the German ship the *Gazelle*, whose crew had surveyed the region in 1875.
10. Müller, *Beiträge* (1905), 7; Luschan, "Vier Schädel" (1908), 146, 149.
11. Hellwig, Tagebuch der Hamburger Südsee-Expedition, 30.11.1908, passim, MARKKArch. Süd 17.
12. Weltmuseum Wien, Archiv, SM Friedrich Thiel; F. Thiel an F. Heger, Ethnogr. Abt. des Naturhist. K.K. Hofmuseums Wien, 4. u. 18.1. u. 6.2.1894; Schriftwechsel Heger-Thiel.
13. Buschmann, *Anthropology's Global Histories* (2009), 44–45.
14. Krug, *Hauptzweck* (2005), 237–288; Hahl, *Gouverneursjahre* (1937), 184–185; Jaspers, "Historische Untersuchungen" (1979).
15. Thiel an Schnee, 12.10.1904, GStA VI. HA, Nl. Schnee, Nr. 54.
16. Fellmann, *Von Schwaben in den Bismarckarchipel* (2009), 164.
17. Traditionsverband ehemaliger Schutz- und Überseetruppen, Freunde der früheren deutschen Schutzgebiete, http://www.traditionsverband .de/download/pdf/gefechtsspangen.pdf.
18. Wendland, *Wunderland* (1939), 190–191.
19. Bartels, "Referat zu Eugen Fischers Vortrag" (1905).
20. Thiel an Schnee, 12.10.1904, GStA VI. HA, Nl. Schnee, no. 54.
21. Anderhandt, *Hernsheim*, vol. 2 (2012), 241.

22. Wahlen, "How I Repopulated the Ninigos" (1952), 71; "Once a King on Maron" (1958), 79, 95. Thanks to Jakob Anderhandt for alerting me to the magazine *Pacific Islands Monthly*.

23. Wilda, *Reise auf S.M.S. "Möwe"* (1903), 129, 160–161.

24. Denkschrift über Desiderata des Kgl. Ethnographischen Museums zu Dresden in Bezug auf die Gegenden, welche die Schiffe der Kaiserlichen Deutschen Marine berühren, gez. A.B. Meyer, Dresden, den 1. Juli 1883, 5, 13–15, 23–24.

25. Luschan, "Ethnographie von Neu-Guinea" (1899), 449–450; Luschan, *Beiträge zur Völkerkunde* (1907), preface.

26. Krämer to Luschan, May 17, 1904, SBB Nl. Luschan.

27. Krämer, "Der Neubau" (1904), 22, 24.

## 12. WHERE DOES THE LUF BOAT BELONG?

1. Stöhr, *Kunst und Kultur* (1987), 195–197, 372–373. Henning von Holtzendorff, later an admiral, earned notoriety for his support for unlimited submarine warfare in the First World War. He sold the statue to the Cologne museum in 1884.

2. "Grütters zu Kolonialobjekten: 'Dialog auf Augenhöhe führen,'" *Süddeutsche Zeitung*, October 17, 2019, https://www.sueddeutsche .de/politik/kulturpolitik-berlin-gruetters-zu-kolonialobjekten-dialog -auf-augenhoehe-fuehren-dpa.urn-newsml-dpa-com-20090101-191017 -99-339110.

3. Fellmann, "Gesammelt" (2019), 34.

4. Scholz, "Humboldt Lab" (2015), 287.

5. Hermann Parzinger, "Editorial," *SPK. Das Magazin* no. 1, 2019, 3.

6. "Toi moko aus dem Ethnologischen Museum kehren nach Neusee-land zurück," press release, Stiftung Preussischer Kulturbesitz, Berlin, October 10, 2020, https://www.preussischer-kulturbesitz.de /pressemitteilung/artikel/2020/10/12/toi-moko-aus-dem-ethno logischen-museum-kehren-nach-neuseeland-zurueck.html.

7. The Heidelberg Statement: "Decolonising Requires Dialogue, Expertise and Support," approved at the 2019 Annual Conference of the Directors of Ethnographic Museums in German-Speaking Countries, May 6, 2019, https://www.basa.uni-bonn.de/medien /2019-heidelberg-statement.

8. Zimmerer, *Kulturgut aus der Kolonialzeit* (2015), 25.
9. Holfelder, *Raubgut* (2019), 139–140.
10. Stephan, *Südseekunst* (1907), 131.
11. "Festrede von Chimamanda Adichie," Humboldt Forum, September 22, 2021, https://www.humboldtforum.org/de/programm/digitales-angebot/digital/festrede-von-chimamanda-adichie-32872/.
12. "Raubkunst im Humboldt Forum?" radio feature by Lorenz Rollhäuser, Deutschlandfunk, Kultur, September 23, 2017.
13. Stephan an Luschan, 14.9.1907 (S.4), SBB Nl Luschan. Thanks to Rainer Buschmann for alerting me to this source.
14. "Grütters zu Kolonialobjekten."
15. "About the Collection," Südsee und Australien Collection, Ethnologisches Museum, Berlin, July 6, 2018, https://smb.museum-digital.de/collection/12.
16. Craig (ed.), *Living Spirits*, 25–42, 145, 165.
17. See Hermann Parzinger's remarks in *taz* newspaper (June 25, 2021).
18. Quoted in Craig (ed.), *Living Spirits*, 4.

# Bibliography

Aly, Gottlob Johannes. "Nach allen fünf Erdteilen. Zwei Jahre Pfarrer an
  Bord S.M.S. Elisabeth." *Gemeinde-Blatt der Hauptkirche St. Petri
  in Hamburg* 11, no. 1 / 2 (1936), 1–7, and no. 3 / 4 (1936), 13–21.
Aly, Götz. "Nulla dies sine linea. Pädagoge, Philologe und Schulpolitiker.
  Friedrich Aly (1862–1913) in seiner Zeit." *Hessisches Jahrbuch für
  Landesgeschichte* 71 (2021), 61–78.
——— (ed.). *Siegfried Lichtenstaedter, Prophet der Vernichtung. Über
  Volksgeist und Judenhass.* Frankfurt a.M., 2019.
*Amtliche Berichte aus den Königlichen Kunstsammlungen.* [Teils Amtliche
  Berichte aus den Preußischen Kunstsammlungen, teils als
  Beiblatt zum Jahrbuch der Königl. Preuß. Kunstsammlungen,
  teils als Beiblatt zum Jahrbuch.] Berlin, 1880–1919.
Anderhandt, Jakob. "Abenteuer, Technik, Fortschritt. Aus den Lebenser-
  innerungen von Eduard Hernsheim." *Eremitage: Zeitschrift für
  Literatur* 12 (2006), 33–56.
———. *Eduard Hernsheim, die Südsee und viel Geld. Biographie,* 2 vols.
  Münster, 2012.
———. "Statt im Großen zu irren. Das praktische Kolonialprogramm
  Eduard Hernsheims." *Saeculum: Jahrbuch für Universalgeschichte*
  64 / I (2014), 55–71.
Baessler, Arthur. *Südsee-Bilder.* Berlin, 1895.
Bartels, Paul. "Referat zu Eugen Fischers Vortrag 'Anatomische Untersu-
  chungen an den Kopfweichteilen zweier Papua.'" *Korrespondenz-
  blatt der dt. Gesellschaft für Anthropologie, Ethnologie und
  Urgeschichte* 36, no. 10 (1905), 118–122.

Bastian, Adolf. *Zur Kenntnis Hawaiis. Nachträge und Ergänzungen zu den Inselgruppen in Oceanien.* Berlin, 1883.

Baumann, Karl. *Franz Hellwig in Deutsch-Neuguinea. Eine Lebensgeschichte aufgrund überlieferter postalischer und literarischer Dokumente.* Faßberg, 1994.

———, Dieter Klein, and Wolfgang Apitzsch. *Biographisches Handbuch Deutsch-Neuguinea, 1882–1922. Kurzlebensläufe ehemaliger Kolonisten, Forscher, Missionare und Reisender,* 2nd ed. Berlin, 2002.

Bode, Wilhelm von. *Mein Leben,* 2 vols. Berlin, 1930.

Brüll, Margarete. "Die deutschen Kolonien in der Südsee." In Museum für Völkerkunde (ed.), *Als Freiburg die Welt entdeckte. 100 Jahre Museum für Völkerkunde.* Freiburg, 1995.

Buschmann, Rainer F. *Anthropology's Global Histories: The Ethnographic Frontier in German New Guinea, 1870–1935.* Honolulu, 2009.

———. "Exploring Tensions in Material Culture: Commercializing Ethnography in German New Guinea, 1870–1904." In O'Hanlon and Welsch (eds.), *Hunting the Gatherers,* 55–80.

———. "Illuminating Ethnographic Borderlands: Modelling Collection Histories in German New Guinea, 1880–1914." *Museumkunde* 81, no. 1 (2016), 35–39.

———. "Oceanic Collections in German Museums: Collections, Contexts, and Exhibits." In Lucie Carreau et al. (eds.), *Pacific Presences,* vol. 1: *Oceanic Art and European Museums,* 197–250. Leiden, 2018.

Carstensen, Christian, and Andrea Dörfel. "Andenken und Trophäen. Wie Ethnographica und Großwildtrophäen in Museen gelangten." In Harms (ed.), *Andenken an den Kolonialismus,* 95–113.

Craig, Barry (ed.). *Living Spirits with Fixed Abodes: The Masterpieces Exhibition. Papua New Guinea National Museum and Art Gallery.* Honolulu, 2010.

Dempwolff, Otto. "Bericht über eine Malaria-Expedition nach Deutsch-Neu-Guinea." *Zeitschrift für Hygiene und Infektionskrankheiten* 47, no. 1 (1904), 81–132.

———. "Die Erziehung der Papuas zu Arbeitern." *Koloniales Jahrbuch, Beiträge und Mitteilungen aus dem Gebiete der Kolonialwissenschaft und Kolonialpraxis* 11 (1899), 1–14.

————. *Tagebuch von den Westlichen Inseln 1902*, ed. Michael Duttge. Norderstedt, 2019.

————. "Über aussterbende Völker. Die Eingeborenen der 'westlichen Inseln' in Deutsch-Neu-Guinea." *Zeitschrift für Ethnologie* 36 (1904), 384–415.

*Deutschland und seine Kolonien im Jahre 1896. Amtlicher Bericht über die erste Deutsche Kolonial-Ausstellung*, ed. Arbeitsausschuss der Dt. Kolonial-Ausstellung. Berlin, 1897.

Eichhorn, August. "La mort d'une tribu." *Documents* 1, no. 6 (1929), 336–337.

Fellmann, Johanna. *Von Schwaben in den Bismarckarchipel. Tagebücher der Missionarsfrau Johanna Fellmann aus Deutsch-Neuguinea 1896–1903*, ed. Ulrich Fellmann. Wiesbaden, 2009.

Fellmann, Johannes. "Gesammelt, erbeutet, erworben? Ob Offizier, Gouverneur, Wissenschaftler, Händler oder Missionar: In den deutschen Kolonien herrschte die Gier nach ethnographischen Objekten." *Arsprototo. Das Magazin der Kulturstiftung der Länder* 1 (2019), 27–35.

Finney, Ben R. "Voyaging Canoes and the Settlement of Polynesia." *Science* 196 (1977), 1277–1285.

Finsch, Otto. *Samoafahrten. Reisen in Kaiser-Wilhelms-Land und Englisch-Neu-Guinea in den Jahren 1884 u. 1885 an Bord des deutschen Dampfers "Samoa."* Leipzig, 1888.

————. *Über Naturprodukte der westlichen Südsee, besonders der deutschen Schutzgebiete*. Beiträge zur Förderung der Bestrebungen des Deutschen Kolonialvereins, vol. 7. Berlin 1887.

Fischer, Hans. *Die Hamburger Südsee-Expedition. Über Ethnographie und Kolonialismus*. Frankfurt a.M., 1981.

Friederici, Georg. "Malaio-Polynesische Wanderungen." In Georg Kollm (ed.), *Verhandlungen des neunzehnten Deutschen Geographentages zu Straßburg im Elsass, vom 2. Bis 7. Juni 1914*, xxxi–xxxiv, 198–212. Berlin, 1915.

————. *Wissenschaftliche Ergebnisse einer amtlichen Forschungsreise nach dem Bismarck-Archipel im Jahre 1908*, vol. 2: *Beiträge zur Völker- und Sprachenkunde von Deutsch-Neuguinea*. Berlin, 1912. (Reprint, 2018.)

*Führer durch das Museum für Völkerkunde*, ed. Generalverwaltung der Königl. Museen zu Berlin. Berlin, 1908.

Green, Roger Curtis. "The Lapita Cultural Complex. Current Evidence and Proposed Models." *Bulletin of the Indo-Pacific Prehistory Association* 11 (1991), 296–305.

———. "Near and Remote Oceania: Disestablishing 'Melanesia' in Culture History." In Andrew Pawley (ed.), *Man and a Half: Essays in Pacific Anthropology and Ethnobiology in Honor of Ralph Bulmer*, 491–502. Auckland, 1991.

Grimme, Gesa. "Provenienzforschung im Projekt 'Schwieriges Erbe: Zum Umgang mit kolonialzeitlichen Objekten in ethnologischen Museen.'" Final report. Linden-Museum. Stuttgart, 2018.

Haddon, Alfred C., and James Hornell. *Canoes of Oceania*, 3 vols. Reprint. Honolulu, 1975.

Hahl, Albert. *Deutsch-Neuguinea*. Berlin, 1936.

———. *Gouverneursjahre in Neuguinea*. Berlin, 1937.

Hambruch, Paul. "Die Anthropologie von Kaniët." *Mitteilungen aus dem Museum für Völkerkunde in Hamburg*, supp. 5 (1906), 23–70.

———. "Die Schiffahrt in der Südsee." *Der Erdball* 5, no. 10 (1931), 381–391.

———. *Wuvulu und Aua (Maty- und Durour-Inseln). Auf Grund der Sammlung F. E. Hellwig aus den Jahren 1902 bis 1904*. Hamburg, 1908. (Reprint, 2018.)

Harms, Volker (ed.). *Andenken an den Kolonialismus. Eine Ausstellung des Völkerkundlichen Instituts der Universität Tübingen*. Tübingen, 1984.

Helferich, Klaus. "Boote aus Melanesien und Australien." In Koch (ed.) *Boote aus aller Welt*, 33–54.

Hellwig, Franz Emil. "Tagebuch der Expedition." *Ergebnisse der Südsee-Expedition 1908–1910*, vol. 1: *Allgemeines*, ed. Georg Thilenius, 41–359. Hamburg, 1927.

Hernsheim, Franz. *Südsee-Erinnerungen*. With a foreword by Otto Finsch. Berlin, 1888.

———. *Südsee-Schriften. Lebenserinnerungen und Tagebücher*, ed. Jakob Anderhandt. With a foreword by Robert Creelman. Hamburg, 2019.

Holfelder, Moritz. *Unser Raubgut. Ein Seitenschritt zur kolonialen Debatte*. Berlin, 2019.

Irwin, Geoffrey. *The Prehistoric Exploration and Colonisation of the Pacific*. Cambridge, 1992.

Jacques, Norbert. *Südsee. Ein Reisetagebuch.* Munich, 1922.

Jaspers, Reiner. "Historische Untersuchungen zu einem Mord an Missionaren auf New Britain (Papua New Guinea) 1904." *Zeitschrift für Missionswissenschaft und Religionswissenschaft* 68 (1979), 1–24.

Joannidis, A. G., J. Blanco-Portillo, K. Sandoval, et al. "Native American Gene Flow into Polynesia Predating Easter Island Settlement." *Nature* 583 (2020), 572–577.

Kamp, Michael. "Das Museum als Ort der Politik. Münchner Museen im 19. Jahrhundert." PhD diss., LMU Munich, 2002. https://edoc.ub .uni-muenchen.de/4080/.

Kell, Katherine T. "Folk Names for Tobacco," *Journal of American Folklore* 79 (1966), 590–599.

Kirch, Patrick Vinton. "Lapita and Its Aftermath: The Austronesian Settlement of Oceania." *Transactions of the American Philosophical Society,* n.s. 86, no. 5 (1996), 57–70.

———. *On the Road of the Winds: An Archaeological History of the Pacific Islands before European Contact,* rev. and exp. ed. Berkeley, 2017.

———. "Peopling of the Pacific: A Holistic Anthropological Perspective." *Annual Review of Anthropology* 39 (2010), 131–148.

Knoll, Liselotte. "Felix v. Luschan. Ergänzungen und Beiträge zu biographischen Daten eines Pioniers der Ethnologie." Thesis, University of Vienna, 2004.

Koch, Gerd (ed.). *Boote aus aller Welt.* Berlin, 1984.

———. "Boote aus Polynesien und Mikronesien." In Koch (ed.), *Boote aus aller Welt,* 11–31.

———. "Hundert Jahre Museum für Völkerkunde. Abteilung Südsee." *Baessler Archiv N.F.* 21 (1973), 141–174.

———. *Südsee. Führer durch die Ausstellung der Abteilung Südsee.* Berlin, 1969.

Koenig, Harry. *Heiß Flagge! Deutsche Kolonialgründungen durch S.M.S. "Elisabeth."* Leipzig, 1934.

———. *Über See! S.M.S. "Elisabeth" Weltreise—Zanzibar—Tsingtau.* Berlin, 1926.

König, Viola. "Die Konzeptdebatte." In König and Scholz (ed.), *Humboldt-Forum,* 13–62.

———, and Andrea Scholz (eds.). *Humboldt-Forum. Der lange Weg 1999–2012.* Berlin, 2012. [Also published in *Baessler Archiv* vol. 59 (2011).]

*Königliche Museen zu Berlin. Das Königliche Museum für Völkerkunde am 18. Dezember 1886.* Berlin, 1886.

"Konzept zur Präsentation der außereuropäischen Sammlungen im Humboldt-Forum. Ethnologisches Museum." With an introduction by Hermann Parzinger et al. In König and Scholz (eds.), *Humboldt-Forum*, 113–184.

Krämer, Augustin. *Forschungsreise S.M.S. "Planet" 1906 / 7,* vol. 1: *Reisebeschreibung,* ed. Reichs-Marine-Amt. Berlin, 1909.

———. *Forschungsreise S.M.S. "Planet" 1906 / 7,* vol. 5: *Anthropologie und Ethnographie. Beobachtungen und Studien,* ed. Reichs-Marine-Amt. Berlin, 1909.

———. "Der Neubau des Berliner Museums für Völkerkunde im Lichte der ethnographischen Forschung." *Globus* 86, no. 2 (1904), 21–24.

———. "Zur Volkskunde der Matupiter und Wanderungsfragen. Ein Beitrag zur Monographie." In Michael Hesch and Günther Spannaus (eds.), *Kultur und Rasse, Otto Reche zum 60. Geburtstag,* 354–363. Munich, 1939.

Krämer-Bannow, Elisabeth. *Bei kunstsinnigen Kannibalen der Südsee. Wanderungen auf Neu-Mecklenburg 1908–1909.* Berlin, 1916. [*Among Art-Loving Cannibals of the South Seas: Travels in New Ireland, 1908–1909,* trans. Waltraud Schmidt. Adelaide, 2009.]

Krug, Alexander. *"Der Hauptzweck ist die Tötung von Kanaken." Die deutschen Strafexpeditionen in den Kolonien der Südsee 1872–1914.* Tönning, 2005.

Kuhn, Hellmuth. *Die deutschen Schutzgebiete, ihr Erwerb und ihre oberste Verwaltung.* Berlin, 1913.

Kundraß, Eva. "Zwischen Natur- und Geisteswissenschaft," In Ruggendorfer and Szemethy (eds.), *Felix von Luschan,* 99–111.

Laukötter, Anja. *Von der "Kultur" zur "Rasse," vom Objekt zum Körper? Völkerkundemuseen und ihre Wissenschaften zu Beginn des 20. Jahrhunderts.* Bielefeld, 2007.

Lichtenstaedter, Siegfried (pseudonym Mehemed Emin Efendi). *Kultur und Humanität: Völkerpsychologische und politische Untersuchungen.* Würzburg, 1897.

Loosen, Livia. *Deutsche Frauen in den Südsee-Kolonien des Kaiserreichs. Alltag und Beziehungen zur indigenen Bevölkerung, 1884–1919.* Bielefeld, 2014.

Luschan, Felix von. *Anleitung zu wissenschaftlichen Beobachtungen auf dem Gebiete der Anthropologie, Ethnographie und Urgeschichte.* Berlin, 1910.

———. "Die anthropologische Stellung der Juden." *Allgemeine Zeitung des Judentums* 52 (1892), 616–618, and 53 (1892), 628–630.

———. "Anthropologische Studien." In Eugen Petersen and Felix von Luschan (eds.), *Reisen in Lykien, Milyas und Kibyratis,* 198–226. Vienna, 1889.

———. *Beiträge zur Völkerkunde der deutschen Schutzgebiete.* Berlin, 1897.

———. *Beiträge zur Völkerkunde in den deutschen Schutzgebieten, erw. Sonderausg. aus dem Amtlichen Bericht über die erste deutsche Kolonialausstellung 1906.* Berlin, 1907.

———. "Bericht über eine Reise in Südafrika." *Zeitschrift für Ethnologie* 38 (1906), 863–895.

———. "Ethnographie von Neu-Guinea." In M. Krieger (ed.), *Neu-Guinea,* 439–524. Berlin, 1899.

———. "Rassen und Völker." Speech given on November 2, 1915, Berlin. [Also published in *Deutsche Reden in schwerer Zeit,* vol. 33.]

———. "Über vier Schädel von Abusir." In Heinrich Schäfer et al., *Priestergräber und andere Grabfunde vom Ende des alten Reiches bis zur griechischen Zeit vom Totentempel des Ne-user-rê,* 146–151. Leipzig, 1908.

———. "Völkerkunde." In *Deutschland und seine Kolonien im Jahre 1896,* 203–269.

———. *Völker, Rassen, Sprachen.* Berlin, 1927. (First ed., 1922.)

———. "Ziele und Wege der Völkerkunde in den deutschen Schutzgebieten." In *Verh. des Dt. Kolonialkongresses 1902 zu Berlin am 10.u.11. Okt.,* 163–174. Berlin, 1903.

———. "Zur Ethnographie des Kaiserin-Augusta-Flusses." *Baessler-Archiv* 1 (1911), 103–117.

Malinowski, Bronisław. *Argonauten des westlichen Pazifik. Ein Bericht über Unternehmungen und Abenteuer der Eingeborenen in den Inselwelten von Melanesisch-Neuguinea.* Frankfurt a.M., 1984. [Originally published as *Argonauts of the Western Pacific: An Account of Native Enterprise and Adventure in the Archipelagoes of Melanesian New Guinea.* New York, 1922.]

Melk-Koch, Marion. "Zwei Österreicher nehmen Einfluss auf die Ethnologie in Deutschland: Felix von Luschan und Richard

Thurnwald." In Britta Rupp-Eisenreich and Gustav Stangl (eds.), *Kulturwissenschaften im Vielvölkerstaat. Zur Geschichte der Ethnologie und verwandter Gebiete in Österreich, ca. 1780—1980*, 132–140. Vienna, 1995.

Mencken, H. L. "Designations for Colored Folk." *American Speech* 19 (1944), 161–174.

Mönter, Sven. "Dr. Augustin Krämer: A German Ethnologist in the Pacific." PhD diss., University of Auckland, 2010.

Müller, Wilhelm. *Beiträge zur Kraniometrie der Neu-Britannier*. Berlin, 1905.

———. "Die Religionen der Südsee 1905–1910." *Archiv für Religionswissenschaft* 16 (1913), 176–207.

Nevermann, Hans. *Admiralitäts-Inseln*. Hamburg, 1934.

———. "Das Agomes-Boot des Museums für Völkerkunde." *Berliner Museen* 4, no. 3 / 4 (1954), 35–38.

———. "Augustin Krämer 75 Jahre." *Archiv für Anthropologie, Völkerforschung und kolonialen Kulturwandel* N.F. 26 (1941), 138–139.

———. *Die Schiffahrt exotischer Völker*. Berlin, 1949.

Nuhn, Walter. *Kolonialpolitik und Marine. Die Rolle der Kaiserlichen Marine bei der Gründung und Sicherung des deutschen Kolonialreiches 1884–1914*. Bonn, 2002.

O'Connell, James F., and Jim Allen. "The Restaurant at the End of the Universe: Modelling the Colonisation of Sahul." *Australian Archaeology* 74 (June 2012), 5–17.

O'Hanlon, Michael, and Robert L. Welsch (eds.). *Hunting the Gatherers: Ethnographic Collectors, Agents, and Agency in Melanesia, 1870s–1930s*. New York, 2000.

"Once a King on Maron: Heinrich Rudolph Wahlen Expects to Live to Be One Hundred." *Pacific Islands Monthly* 28, no. 11 (1958), 79, 95.

*Original-Mittheilungen aus der Ethnologischen Abtheilung der Königlichen Museen zu Berlin*. Berlin, 1885–1886.

Parkinson, Richard. *Dreißig Jahre in der Südsee. Land und Leute, Sitten und Gebräuche im Bismarckarchipel und auf den deutschen Salomoinseln*. Stuttgart, 1907.

———. *Im Bismarck-Archipel. Erlebnisse und Beobachtungen auf der Insel Neu-Pommern (Neu-Britannien)*. Leipzig, 1887.

Poser, Alexis von, and Bianca Baumann (eds.). *Heikles Erbe: Koloniale Spuren bis in die Gegenwart.* Dresden, 2016.

Posth, Cosimo, et al. "Language Continuity Despite Population Replacement in Remote Oceania." *Nature Ecology & Evolution* 2 (2018), 731–740.

Romilly, Hugh H. *The Western Pacific and New Guinea. Notes on the Natives, Christian and Cannibal, with Some Account of the Old Labour Trade.* London, 1886.

Ruggendorfer, Peter, and Hubert D. Szemethy (eds.). *Felix von Luschan (1854–1924). Leben und Wirken eines Universalgelehrten.* Vienna, 2009.

Rusch, Walter. "Der Beitrag Felix von Luschans für die Ethnographie." *Ethnographisch-Archäologische Zeitschrift* 27 (1986), 439–453.

Sapper, Karl. "Die Bedrohung des Bestandes der Naturvölker und die Vernichtung ihrer Eigenart." *Archiv für Rassen- und Gesellschafts-Biologie einschließlich der Gesellschaftshygiene* 12 (1916 / 1918), 268–320, 417–439.

Schellong, Otto. *Alte Dokumente aus der Südsee. Zur Geschichte der Gründung einer Kolonie. Erlebtes und Eingeborenenstudien.* Königsberg [Kaliningrad], 1934.

———. "Einige Bemerkungen über die Fahrzeuge (Kanus) der Papuas von Kaiser-Wilhelmsland und dem Bismarck-Archipel." *Internationales Archiv für Ethnographie* 16 (1904), 176–179.

Schmidt, Wilhelm. "Ethnographisches von Berlinhafen, Deutsch-Neu-Guinea." *Mittheilungen der Anthropologischen Gesellschaft in Wien* 29 (1899), 13–29.

Schnee, Heinrich. *Bilder aus der Südsee. Unter den kannibalischen Stämmen des Bismarck-Archipels.* Berlin, 1904.

——— (ed.). *Deutsches Kolonial-Lexikon.* 3 vols. Leipzig, 1920.

Schnee, Paul. "Unsere schwarzbraunen Landsleute in Neuguinea." *Beiträge zur Kolonialpolitik und Kolonialwirtschaft* 1, no. 1 (1899 / 1900), 27–32, 61–64, 88–96, 117–127.

Scholz, Andrea. "Das Humboldt Lab Dahlem. Experimentelle Freiräume auf dem Weg zum Humboldt-Forum." In Michael Kraus and Karoline Noack (eds.), *Quo vadis, Völkerkundemuseum? Aktuelle Debatten zu ethnologischen Sammlungen in Museen und Universitäten,* 277–297. Bielefeld, 2015.

Schott, Lothar. "Zur Geschichte der Anthropologie an der Berliner Universität." *Wissenschaftliche Zeitschrift der Humboldt-Universität zu Berlin. Mathematisch-naturwissenschaftliche Reihe* 10, no. 1 (1961), 57–65.

Stephan, Emil. *Südseekunst. Beiträge zur Kunst des Bismarck-Archipels und zur Urgeschichte der Kunst überhaupt.* Aus dem Königlichen Museum für Völkerkunde zu Berlin mit Unterstützung des Reichs-Marine-Amts. Berlin, 1907.

Stöhr, Waldemar. *Kunst und Kultur aus der Südsee.* Köln, 1987.

Tappenbeck, Ernst. *Deutsch-Neuguinea.* Berlin, 1901.

Thamm, Adolph. *Samoa—eine Reise in den Tod. Die Briefe des Obermatrosen Adolph Thamm v. S.M. Kanonenboot Eber 1887–1889.* Eingeleitet und kommentiert von Karl-Theo Beer. Hamburg, 1994.

Thilenius, Georg. "Die Arbeiterfrage in der Südsee." *Globus* 77, no. 5 (1900), 69–72.

———. "Die Bedeutung der Meeresströmungen für die Besiedelung Melanesiens." In *Mitteilungen aus dem Museum für Völkerkunde in Hamburg*, 1–21. Hamburg, 1906.

———. *Ethnographische Ergebnisse aus Melanesien*, vol. 1: *Reisebericht— Die polynesischen Inseln an der Ostgrenze Melanesiens.* Halle, 1902.

———. *Ethnographische Ergebnisse aus Melanesien*, vol. 2: *Die westlichen Inseln des Bismarck-Archipels.* Halle, 1903.

———. *Das Hamburgische Museum für Völkerkunde.* Berlin, 1916.

———. "Die Ornamentik von Agomes." *Correspondenz-Blatt der deutschen Gesellschaft für Anthropologie, Ethnologie und Urgeschichte* 34 (1903), 180–185.

Tischner, Herbert. "Eine Häuptlingsbestattung auf Luf nach hinterlassenen Aufzeichnungen F. E. Hellwig's." *Zeitschrift für Ethnologie* 75 (1950), 52–59.

Torrence, Robin, and Pamela Swadling. "Social Networks and the Spread of Lapita." *Antiquity* 82 (2008), 600–616.

Tunis, Angelika. "Ein erfülltes Leben für die Wissenschaft in Theorie und Praxis." In Ruggendorfer and Szemethy (eds.), *Felix von Luschan*, 43–51.

Virchow, Hans. "Gedächtnisrede auf Felix v. Luschan." *Zeitschrift für Ethnologie* 56 (1924), 112–117.

*Vorläufiger Führer durch das Museum für Völkerkunde. Schausammlung.* Berlin, 1926.

Wahlen, H. R. "H. R. Wahlen Tells 'How I Repopulated the Ninigos.'" *Pacific Islands Monthly* 22, no. 5 (1952), 71, 77–79.

[Warnecke, Karl.] "Die nordwestlichen Inselgruppen des Bismarck-Archipels." *Deutsches Kolonialblatt. Amtsblatt für die Schutzgebiete des Deutschen Reichs* 13 (1902), 197–223.

Wendland, Wilhelm. *Im Wunderland der Papuas. Ein deutscher Kolonialarzt erlebt die Südsee.* Berlin, 1939.

Wilda, Johannes. *Reise auf S.M.S. "Möwe." Streifzüge in Südseekolonien und Ostasien.* Berlin, 1903.

Zimmerer, Jürgen. "Kulturgut aus der Kolonialzeit—ein schwieriges Erbe?" *Museumskunde* 80, no. 2 (2015), 22–25.

Zimmerman, Andrew. *Anthropology and Antihumanism in Imperial Germany.* Chicago, 2001.

———. "Kolonialismus und ethnographische Sammlungen in Deutschland." In Pim den Boer et al. (eds.), *Europäische Erinnerungsorte,* vol. 3: *Europa und die Welt,* 173–186. Munich, 2012.

# Sources and Acknowledgments

In comparison with the history of German colonialism in Africa, the events of the German colonies in the South Seas have been the subject of little critical research in Germany. Several outstanding scholars based in the broader Pacific region have, however, written on the topic. Sven Mönter, of the University of Auckland, has worked on the ethnologist Augustin Krämer. Rainer Buschmann, a professor at California State University Channel Islands, has written for years about the ethnographic devastation of German New Guinea. Andrew Zimmerman did pathbreaking research on anthropology and colonialism in imperial Germany while at the University of California San Diego. Jakob Anderhandt from Sydney composed a thorough, eminently readable two-volume work entitled *Eduard Hernsheim, die Südsee und viel Geld* (Eduard Hernsheim, the South Seas, and Piles of Money).

Among the few critical works published in German, I would respectfully highlight the unfortunately obscure *"Der Hauptzweck ist die Tötung von Kanaken." Die deutschen Strafexpeditionen in den Kolonien der Südsee 1872–1914* ("The Main Point Is the Killing of *Kanaken*": German Punitive Expeditions in the South Seas Colonies, 1872–1914) by Alexander Krug, published in 2005. Several German ethnologists have made impressive first attempts to investigate

the holdings of ethnological museums, including Hans Fischer, in *Die Hamburger Südsee-Expedition. Über Ethnographie und Kolonialismus* (The Hamburg South Seas Expedition: On Ethnology and Colonialism) and the contributors to the 1984 catalogue *Andenken an den Kolonialismus. Eine Ausstellung des Völkerkundlichen Instituts der Universität Tübingen* (Remembrance of Colonialism: An Exhibit of the Ethnological Institute at the University of Tübingen), edited by Volker Harms.

A number of works glorify the Imperial Germany Navy but remain useful. One typical example is Walter Nuhn's *Kolonialpolitik und Marine. Die Rolle der Kaiserlichen Marine bei der Gründung und Sicherung des deutschen Kolonialreiches 1884–1914* (Colonial Policy and the Navy: The Role of the Imperial Navy in the Founding and Protection of the German Colonial Empire, 1884–1914). Other books, such as Hermann Joseph Hiery's 2005 *Bilder aus der deutschen Südsee* (Pictures from the German South Seas), fall under the category of "overenthusiasm in the exotic" and "voyeurism in the guise of ethnology."

Along with recent works of scholarship, I have based this book on memoirs, travelogues, magazine articles, ethnological works, and official publications from the period under investigation. In general, neither German nor other European colonists expressed any inklings of a bad conscience. On the contrary, they wrote quite openly about their massacres, ignorance, racist obsessions, economic goals, and ethnological looting sprees. The sources I consulted in various archives are by no means kept under lock and key.

For information and helpful criticism, I would like to thank Jakob Anderhandt, Margit Berner, Rainer Buschmann, Susan Zimmermann, and Michael Duttge. I am also indebted to doctoral candidate Alexander Schnickmann for his constant intellectual

involvement, research, and other work, which influenced this book in a variety of ways.

This book is dedicated to the Jewish German and Bavarian financial official Siegfried Lichtenstaedter. In 1897, he published under the pseudonym Mehemed Emin Efendi an unjustly forgotten, fundamental critique of German colonialism. Its harmless-sounding title was *Kultur und Humanität* (Culture and Humanity). To coincide with the German edition of this book, the Comino publishing house and I have brought out a new edition of that groundbreaking polemic. Siegfried Lichtenstaedter was murdered on December 6, 1942, in the Theresienstadt concentration camp.

# Illustration Credits

*Pages*

ii   *Frontispiece:* Private collection

x   Reproduced from Harry Koenig, *Heiß Flagge!: Deutsche Kolonialgründungen durch S.M.S. "Elisabeth"* (Leipzig: R. Voigtländers Verlag, 1934), p. 65.

11   Aly Family Archive

21   Reproduced from Richard Parkinson, *Dreißig Jahre in der Südsee* (Stuttgartt: Strecker & Schröder, 1907), p. 445.

23   Reproduced from Otto Dempwolff, *Tagebuch von den Westlichen Inseln 1902*, ed. Michael Duttge (Norderstedt: Books on Demand, 2019), p. 52.

27   Reproduced from *Forschungsreise S.M.S "Planet" 1906 / 7*, vol. 1: *Reisebeschreibung* (Berlin: Verlag von Karl Siegismund, 1909), p. 82.

30   *(above):* Reproduced from Wilhelm Wendland, *Im Wunderland der Papuas* (Berlin: Verlag für Volkstum, 1939), p. 112.

30   *(below):* Bundesarchiv, Koblenz, 134-D014.

38   Bundesarchiv Militärarchiv, Freiburg, RM 1, 2424, Bl. 124–125.

44   Reproduced from *Festschrift für Adolf Bastian zu seinem 70. Geburtstage. 26 Juni 1896* (Berlin: Dietrich Reimer, 1896).

45   Reproduced from Theodor de Bry, *Vierdte Buch von der Neuwen Welt* (Johann Feyerabend, 1594), plate XV.

50   Reproduced from *Pacific Islands Monthly*, no. 11, 1958, p. 85.

51   Reproduced from Otto Dempwolff, *Tagebuch von den Westlichen Inseln 1902*, ed. Michael Duttge (Norderstedt: Books on Demand, 2019), p. 53.

55   Reproduced from Hans Nevermann, *Kultur der Naturvölker* (Potsdam: Athenaion, 1939), plate II.

57   Ethnologisches Museum Berlin, object VI 24779a / b.

65   Landesarchiv Baden-Württemberg.

73   Reproduced from Wilhelm Wendland, *Im Wunderland der Papuas* (Berlin: Verlag für Volkstum, 1939), p. 132.

76   Naturhistorisches Museum, Vienna, inv. no. 3337.

85   Museum am Rothenbaum, Hamburg, Hamburger Südsee-Expedition / Bestand Vogel: inv. no. 9 / 2154.

88   Museum am Rothenbaum, Hamburg, Hamburger Südsee-Expedition / Bestand Vogel: inv. no. 9 / 2158.

93   Reproduced from Otto Dempwolff, *Tagebuch von den Westlichen Inseln 1902*, ed. Michael Duttge (Norderstedt: Books on Demand, 2019), p. 12.

97   Museum der Universität, Tübingen, Glasdi AOI-Es-Dia1276, Slg. Augustin Krämer.

104  Reproduced from Richard Parkinson, *Dreißig Jahre in der Südsee* (Stuttgartt: Strecker & Schröder, 1907), plate 30.

106  *(above)*: Staatsbibliothek zu Berlin, Nl. Luschan, K. 10.

106  *(below)*: Reproduced from Richard Parkinson, *Dreißig Jahre in der Südsee* (Stuttgartt: Strecker & Schröder, 1907), plate 31.

107  *(above)*: Museum der Universität, Tübingen, Glasdi AOI-Es-Dia1283, Slg. Augustin Krämer.

107  *(below)*: Weltmuseum Wien, Vienna, Teil-NI Otto Finsch 3 / 1 / 3.

108  *(above)*: Reproduced from *Forschungsreise S.M.S "Planet" 1906 / 7,* vol. 5: *Anthropologie und Ethnographie* (Berlin: Verlag von Karl Siegismund, 1909), p. 90.

108  *(below)*: Reproduced from F. Grabowsky, *Grundtypus und Endresultat* (Leiden: Internat. Arch. F. Ethnog, 1894).

121  Reproduced from *Forschungsreise S.M.S "Planet" 1906 / 7,* vol. 5: *Anthropologie und Ethnographie* (Berlin: Verlag von Karl Siegismund, 1909), p. 79.

124  Reproduced from Hans Nevermann, *Kultur der Naturvölker* (Potsdam: Athenaion, 1939), plate 23.

138  Museum der Universität, Tübingen, Glasdi AOI-Es-Dia1279, Slg. Augustin Krämer.

155  © Stiftung Humboldt Forum im Berliner Schloss / David von Becker.

162  *(above)*: Staatsarchiv, Hamburg, 731-8_A 758.

162  *(below)*: Aly personal collection.

164  Ethnologisches Museum, Berlin.

# Index

Page numbers in *italics* refer to photographs and illustrations.

Adichie, Chimamanda Ngozi, 147
Admiralty Islands, 124
Ali Island, 16–18
Aly, Gottlob Johannes, 1, 10–12, *11*, 53, 159
Aly (Siar) Island, 16, 18–19
Anderhandt, Jakob, 33, 47, 52, 57, 131
Andersen, A. F. V., 62
Ankermann, Bernhard, 82–83
anonymous purchase, 69–73
anthropology, ethnology *versus*, 75
anti-missionary rebellion. *See* Baining people, rebellion of
artifacts, 124; auction of, 60–61; controversy regarding, 133–135; cost of, 87–88, 133; endangering of, 134; ethical responsibility regarding, 143; examples of, 67; misrepresentation of, 5; restitution of, 142, 154–155. *See also* looting; *specific items; specific museums*
auction, of artifacts, 60–61
Australia, artifact return by, 154–155

Baessler, Arthur, 26
Baining people, rebellion of, 128–130
bartering, with tobacco, 53–58, *57*, 59, 63, 69–71, 150
Bastian, Adolf, 43–46, 63, 74, 79, 80–81; biography, 159; opinion on "natural peoples," 102
Bennigsen, Rudolf von, 64, 159–160
Berlin Ethnological Museum, 46, 55, 57, 66, 77
*Bilder aus der Südsee* (Schnee), 63–64
Bismarck, Otto von, 31–33, 37–38
Bismarck Archipelago, 1, 118–119, 120. *See also specific locations*
boatbuilding and boatbuilders, *85*, *97*, 101; description of, 103, 109–114, 120–121; studies regarding, 116–117
boathouse. *See* Luf boathouse
boats: description of, 109–114, 120–122; destruction of, 122; von Luschan's love of, 84–89; significance of, 122; storage of, 109–110. *See also* canoes; *specific vessels*

Bode, Wilhelm von, 77, 81–82, 89
Boether, Paul, 67
*Braunschweiger Landes-Zeitung*, 68
Bry, Theodor de, 44
*Buzzard (Bussard)*, 66, 72

cannibalism, 3
canoes, 88; acquisition of, 70, 87–88;
    celebration of, 120–121; descrip-
    tion of, 24, 86; destruction of,
    15–19, 31, 34–36, 47, 66; from
    Hermit Islands, 99; war, 87–89.
    *See also* boats
Caprivi, Leo von, 39
Carcone, trading post on, 31
Caro, Ludwig, 67
*Carola*, 6, 33, 36, 95
Carola Harbor, 36
Catholic Society of the Divine Word
    (Ali Island), 16
Clausmeyer Collection, 136
coconut plantation, 30, 47–48, 92, 94
coconut trees, destruction of,
    17–18
communal men's house, display of,
    80–81
compulsive collecting, 74, 77–79,
    81–82
*Condor*, 66
Cook, James, 114
copra (dried coconut), 2, 58–59
*Cormorant*, 66, 68
Craig, Barry, 153–154
curators, role of, 145–146

Darwin, George H., 86
deceit, example of, 59–60. *See also*
    looting; tobacco

Dempwolff, Otto, 23, 74; on attack
    on Luf, 36, 42; biography of, 160;
    description of Franz Hellwig,
    76; on Hermit Islands, 92–95;
    on Indigenous people, 102; and
    Luf Boat, 96–98; opinions on
    malaria, 28
Deters, Dorothea, 20–21
Devlin, Jimmy, 94–96
Dilthey, William, 77
disease, 28–31, 132
Dorotheum, 61
dried coconut (copra), 2, 58–59
d'Urville, Jules Dumont, 114
dwellings, 51

Easter Islands, looting from, 63
*Eber*, 36
Eichhorn, August, 96–97
*Elisabeth*, x, 10–13, 15
Epp, Franz Ritter von, 92
ethical responsibility, 143
ethno-anthropology, 75–76
ethnology, 7–9, 75, 77–78
Evangelical Rhenish Mission (Aly
    Island), 16
exploitation, 47–48, 59–60, 132
extermination, justification for, 132

*Falcon*, 66, 72
Fellmann, Heinrich, 91, 141
Fellmann, Johanna, 91
Finck, Captain, 34
Finney, Ben, 115–117
Finsch, Otto, 13, 18–19, 54, 56, 70–71,
    107, 160
First German Colonial Exposition, 78
Fischer, Eugen, 84, 129–130

forced labor, 30; effects of, 47, 131; Heinrich Rudolph Wahlen and, 92, 94; overview of, 131–133
forests, destruction of, 6, 131–132
*Freya*, 31
Friederici, Georg, 115, 117
Friedrich-Wilhelmshafen (Madang), 15
Frings, August, 129
Frings, Charlotte, 129

*Gazelle*, 92
Geiseler, Wilhelm, 34, 47
German Colonial Museum, 53
German Navy, 33–39
German New Guinea, 2–3, 14, 30
Gilbert Islands, 36
Golageril, 81
Gossler, Gustav von, 46
Grapow, Max von, 49, 68
graves, digging up of, 126–127
Green, Roger, 114
Grütters, Monika, 5, 140, 143, 152–153

Hagen, Curt von, 18
Hahl, Albert, 16, 65–66, 80, 126, 160–161
Hambruch, Paul, 40, 96, 109
Hamburg Ethnological Museum, 125, 128
Hauser-Schäublin, Brigitta, 96–97
Heidelberg Statement, 143–144
Hellwig, Franz Emil, 76; on attack on Luf, 33; biography of, 161; on Hermit Islands, 92; and human remains, 127; looting by, 60–61, 69–70

Herbertshöhe (Kokopo), 14, 73, 128–129
Hermit Atoll, Hermit Islands, 4–7, 27, 45, 47–48, 50, 91
Hernsheim, Eduard, 162; attack request from, 31–32, 39; biography of, 161; description of Schulle, 54; destruction by, 41–42, 47; exploitation by, 57; and human remains, 127; looting by, 46; Luf Boat and, 24, 98–99; and sale of Luf Boat, 98–100; trading outpost of, 29, 31; viewpoint of, 24, 41–42, 52
Hernsheim, Franz, 15, 29, 58–59, 161
Hernsheim & Co.: business of, 13; corruption of, 90; disease spread by, 28; and Luf Boat acquisition, 4, 21, 91–100; petitions of, 15; trading posts of, 58, 66
Hewel, Walter, 92
Heyerdahl, Thor, 116
*Hōkūea*, 116–117
Holfelder, Moritz, 144–145
Holtzendorff, Henning von, 136
*Huckleberry Finn* (Twain), 56
human remains, 76; collection of, 75–76, 125; deaccessioning of, 142; desirability of, 134; display of, 75; robbing for, 126; scientific use of, 129–130; transfer of, 83. *See also* skulls
Humboldt, Alexander von, 136–137
Humboldt, Wilhelm von, 136
Humboldt Forum, 155; conceptual plan for, 46; looted art within, 4; Luf Boat within, 20–24, 137–139, 155–156

*Hyena (Hyäne)*, x, 6, 12, 33, 36, 95
Hyena Passage, 36

Islanders *(Kanaken)*: classification
    system of, 114; culture of, 101–102;
    defense by, 16; defined, 12; escape
    of, 12; negotiations by, 71; origin
    of, 115; subjugation of, 132

Jews, restitutions for, 150

Kaiser-Wilhelmsland, 15
*Kanaken. See* Islanders
Karcher, Guido, 32–35, 43, 95–96,
    161–162
Kirch, Patrick, 114, 118
Koch, Gerd, 22
Koch, Robert, 92
Koenig, Harry, 11–12, 54, 163
Kokopo (Herbertshöhe), 14, 73,
    128–129
*Kon-Tiki*, 116
Kotze, Stefan von, 59
Krämer, Augustin, 74, 75; on attack
    on Luf, 33; artifacts of, 71–72;
    biography of, 163; on collecting,
    74, 134–135; "Contributions to
    a monograph on the Hermit
    Islands (Luf Archipelago)," 103;
    exploration by, 49, 72, 103; on
    Indigenous people, 97–98, 102;
    looting by, 49, 71; and Luf, 39,
    47–48; and Luf Boat, 22, 49,
    103–108; and New Mecklenburg,
    72–73
Krämer-Bannow, Elisabeth, 25–26,
    71, 163
Krug, Alexander, 33, 35

language, as study method, 115
Lapita culture, 119–122
larceny, 59–60. *See also* looting
Lebahn, Wilhelm, 98
Lichtenstaedter, Siegfried, 169n11
lime applicators, *108*
Linden, Karl von, 71
Linden Museum, 8, 64–65, 67–68
Little Mussau Island, 70
Livonius, Otto, 37
looting, 59–60; as "anonymous
    purchase," 69–73; of architectural
    elements, 66; by Augustin
    Krämer, 49; by German colonists,
    53; documentation of, 141; from
    Easter Islands, 63; by Eduard
    Hernsheim, 46, 59; example of,
    36, 66; by Franz Hellwig, 69–70;
    by Gottlob Johannes Aly, 53; by
    Guido Karcher, 43; by Heinrich
    Fellmann, 141; by Heinrich
    Schnee, 70; on Little Mussau
    Island, 70; by Max von Grapow,
    49; misrepresentation within,
    5, 8, 66; by Paul Boether, 67;
    praise for, 43–44; process of,
    63–64; records of, 43; of reli-
    gious statue, 136; and role of
    military, 46; by Wilhelm Müller,
    51–52, 69
Luf: attack on, 33–39; conditions of,
    50–51; demographics of, 6; de-
    scription of, 27–28, 94; destruc-
    tion within, 47; dwellings on, 51;
    expedition effects on, 6; forest
    on, 48; German Navy within,
    33–39; labor withholding within,
    26; orders to destroy, 31–33, 38;

population decline on, 39–42, 47; self-sufficiency within, 29; trading post in, 31; "voluntary extinction" stories from, 25–26

Luf Boat, ii, 21, 104, 106–107, 155; characteristics of, 6; conservators of, 149–153; cost of, 99; description of, 7, 103, 110–114; in Matupi, 98; as museum attraction, 20–24; overview of, 4–7; painted elements on, 108; procurement details of, 144–145; purchase of, 88–89; running fish motif on, 104–106; sale of, 99; shipping of, 90–91, 100, 156; significance of, 115; transport of, 22–24; trustees of, 149–153

Luf boathouse, 23, 23, 48, 98, 121

Luschan, Felix von, 74, 78, 82, 164; on Anderson, 62; assessment of colonialism on ethnology, 29, 83, 134; awards of, 82; biography of, 163; as collector, 77–82, 83–84, 84–86, 123; and human remains, 75, 83; and Indigenous boats, 84–89; and Luf Boat, 7, 99–100; on race theory, 83; at Royal Ethnological Museum, 79–82; on Thilenius, 61

Magellan, Ferdinand, 44–45
malaria, 28
Manus Province, 154
maritime travel, 115
Mascot, 66
masts, description of, 113
Mataafa, Josefo, 87
Matupi, 13, 14, 58–59, 98

Max Planck Institute for Human History, 127
Max Planck Society, 119–120
Melanesia, 114
Melchardt, Erwin, 61
Melk-Koch, Marion, 78
Mencke, Bruno, 67–68
Meyer, Adolf Bernhard, 133–134
migration, 118–119
Mirko, 13
missionaries, 3, 128
Müller, Wilhelm, 50–52, 69, 126–127
Museum of Ethnology (Berlin), 61

Navy, German, 33–39
Near Oceania, 114
Nemin, 103–110
Nevermann, Hans, 21–22, 124
New Britain (Neu-Pommern / New Pomerania), 14
New Britain Archipelago, 14
New Guinea, 1
New Guinea Company, 18
New Ireland (Neu-Mecklenburg), 14
New Mecklenburg, 72
New Pomerania, Bismarck Archipelago, 55
niggerhead, 56
Ninigo Islands, 50, 94–95
Norddeutscher Lloyd, 90
Nuguria Islands (Abgarris / Fead Islands), 131–132

O'Connell, James, 118
O'Keefe, David Dean, 28–29

Pacific, 31
Pak, 140

Papua New Guinea, 2

Papua New Guinea National Museum, 153–154

Papuan Museum of European Ethnology, 147–149

Parkinson, Richard, 104; biography of, 164; and Luf Boat, 23, 91; on effects of colonialism, 28, 47, 56; on looting, 59–60; skull collecting by, 126–127

Parzinger, Hermann, 20, 25, 41, 142–143, 150

"people of nature" / "natural peoples," characteristics of, 102. See also Islanders (*Kanaken*)

Pfeil, Joachim von, 75

Phrygian cap, 105

*Planet,* 103

plantations, 2, 30, 47–52

Pleistocene Era, 118

plug tobacco, 56, 57

Pohnpei Island (Carolines), 65

Polynesia, 116, 119

*Prinz Waldemar,* 100

Prussian Cultural Heritage Foundation, 139–140; 153–154; 2018 event hosted by, 5; and Bastian, 45; deaccessioning by, 142–143

race studies, human remains for, 129–130

racial theories, of Europe, 132

*Raubgut* (Our Loot) (Holfelder), 145

Reche, Otto, 84, 127

Reimers, Otto, 126

religious statue, looting of, 136

Remote Oceania, 114–115

Riemenschneider, Tilman, 147–149

Romilly, Hugh Hastings, 35

Royal Botanical Garden (Berlin), 53

Royal Ethnological Museum (Berlin), 79–84

Royal Zoological Garden (Berlin), 53

running fish motif, 104–106

Sahul, 118

sailors, 30

Samoa, 30, 47

Samoan catamaran, 90

Schaumann, Carl, 16–18

Scheffel, Victor, 58–59

Schellong, Otto, 120–121

Schering, Rudolf, 12, 54

Scherrl, F., 32

Schnee, Heinrich: artifact donations by, 67; biography of, 164–165; punitive expeditions and looting by, 63–64, 66–67, 70

Schnee, Paul, 64; "Our Brown-Black Compatriots in New Guinea," 59; on Indigenous people, 102

Schneider, Lieutenant, 34

Schulle, Friedrich, 54

scientific racism, leaders of, 84

scorched earth approach, 37

sea cucumbers, 47

*Sea Eagle (Seeadler),* 66

*Seagull (Möwe),* 16, 64, 140

Shaw, Tom, 29

Siar (Aly) Island, 16, 18–19

Sini, 103–110

skulls, 76; collecting of, 72, 75–76, 125–128, 133; deaccessioning of, 142–143; research on, 78–79, 82–83, 125–128

slavery, 13. See also forced labor

social networks, 119–120
Solf, Wilhelm, 87
Somare, Michael, 154
source communities, 140–146
South Seas, forced labor within, 13.
    See also *specific locations*
Southwell, Charlie, 32
*Sparrowhawk (Sperber)*, 72
Steinen, Karl von, 77
*Stella*, 92
Stephan, Emil, 48, 74, 146, 151
St. George's Channel, 14
Stöhr, Waldemar, 136
Stuttgart, 72
Sunda, 118
syphilis, 28–31, 30, 132

Tami Islands, 85, 88, 120
Tappenbeck, Ernst, 56–57
Tetzlaff, Carl, 41
Thamm, Adolph, 36, 57–58
Thiel, Friedrich, 91, 127
Thiel, Maximilian (Max), 58, 125,
    129; awards of, 72, 123–125;
    biography of, 165; collection
    of, 59, 61–62, 71–72, 125; on
    forced labor, 131; looting by, 64,
    70, 125, 151; Luf Boat purchase
    by, 20–24, 91–100; and Matupi
    party, 92, 93; on Parkinson,
    164
Thilenius, Georg, 6, 22, 39–40,
    74–75, 110–114
Thurnwald, Richard, 84
Tischner, Herbert, 41
tobacco, 53–58, 57

To Mari(a), 128–129, 57
trading, 53–58, 71
trading posts, 58
translocation, 145–146
Twain, Mark, 56

University of Berlin, 82; human
    remains at, 83

Vienna Museum of Natural History,
    125, 127–128
Virchow, Hans, 79–80, 86
Vogel, Hans, 69, 85, 88
voluntary extinction, 25–26, 96
Vormann, Franz, 16
*Vulture (Geier)*, 66

Wahlen, Heinrich Rudolph, 47–49,
    91–94, 93; biography of, 165; on
    forced labor, 131; mansion of, 50,
    91; Nazi Party and, 92
Wahlen Castle, 50, 91
Warnecke, Karl, 49–50, 91
Weisser, Jakob, 63
Wendland, Wilhelm, 73, 129
Wesleyan Methodist mission, 73
"When the Romans Got Impudent"
    (Scheffel), 58–59
Wahrendorff, Bernhard, 34–35
Wilda, Johannes, 59, 66, 131–132
Wilhelm, Kaiser, II, 87, 123, 125
Wilhelm, Mount, 1

Xelau, 103–110, 138

Zimmerman, Alfred, 56–57